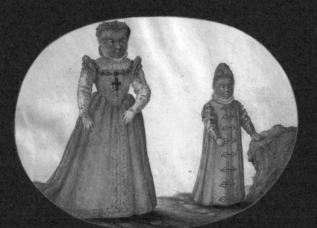

Special Cases

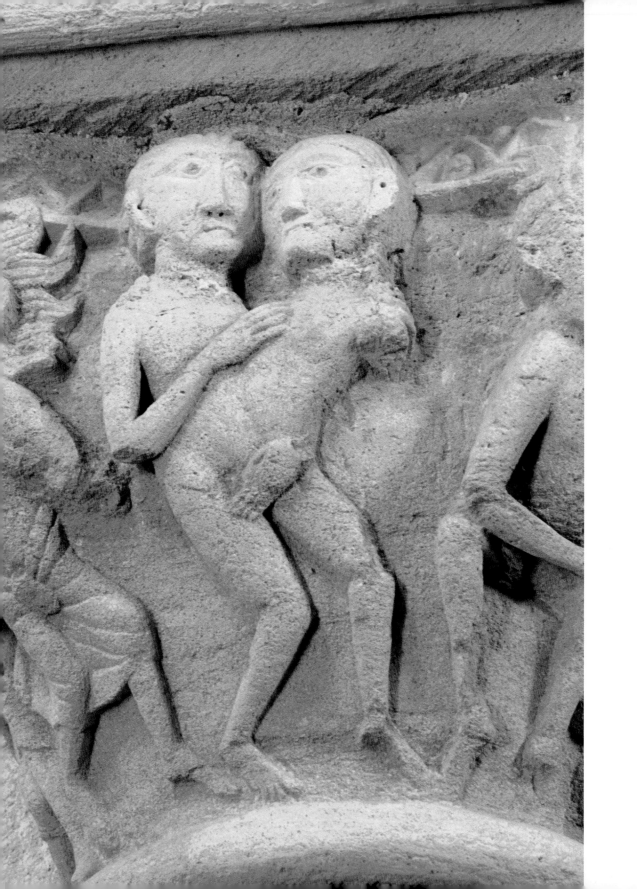

NATURAL
ANOMALIES

Special

AND

Cases

HISTORICAL
MONSTERS

Rosamond Purcell

CHRONICLE BOOKS

SAN FRANCISCO

This book was inspired by and uses text and images from the exhibition
Special Cases: Natural Anomalies and Historical Monsters, produced by The
Getty Research Institute for the History of Art and the Humanities
(September 24–December 17, 1994) and curated by Rosamond Purcell.
Images on pages 27, 63, 92, 103, 109, 140, and 145 are reprinted with
permission, © 1994 by The Getty Research Institute for the History of
Art and the Humanities, Santa Monica, CA.

Excerpt from "The Petrified Man" by Eudora Welty in *A Curtain of Green,*
© 1939 and renewed 1967 by Eudora Welty, reprinted by permission of
Harcourt Brace & Company.

ISBN 0-8118-1568-4
Library of Congress Cataloging-in-Publication Data available.

Printed in Japan.

Book and cover design: Pamela Geismar
Front cover photograph: Hydrocephalic child by Rosamond Purcell. See
also pg. 89. Spine illustration: Giants and traitors from Dante's *Inferno.*
See also pg. 106. Back cover photograph: Skeleton of a giant by
Rosamond Purcell. See also pg. 103. Endpapers: Portraits of Petrus
Gonsales and his family, courtesy of the National Gallery, Washington,
D.C. See also pg. 129. Page 2: Conjoined twins from Anzy-le-Duc by
Rosamond Purcell. See also pg. 72.

Distributed in Canada by Raincoast Books
8680 Cambie Street
Vancouver, B.C. V6P 6M9

10 9 8 7 6 5 4 3 2 1

Chronicle Books
85 Second Street
San Francisco, CA 94105

Web Site: www.chronbooks.com

Contents

DEDICATION

William Ira Bennett
Pere Alberch Vie
Willem J. Mulder

They lit the way—

Old books inspire in me the kind of love reserved for a precious pet; turning their pages slows the heart beat. The best, often a source of great tactile, visual, and intellectual pleasure, may also induce allergies to dust, mites, and mold. Along with besotted bibliophiles march legions of minute insects and fungi. I have held a few of these old books and many newer ones while working on this project. In truth, I am a drive-by reader, enamored of both ancient and contemporary texts. I often close a good book after reading several paragraphs or pages; my mind becomes so full of the flavor of someone else's writing that I am forced to stop. I am grateful to every author cited in the endnotes as well as to some who shockingly, and even against better judgment, I did not consult, and who therefore remain uncited. This boundless topic, of anomalies and monsters, is like a hillside of stones rolling into water, sending out endlessly intersecting rings. I have tried to place illustrations and historical accounts at some of these intersections, even though the urge to make a list of every permutation of every mutated being who ever lived remains as hypnotizingly compelling as Homer's recitation of the catalogue of ships off the coast of Troy, or as Linnaeus's catalogue of all organic life. In this text, of necessity, I have singled out a few marginal figures to take the stage, and by omission, all the rest were banished—out to the borders, yet again. I have barely touched on the vital topic of racism, both as atavistic tribal aversions to the "other," and as culturally institutionalized ostracisms. Chronological "time lines" have been set aside. This book honors the form of a slide show or an exhibition organized around associative clusters of phenomena, yielding at all times to gravitational attraction. This book comes three years after the exhibition for which I was the curator, *Special Cases: Natural Anomalies and Historical Monsters,* held at and sponsored by the Getty Research Institute in Santa Monica, California. The organization and contents of the book, although revised and expanded, were profoundly influenced by the original exhibition, and by the ideas, art historical research, and great kindness of the staff of the Getty Research Institute and at the Getty Museum. Many thanks to all of you. Thank you in particular to Thomas Reese, then acting director of the Getty Research Institute, who invited me first as a visiting artist to Los Angeles and second as a curator to develop the exhibition. The train of thought he

originally stimulated has afforded me many months of pleasure, excitement, and agony, in almost equal measure. Original text by the historian Katharine Park on the Romanesque conjoined twins appeared in the exhibition at the Getty Research Institute in 1994. I have rewritten and condensed that information for *Special Cases*. I am very grateful for the wise suggestions she has made in conjunction with this project. Every once in a while the texts I wrote for the exhibition appear in the book embedded in a new context. They serve as beacons, keeping me on this strange new course, without, I trust, spoiling the plot. On the home front, gratitude flows in an endless stream to Lisa Melandri, for her wise and patient assistance both on the original exhibition and on the book. Thank you, Su-Chu Hsu (Xiaoniu), for appearing in person to tell the story of Pangolin Woman; Richard Selzer for telling me about the paintings of Lam Qua; and Toby Appel of the Harvey Cushing/John Hay Whitney Medical Library, Yale University, for showing them to me. Thank you, Gretchen Worden of the Thomas Dent Mütter Museum, College of Physicians, Philadelphia, for holding down such a fabulous fort with such panache. Thanks to Katharine M. Wolff and Valli Miatto Buonanno for their translations from Spanish in the first case and Italian and Latin in the second; Marjory Wunsch for her drawings included herein; Zona, Inc. for expert photographic services; Diana Fane, Larry Fane, Laura Lindgren, Ken Swezey, Elizabeth Meryman, Richard Meryman, Dr. Paolo Scarani, Harriet Ritvo, Felicita D'Escrivan, Olivia Parker, and Stephen Gould, for professional consultations as well as valued friendships. Thank you, Andrew Purcell, for delivering the news on Herodotus and his gold-digging ants; John Henry Purcell for a brilliant portrayal onstage of the changeling, Bottom the Weaver; and Dennis Purcell for all his encouragement and, especially on behalf of this project, for working the Web. Thank you to my awesome agent, Jill Kneerim. At Chronicle Books I thank Karen Silver, Jeff Campbell, Pamela Geismar, and my original fairy godmother, Annie Barrows. Many of the illustrations for *Special Cases* come from distinguished museums and libraries. A longtime frequenter of natural history and anatomical museums, I have photographed many anonymous and a few celebrated specimens. They come to you from the dustiest corners of the furthest reaches of the oddest places.

"Ancient traditions, when tested by the severe processes of modern investigation, commonly enough fade away into mere dreams; but it is singular how often the dream turns out to have been a half-waking one, presaging a reality."
—T. H. Huxley, *The Book of Beasts*[1]

Introduction

In the *Physiologia* of 1680, Athanasius Kircher described, step by step, how to make a projecting machine. First, you build a container and a chimney so that the smoke from a lantern set within the box will rise. After inserting a lens of good quality, and painting in transparent watercolors on glass, you can start the show: "the light of the lantern coming through the lens glass will show the image painted on the flat glass straight and bigger on the wall with all the colors very lifelike."[2] Kircher's drawings of his projecting machines were based on the same principles used in slide equipment today, without the electricity. But Kircher went further in his second design by suggesting that you could put the machine out of sight behind a wall and project through a small hole into the next room. In this way, "you will affect the spectators with more wonder and admiration." The viewers will not know the cause of the effect; whatever has been painted, whether "happy, sad, horrible, terrifying, and also prodigious, will appear together with sentences and writings delineated in the center." Another of Kircher's machines was based on a series of mirrors using sunlight as a light source. It featured a wheel on which the heads of various animals—say a goat or an ox—have been painted; "they will appear to be very realistic if you place each on a human neck." He suggested that through manipulation of the angles of the mirror and use of shaped concave or convex glass, all manner of effects may be achieved: a column reflected becomes a hall of columns, painted sections of figures or landscapes can become a single whole when reflected, "now a man, now a woman, now Peter, now Paul." The viewer may also participate. "If you choose, you may give yourself three eyes in your head, for the Holy Trinity (although one will be dimmer than the other two). . . . To see yourself as a crane-necked man, you must use a mirror that curves in like a navel and swells out into a cylindrical tube, and if you look at your reflection obliquely you will see the horn of a rhino growing from your head." The use of color crystals along with distortion will create beings "red like satyrs, yellow like jaundice, blue or black like Ethiopians," and if the glass is crazed, it will show premature aging: "you may want the face of a goat or a Satyr, ugly, horned, wrinkled, with a ridiculous gaping mouth." There are, he asserted,

"a thousand ways to deform a man," and, if you use the methods he recommended, "no monster is so ugly whose shape you will not find in yourself."

Kircher's machine seems at once modern and sweetly obsolete. 1680 was early for a slide projector striving toward animation; the candle illuminating the "parallelogram" that held the slides made the projection flicker, most likely giving it a bit of illusory motion. On the wall, Death with his hourglass moves. Between one slide and the next falls a darkness that allows the afterimage to fade. In time another slide moves across the lens to quiver in the lamp light. . . . Kircher relished illusion and special effects. He apparently saw himself as the

architect, Daedalus, creator of wings for the boy, Icarus. Unlike many scholars today, he did not think it beneath him to turn image into spectacle or to fix a broken projector. Both perennial and universal, Kircher's ideas for thrilling distortion, including humans with horns, with crane-necks, Ethiopians, and the Devil, came from a lexicon of symbols closely associated with his culture and most likely familiar to his visitors.

Let us assume that Kircher could set aside his role as gleeful impresario and instruct his audience. We can imagine his slide shows, for Kircher left us ample documentation of his favorite themes. After inviting in an audience, and using the flame from lamps as a light source,

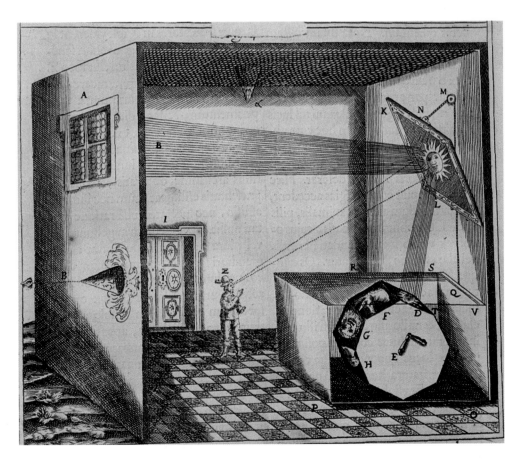

One of the versions of Athanasius Kircher's projecting machine showing the optical relationship of the viewer to the mirror, the light source, and the wheel. By positioning himself properly the viewer may seem to have assumed an alien head. [From Kircher's Physiologia, 1680; private collection; photo by author.]

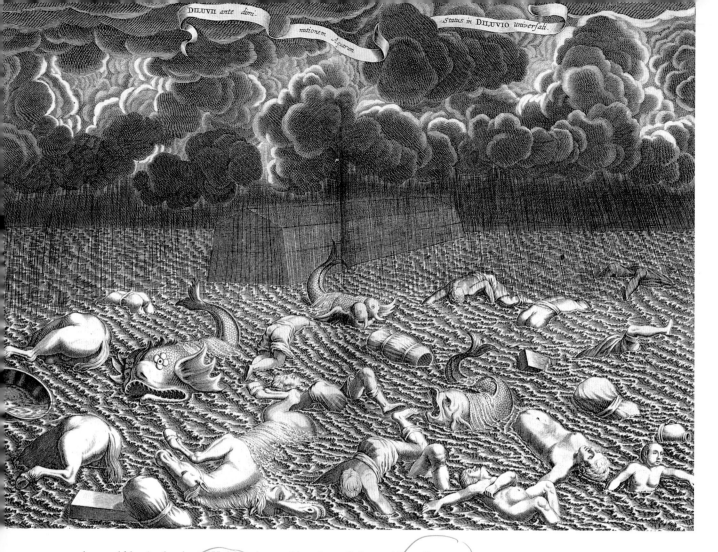

he would begin the show. We know he would project religious subjects: Jesus on the cross. The face of Jesus, pale on the wall as on a shroud. . . . From his travel slides, Kircher might show his drawing for the design of Noah's Ark. The Tower of Pisa. Exquisite drawings of the eruption of Vesuvius, and of Etna. A cross-section of the earth would show the interlinking channels of fire in whose pockets, he declared, dragons dwell, emerging from time to time to fly around near Lake Lucerne. He'd show a drawing of the bodies of horses, men, and sea monsters, including a two-headed elephant fish with wings, all of whom had missed the boat and were floating in the turbulent, rising waters of the original Flood. This projection is dark: the sky is dark, and the figures are embedded in the water in a complex tapestry of the destruction of life.

 Once Kircher had finished—which would take a very long time because he was so prolific—members of his audience, in this out-of-time event, would be invited to step forward with a story or two. In a thoroughly anachronistic

Those who drowned in the flood before the waters subsided, from Arca Noe **by Athanasius Kircher, Amsterdam, 1675. [By permission of the Houghton Library, Harvard University.]**

display, scientists, natural historians, writers, philosophers, and impresarios would project their own visions, according to their cultural biases and personal idiosyncrasies. With each new flickering image would come opinion, argument, and bias, bound by the nature of time to a particular cultural view, incorporating magic, religion, and medicine, rumor or reality, and projected through this singular lens.

A landscape might depict a flood, rocks that explode as a mountain erupts, or trees that rain down poison. Or the scene might quiver quietly, a mythical landscape appearing as a drawing on human skin. The nineteenth-century showman P. T. Barnum, upon seeing the drawing from Kircher's *Arca Noe* of all those who'd missed the boat, might be tempted to show off Constantine the Greek—his body was covered by a veritable canvas of needle-worked animals—tigers, peacocks, elephants, monkeys, and a monkey-faced man. An artificial tri-

umph, this breathing landscape, accommodating itself to the bends and creases of Constantine's limbs, represents the cosmos: a mystical animal-filled world.

If Ulisse Aldrovandi, the sixteenth-century natural historian, took over, he'd show a Renaissance version of a side-show creature: a crane-necked man described in his book *Monstrorum Historia.* "According to Lycosthenes, in the farthest parts of Sirican, or as others think in some valleys of the Tartars, there dwell a people of a neck so long that it imitates absolutely that of cranes; furthermore on the top of the neck the face is of a beast, but with eyes and nostrils like humans and also adorned with a beak and a beard like a rooster."[3]

If Jacob Johannes Scheuchzer, the eighteenth-century paleontologist, were running the show, he'd project his greatest find—the petrified body of *Homo diluvii,* "man from the flood"— as proof that man had died for all his sins.[4] Scheuchzer, convinced of the organic nature of fossils and of their significance as evidence of the Flood, did not live to hear that instead of a man he had, in fact, discovered a giant salamander, the first such fossil ever found.

If the projectionist were the anonymous fifteenth-century French artist of *the Livre des Merveilles du Monde,* a compilation of the works of Marco Polo, Isidore of Seville, Odoric of Pordenone, John Mandeville, and other travel writers of variable credibility, we'd see manuscript painting in a courtly style: a pale blue and gold miniature of caves, perhaps, or woods, islands, and rocks,

The eastern decorative style of Constantine's tattoos transformed him into a man of ancient origins. Both lavish painting and piercing of the body have long worldwide histories. [Courtesy of the Museum of the City of New York.] ⟶

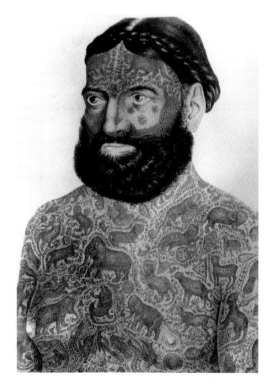

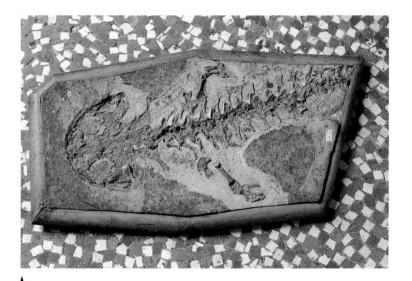

J. J. Scheuchzer in the early eighteenth century argued that ichthyosaurs, pleisiosaurs, and fishes found in stone were all organic remains of fishes—fishes who had died in, and were therefore proof of, Noah's Flood. Scheuchzer mistook this fossil for an original *Homo diluviens*, "Man from the Flood." Over a century later, in Paris, the scientist Cuvier chipped away at the fossil, freeing the forelimbs of a giant salamander to set the record straight. [Courtesy of Teylers Museum, Haarlem, the Netherlands; photo by author.]

through which headless people, big-eared giants, men with four eyes or with their feet on back-to-front wandered, where wild men chewed on twisting eels and cannibals, black, certainly hairy, gnawed on someone else's bones. The encyclopedic crowding of quaint monsters into these supposedly distant barbarian landscapes contributes to the implausibility of the scenes. And not every one in the audience would want to see them. A large component of the historically sustained ability to believe in fictional monsters lies in their absence. In order to believe in a nonexistent being, it must be poorly seen, kept in exile. It must remain on foreign ground, beyond the sea, behind impassable mountains. Very far away. East of the sun, west of the moon.

Indeed if a pre-Christian Greek artist projected his monsters on this screen, they would appear as solitary, defiantly antisocial creatures living on inaccessible islands. There would be no clear way to find them. "Never on foot, or ship could you find the marvelous road."[5]

If Shakespeare were then to show Caliban, the "freckled whelp" of Prospero's Island, up on the screen, his misery and his outcast state would echo that of other outcast misfits—Grendel, Cain, Polyphemus, the Cyclops, and

creatures Shakespeare's Othello observed on his travels: ". . . the cannibals that each (other) eat, / The Anthropophagi, and men whose heads / (Do grow) beneathe their shoulders."[6]

Giants, cannibals, and wild men were all members of fictional groups as well as individual legendary misfits. Shakespeare might well have seen an early Ptolemaic map in which cannibals lurked behind hills, and Ptolemy, the Greek cartographer, might jump up in excitement to show his view of the monsters in Africa.

Truly the word "monster" comes from *monstrare,* "to show," although the Romans long associated the word with the Latin *monestro,* a derivative of the verb *monere,* "to warn strongly." At many periods of time, monsters were seen as portents sent by the gods or by God to admonish people for their sins. And even when taken as amusements or as God's "joke," the undertone to the word "monster," its lining, has linguistic vestiges of the moralizing effect of, "to warn." Although, over the centuries, we have called beings who have never mastered our manners and rules *monsters* because they operate outside our social realm, we also call *monsters* those who are less than human but somehow, apparently, other than animals—beings caught in a complex netherworld of belonging only to themselves, but never, no matter how close, to us. Here I speak both of the anomalous being, born as two-headed chickens or children, and the fabricated monsters of classical, medieval, and early modern legends. In this theater, *monstrata,* they appear.

Through the centuries, Western scholars have cited hairiness, darkness, smallness, and imperfect rational skills as justification for questioning the eligibility of those possessing these traits for membership in the human race.

Perception of the anomalous is bound to cultural expectation. We have searched the world quite thoroughly since medieval times, vaporizing mythological monsters as we go, even as collective memory seems to crave their imagined presence. We have inherited a rich fictional past that cannot be denied; rumor, illusion, dreams, and hearsay amuse us, while science, if serious, generally is less "amusing." Unicorns continue to have more glamour than all our benighted rhinos.

Aldrovandi's book, *Monstrorum Historia,* published after his death by his faithful students, describes both the race of preposterous goose- or crane-necked men and the singular Crane Man captured in Madagascar, described as the fantastic progeny of the union between a pygmy and a crane and placed on display in Nantes, Paris, and Cologne in 1660. As an encyclopedist, Aldrovandi was bound to record—dispassionately if he could—the most far-fetched as well as the most reasoned reports of monsters. It was as if he worked as the editor

for a medical journal, a tabloid newspaper, and *Eyewitness News* all at once, a complicated undertaking for a professor of natural history and a collector. He saw himself in the role of Ulysses, and he took his name and modeled his intellectual wanderings after that hero. In this fashion, any event of an unusual nature became worthy of his attention.

The Greek historian Herodotus (c. 484-425 B.C.) might then step up to describe the mountains of Asia, in which fierce ants as big as dogs dug for and hoarded gold. Men deceived the ants by attaching empty bags beneath donkeys, who scooped the gold from the ground. The audience, for the most part, would dismiss the story impatiently, as though it were a fairy tale, although a few would listen without comment. Pliny the Elder (23-79 A.D.), the author of thirty-seven volumes of natural history, encouraged by the story of the ants, might then jump up to talk about bees, born without feet, and ruled by a king, saying, "Honey forms chiefly . . . at the rising of the stars."[7] But since he didn't have a picture to show to prove any of it, the audience would no doubt tell him to shut up and sit down.

Then Olaus Worm, the natural philosopher and expert in antiquities from Denmark, might sober things up by showing a narwhal tusk—and insisting that the famous navigator Mercator told the truth when he declared, in 1621, that the horn of the unicorn, the white horse, came in fact from this graceful mammal of the northern seas. Worm would explain that the seamen who brought the tusks to Europe had no direct contact with the collectors craving this six- to ten-foot-long treasure. No merchant bothered to explain, either— it was far more lucrative to have the apothecary's clients believe that a small piece of this tusk was a healing amulet from a unicorn. The princely and ecclesiastical collectors, however, wanted only to possess the rarest of the rare: a horn from the snow-white horse full of spiritual power.

At this point an argument might well break out as the audience weighed in with opinions as to the nature of the unicorn. Was the creature simply a mis-reading for the word *Re'em* from the Bible, the *Re'em* in reality a huge ox most likely extinct from the northern woods? Was the unicorn a large white steed, running wild in far-off places, or an intensely timid animal the size of

One of many graphic interpretations con-temporaneous with the supposed appearance of the Crane-necked or Goose-necked man, the progeny of an interspecial alliance between the bird and a human. [From Ulisse Aldrovandi's Monstrorum Historia, **Bologna, 1658; private collection.**] ⟶

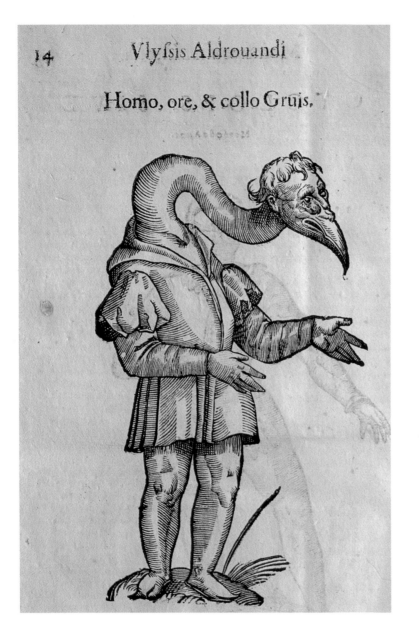

Homo, ore, & collo Gruis.

a small pony or goat, tamable only by a gentle virgin, preferably French? The angle of the unicorn's horn would also be hotly debated: Was it a long vertical or horizontal shaft projecting directly from the forehead of the animal or did it curve backward, like the horns of the goat? The painter, engraver, and theoretician Albrecht Dürer (1471-1528) could have told them: the unicorn horn came from the black rhinoceros. Kircher, at this moment, might use an optically versatile lens to create all the possible permutations of the unicorn.

Linguistic difficulties would abound at this event. P. T. Barnum's Latin was most likely rusty or nonexistent; Herodotus's Greek difficult to follow; and Shakespeare full of unappreciated puns—delivered in both Elizabethan English and made-up French. Kircher, the host, would have spoken in Latin or Italian. If we could follow what he was saying, we would have thought his explanations an archaic blend of biblical texts, supposed miracles, and unrelated scientific data. But we would miss the point. At the end of the twentieth century, we make distinctions between what is true and what is believed, whereas, as the contemporary cultural historian Mary Campbell explains, in earlier times every natural event had a figured equivalent. Although Kircher was on the cutting edge of scientific thought, he would be sympathetic to "God . . . as an author, history as a fable, the hooting of an owl as an augury."[8]

This is not a book about the history of the "freak." The monster, the flawed being, or the rare beast enslaved, captured, brought home, and put on exhibition for the captor's profit will be cited only occasionally, not because the exploited anomaly does not matter, but because others have written with thoroughness and eloquence on the subject. The focus in this book remains on the wall of shadow pictures, on the inescapable relationship between a dreamed-up monster and its painfully viable counterpart.

The paradox of any monster is that it may appear at once as an original and as a half-forgotten vision. Even though a frightening animal, a komodo dragon, or those chaotic creatures, conjoined twins, have not been seen before, their appearance may provoke the urge to climb to higher ground. Something tugs at the roots of memory, provoking fear; it may be the reminder that we suspected this never-before-seen creature always existed, and we'd always meant to give it room. But where? If all our instincts are to shore up against disaster, how can calamity be classified? The ground slips when the monster comes along. The issue in the study of anomalies is always one of classification—of perspective, scale, and the deep, inherited "misseeing" of the anomalous fictional creature and the genuine anomalous human being, which goes on and on. We weigh all extremes: in early times, men wondered if a Pygmy—by virtue of his minute stature—might be declared less than human. Is skin color an index of moral and intellectual prowess? Is a hairy-faced man as precious as an insect? Is an insect born of fire, and there-fore of extraordinary origin, or as benighted as an albino from the Moluccas, who was believed a kin of the cockroach?

This book should be read as an exhibition catalogue. In words, with illustrations, and in no particular chronological order we shall consider some of what has been thought and said as generations circle round the victims and the victors of anomalous conditions. Literature, anthropology, mythology, and a small amount of science contribute to this meditation on the monstrous, and while a great many clever writers have helped me think, the subject itself, without question, has the inherent intricacy of a life-long puzzle. The apprehension of monstrosity begins perhaps, as Yeats put it, "where all the ladders start; in the foul rag and bone shop of the heart."[9] Still, on the wall of the cave, and in the theater, the chimera pictures roll.

Here is the giant Bourgeois, owned and cherished by Peter the Great; here the tiny boy with the microcephalic head, kept and confided in by the Emperor Domitian. The evil men who had been born feet-first, Richard III and Caligula. The black child born of white parents. Twins connected from birth to death. Terrible tumors, enormous skulls, and twisted bones. Mythical, natural, apocalyptic, these emblematic victims of difference and suffering provide, even when the screen goes dark, a powerful visual afterlife.

Unfathomable for those who are not in physical pain to understand the dilemma of human beings for whom pain does not cease—pain of twisted

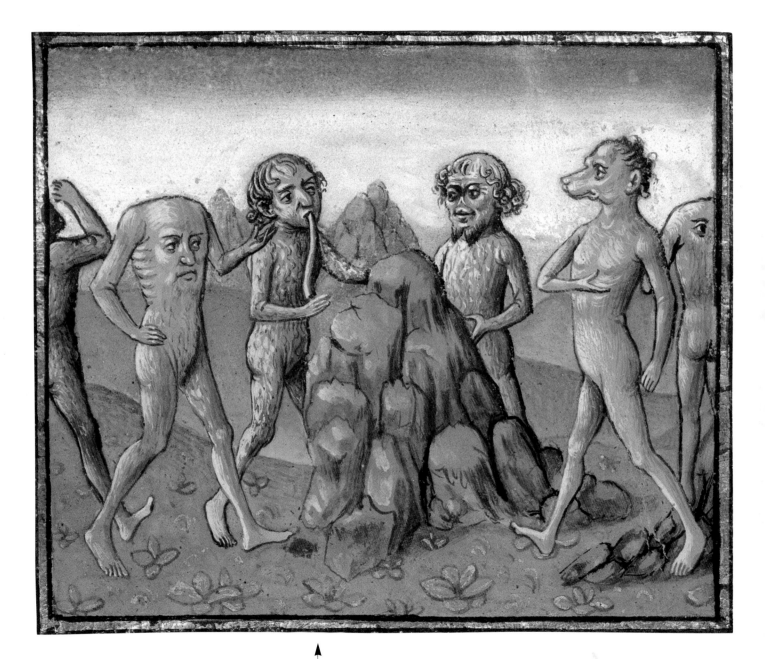

Representatives of four of the traditional mythical monstrous races: a wild man eating eels; a Cynocephalus, or dog-headed man; a member of the Sciritae with a characteristically flattened nose; and one and a half of the headless Blemmyae, whose faces appeared on their chests. [Detail from the manuscript *Miroir Historiale*; Vincent de Beauvais, artist, Jean de Vignay, translator; courtesy of the J. Paul Getty Museum.]

bones, of missing limbs, of misshapen features. Impossible to know the emotional state of those people for whom, as the photographer Diane Arbus said, "life's trauma has already happened."

The struggle to wrest the biologically viable monster from his imagined apocalyptic cousins began with doctors in the Middle Ages, the surgeon Ambroise Paré in the sixteenth century, and ended supposedly in the early nineteenth century with the invention of teratology, the science of the study of biological monsters, those natural forms that deviated from normal structure, by Isidore Geoffroy Saint-Hilaire (1805-61).

The arcane language of doctors, scholars, and scientists, under the umbrella of professionalism, can perversely convey the impression that the ignorant public should be spared the privilege of too much information. On the other hand, persuasive stories of maternal imprinting, fear of the Anti-Christ and Armageddon, the face of Christ in a tree and on a shroud, or the face of Elvis on Mars persist in the popular news for those, as one observer said, with "pious imaginations." On display and in the back rooms of world-famous medical museums, twisted skeletons, bottled freaks, and blighted births confront us with the same uncanny power they've always had—from ancient times.

The Cyclops, the siren, and the sheep-man have biological counterparts in the realm of teratology. Natural explanations for strange-sounding creatures continue to emerge. Were Dog-headed men actually lemurs on the shore of Madagascar? Was the huge Roc, the bird who supposedly picked up elephants and dropped them to be eaten on the ground—the *aepyornis,* the extinct "elephant bird" from Madagascar? "The men who wore their heads beneathe their shoulders" truly men carrying face-depicting shields to cover their waists and chests? People see what they choose to see. According to an old text, Plautus once mistook a woodpecker for a griffin. But then, as Mary Campbell puts it, "no one has ever needed a griffin, only the idea of a griffin, or the idea of a world in which griffins are possible."[10]

Once, at the Museum of Comparative Zoology at Harvard, I stood gazing up at a rearing reconstructed skeleton of an extinct giant sloth when a woman arrived with her three- or four-year-old son. "Oh, God!" she said looking up at the claws and the massive head. There was a short silence. Her son took his fingers out of his mouth—"Is that God?" he asked.

These small bright males and large brown females of the same species of Paradisea from New Guinea were caught by a collector who was, soon after, himself captured and "eaten by Papuans." The note found in the museum drawer states that all that remained of the collector's holdings were five pairs of these butterflies given first to his wife, and by her to a broker of natural history specimens. [Museum of Comparative Zoology, Harvard University; photo by author.] ——▶

"Often referred to as a 'freak of nature,'
the freak, it must be emphasised, is really
a 'freak of culture.'"
—Susan Stewart, *On Longing*[1]

Collections

In selecting examples for this collection of monstrous collections, it seemed best—as usual—to work across the centuries. And in order to have an adequate "tour" within the wide-ranging territory of collections in general, and considering the temporal restraints of paper and ink in particular, the main focus will rest on collections of anomalous human beings: in reality as mummies, anatomical specimens, and associated artifacts, and in illusion as waxen representations. Animal fossils, artifacts, and creatures of uncertain origins have traditionally and inevitably shared museum shelves with human beings. From time to time they enter this text. As in the case of most edited museum tours, there will be no grand conclusions; simply the evidence over and over again of human nature's typically inventive, acquisitive, and self-serving ways. Several writers recently have eloquently declared Noah's Ark a useful model for the first museum collection, cited, metaphorically speaking, for the intended completeness of all species. Early modern collections of natural history were referred to as "arks." Tradescant's museum at Lambeth in London, an enormous cabinet of curiosities in the early seventeenth century, was perhaps the grandest. These larger collections were precursors to Victorian museums. Interest in the mysteries surrounding singular possibly mythical animals and foreign artifacts lessened as they became more common, to be replaced by the sheer greed of acquisition and the fervor for strict systems of classification of natural history specimens, established by Linnaeus, Cuvier, and other pioneers of early modern science.[2] Noah, the Old Testament collector, confident in the power of the future, wanted animals only two by two. Museum collectors, terrified of incompleteness and losing a specimen, have been known to want it all—every last one. "Impossible," Catherine the Great said in the late eighteenth century of Prince Orlov's collection (apparently enormous) before she threw most of it away, "to enclose Nature in a cabinet."[3] Francis Bacon, the sixteenth-century philosopher, did not approve of the traditional cabinet of curiosities, which included random oddities and evidence of miracles. He called them sites of "broken knowledge." I see the smaller, older collections as repositories for disparate meaningful objects that trigger memories, as philosopher and

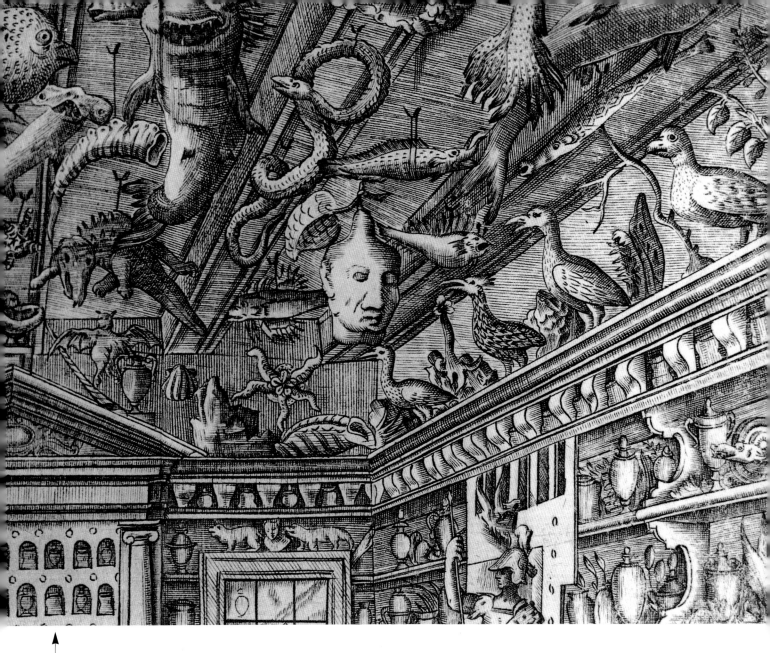

A close look at a small section of the ceiling of this crowded seventeenth-century museum reveals monstrous fish, a hammerhead shark, a giant eel, a fruit bat, a number of sea birds, and, attached to or perhaps tied to the top of the giant human head, a curious object—a shell? a brain? a leaf? [Detail from Musaeum franc. Calceolarium, Verona; courtesy of Yale University, the Harvey Cushing/John Hay Whitney Medical Library.]

historian Krzysztof Pomian recently wrote of "an invisible world mentioned in myths, stories, and accounts." Often the accumulated "history" behind a desired treasure—like a piece of marble with a (naturally formed) landscape on it, or stones that looked like human eyes—consisted of "a play of analogies, correspondences and resemblances."[4] Objects selected for a cabinet of curiosities sent down roots into the imagination, ancestral memory—part science, part myth. Potent objects—the large bones of a percheron, the huge horse on which a knight would ride; the crocodile, who, as Paula Findlen suggests,

might just grow forever;[5] volcanic ash from Mount Etna; or "metal vegetables," pieces of gold or silver that appeared on the surface of the earth—each of these objects would come into a collection as full of fact as of mystery.

Adam, who had been given the task of naming everything in the Garden of Eden, acted as the first curator, the first classifier, the first Linnaeus. Whatever died or withered away after the Fall might have been collected and kept as authentic fragments of an original ecosystem: apples (or figs) from the tree, a snake (with a forked tongue), a human rib, and the head of the devil taken from Eve's womb. Certainly these few objects would constitute the beginnings of a rudimentary cabinet, full of signification, both historical and natural historical. There would be no labels in this place, both because Adam did not write and because each generation, as we know, writes its own labels and assigns its own significance.

Collections have often been a magnet for human remains. In the first century A.D., the museum of Pompey the Great in Rome supposedly included the statue of a woman who had given birth to an elephant, "four pairs of conjoined twins, and a boy with the head of a dog," a still-born child from a male homosexual, also on display as testimony to this marvel. According to Pausanias, the second-century Greek geographer, other sensational collected treasures kept in temples included the bones of Tantalus (he who was fixed forever in a state of craving fruit and water and of obtaining neither), the head of the Medusa (the Gorgon with the snaky locks), a colossal bone of a sea monster, and "three women with hairy bodies"—most likely, as classics scholar Robert Garland writes, the skins of apes (chimpanzees) or monkeys (baboons).[6]

Among many private or institutional collections known specifically for their anomalies were the early-eighteenth-century *Kunstkammer* of Peter the Great in St. Petersburg and the early-nineteenth-century collections now found in the Museo Cesare Taruffi at the Instituto d'Anatomie Abnormale in Bologna. The Great Chamber in the Surgeon's Guild in Delft in 1667 displayed as illustrations many of the same oddities as were seen in the flesh in Roman monster markets: paintings and drawings of hermaphrodites, bearded women, strange tumors and diseases.[7] Many private pre-Industrial Revolution collections contained objects that, although not anomalous from a modern perspective, had not then been biologically fully described and therefore possessed a quality of mystery or magic. The owners of seventeenth-century cabinets took pride in "footless" birds of paradise,

These plaster life casts of the faces of indigenous peoples from the Indonesian island of Nias were made by the nineteenth-century Dutch colonial anthropologist J. P. Kleiweg de Zwaan to support his theory of the diversity of evolutionary types within restricted geographical boundaries. [Universiteitsmuseum, Utrecht; photo by author.]

who "fed on air and never touched the ground," armadillos, salamanders "born from fire," the bezoar (a stonelike object with supposedly magical healing properties), large fish-monsters like the sturgeon or remora, crocodiles (creatures seemingly from a near-mythical world, perhaps the descendants of dragons who came from channels of fire beneath volcanos), a snake from Surinam whose back was "marked with Arabic characters,"[8] sea shells (ordinary to us but more priceless at that time than precious stones), coral as airy as capillaries and red as blood (as if from Christ perhaps), the ear bone of a whale that, held sideways, showed the profile of a sailor, the "pistle bone" of a walrus at least two feet in length, the horn of a narwhal (still held by many during this period to be the unicorn), the enormous tooth of a supposedly human "giant" (dinosaurs were unknown at this time), roots shaped like men, stones shaped like human ears, hands, hearts, and testes, strange stone crabs and echinoderms, and, after 1500, when the New World opened, artifacts from the Americas, that cannibalistic, heathen place: feathers, skin garments, war clubs, and tobacco. The artifacts gathered during these early travels were considered strange—all of them evidence of other beings, perhaps quasi-human in nature. The rumors that Indians were cannibals simply supported the long-held suspicion that at the far reaches of the world lived unenlightened savages capable of such barbarous acts as pouring molten gold down the throats of the Spaniards, who had come, after all, to take the precious metal, not to drink it.

Private cabinets and early museums flourished in Italy, Germany, Great Britain, and France, especially in the seventeeth century, although the history of collecting in these and all other countries is an ancient habit.[9] Naturally, the character and contents of each collection is determined by the collector's preoccupations, inclinations, and financial means, by his foreign sources for the acquisition of desired animals and artifacts. (Perhaps Catherine the Great remains the most well known of women collectors, of whom there were mighty few.) A princely collection differed from the cabinet of a naturalist and from the contents of an apothecary. For example, in

the Musaeum Kircherianum in the College of Rome of the Society of Jesus, our friend and professor of mathematics and languages, Athanasius Kircher,[10] was determined, among much else, to amass as big a collection of terrestrial and sea birds and creatures as he could, to figure more accurately their distribution within his reconstructed architectural drawings of Noah's Ark, for his book *Arca Noe.*[11]

Olaus Worm collected antiquities from archaeological sites as well as a number of North Sea mammals and fishes, including the narwhal, whose tusk, he explained to the misguided, was mistaken for the unicorn's horn. Much later, the nineteenth- and twentieth-century collector Walter Rothschild set great store by albino birds and animals. Willem Cornelis van Heurn (1887–1972), a twentieth-century collector from the Netherlands, collected rats, dogs, cats, snails, frogs, and deformed bird's eggs as well as the shell of every egg he ever ate,[12] and Dr. Cushing of the Peter Bent Brigham Hospital in Boston displayed, in a bottle, a truly arcane treasure: a piece of steak autographed by the Russian physiologist Ivan Petrovich Pavlov with electrosurgical apparatus in Cushing's operating room on August 21, 1929.[13] The mid-sixteenth-century surgeon Ambroise Paré developed his collection in the line of duty. In Paré's time, a medical doctor would have been a worthy recipient of all natural history specimens and organic remains. His collection came, often literally, from his patients: accidentally swallowed objects—needles, nails, or surgically excised stones—kidney stones, gall stones, and other natural calcifications. He also collected items of natural historical interest—whale vertebra, fish, an ostrich skeleton, a bird of paradise, and a chameleon.[14] The doctor as collector of medically engendered detritus persists throughout time. Surely one of the stranger collections of (carefully ordered) needles dates from the mid-nineteenth century; they were

These needles taken from the body of an insane woman after her death reflect not only the extraordinary mental anguish of a morphine addict but also the peculiar sensibility of whoever arranged the morbid collection with such care; it is as though the needles, once a source of frantic and fruitless anticipation, might now be used methodically by a person mending clothes. [Warren Museum, Harvard University; photo by author.]

Some of the original skeletal material may exist in the remnants of the czar's collection in St. Petersburg, but the tableaux by Ruysch exist fully only in the early drawings that are found in his book *Opera Omnia*. [Courtesy of the Getty Research Institute for the History of Art and the Humanities, Santa Monica.]

removed from the body of an insane woman, addicted to morphine. Perhaps she believed that morphine came with every needle. It is curious that whoever prepared this display mounted the needles tidily, on a piece of paper, as if they belonged to a seamstress, and as if the gruesomeness of their history could at least be somewhat tempered by presentation.

The use of animal and human remains as an expressive artistic medium reached new heights in the work of the seventeenth-century Dutch doctor Frederik Ruysch, who used his revolutionary embalming techniques, and his artistic sense of *vanitas mundi,* to preserve and present the more perfect anatomical specimens as moralizing museum exhibitions. His assemblages, landscapes of tiny rib cages and skulls flanked by skeletons weeping into preserved membrane "handkerchiefs," resemble miniature battlefields in the vain and poignant struggle for life.

Ruysch, foremost among seventeenth-century Dutch surgeons, performed autopsies on criminals to educate the public about human anatomy, as well as to offer ethical instruction on the nature of sin. The dissections, performed (of course) by candlelight and accompanied—in the nature of a service or a celebration—with refreshments and music, took place in an amphitheater, which in sixteenth-century Leiden functioned both as a school for anatomy and as a museum. Surrounding the rim and the benches of the theater were human skeletons, often of personal notoriety: a woman strangled for theft, a man executed for stealing cattle and now mounted on the skeleton of an

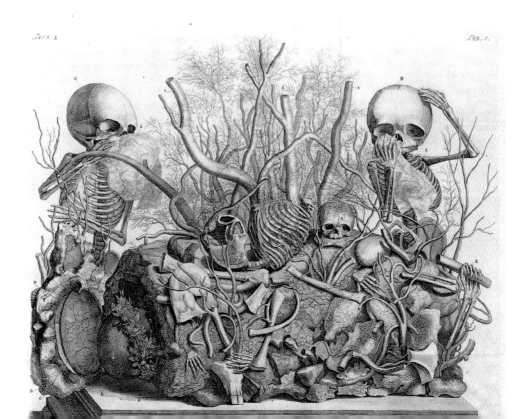

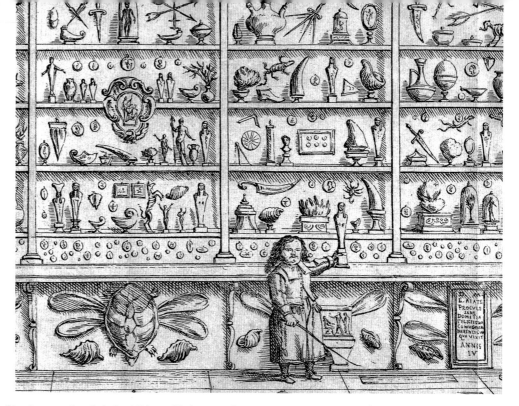

ox, and two women guilty of having murdered their children. Skeletons of Adam and Eve presided over the theater to remind the visitor that with the privilege of viewing a criminal's open corpse came the lesson of the origin and the fruits of sin.[15]

In a 1677 engraving, the dwarf docent/collection manager of the Marchese Fernando Cospi museum in Bologna has been given a sanctified position.[16] The mood in the mid-seventeenth century in Italy was not so much to include every natural object possible in a small private museum as to place emphasis on the "marvelous" qualities of natural phenomena—and this "marvelous" included monsters. As noted earlier, the word *monster* means "to show," and here the dwarf demonstrates his mastery of the collection by designating with his left hand a small statue or stele, Egyptian in nature. In his other hand, a slim pointer dips casually past a classical carved stone and giant bivalves hanging behind him on the wall.[17] In this illustration, the dwarf, Sebastiano Biavati, is to all appearances the only living specimen, a prized acquisition for the collector, Cospi.

In fact, according to the story in the catalogue of Cospi's museum, Cospi, an acquaintance of Sebastiano Biavati's parents, had invited the young man and his sister, Angelica, also a dwarf, to live in his aristocratic apartments. A portrait of Sebastiano hung over the entrance and another, of Angelica, over the door to the second room of the Cospi/Aldrovandi museum. The siblings, the only two dwarfs from a large family, had, when young, along

Curator of the Cospi Collection, the dwarf Sebastiano Biavati. [From the catalogue Museo Cospiano **by Lorenzo Legati, Bologna, 1677; private collection.]**

with the rest of the family, eaten some spoiled chicken, and of all the family they had been most afflicted—their growth stunted forever. Angelica Biavati was apparently quite charming; a love-struck fellow student in her evening poetry class in Bologna wrote a tribute to her beauty, which appears in Cospi's museum catalogue of 1677. The portraits, tributes to both brother and sister, placed to guard the collection as if they were patron saints, also symbolized Cospi's patronage over the treasures, which included the dwarfs. Sebastiano, the collection manager, represented a more refined and sympathetic connection to the world of hoarded creatures and exotic artifacts than might a curator of average stature and normal proportions.

In the frontispiece to Cospi's catalogue, on top of the shelves, high above the dwarf's head, is a torso of a small mammal joined with the tail of a snake. In similar views of early collections, hybrids—perhaps more artificial than biological in origin—and biological monsters may be clearly seen. Monsters appear, of course, in the midst of ordinary life, and most sixteenth- and seventeeth-century cabinets of curiosities included natural "wonders": monstrous eggs, two-headed snakes or calves, a chicken with extra digits, the hand of an Egyptian mummy, a mermaid, magic stones, dragon's teeth, and a horned horse. A double dog is tucked up high on a shelf in the frontispiece of the cata-

logue to the scientist Ferrante Imperato's museum, while in the illustration of the apothecary Francesco Calzeolari's museum, a giant severed head swings from the rafters. Although in one of his catalogues Calzeolari writes of the medical importance of dried Egyptian mummies in his collection, he does not mention this conspicuous head, which leads to a number of questions: Is this the decapitated head of a criminal? Did the collector know who it was? Has it been rescued from the anatomist or the hangman in order to hang in perpetuity as a symbol of sin and retribution? In lists of collections from northern European cabinets the remains of criminals are often described and clearly coveted.

Peter the Great's early-eighteenth-century *Kunstkammer*, the first museum in Russia, included living exhibitions. Peter, a giant himself at six foot, seven inches, had a marked fondness for all anomalies, and in his museum he installed Foma, a boy whose hands and feet had only two digits apiece, and a beloved giant named Bourgeois, whom Peter tried unsuccessfully to breed by procuring a giantess from Sweden to be his wife. In the manner of Biavati, both Foma and Bourgeois displayed both themselves and the objects in the museum to visitors. Although Peter's monsters were not given curatorial authority, the Czar, who had a tender streak, apparently treasured these men as he did his horse, his dog, and his wife, Catherine. The skeleton of Bourgeois may still be seen in the *Kunstkammer* of Peter, although the skull on the skeleton clearly comes from another person.

Although Peter adored Catherine, their relationship was not without conflict. In a moment of fury, he decapitated the head of his own young mistress as well as the head of his wife's lover and left them properly pickled in alcohol beside Catherine's bed. According to some accounts, and to Catherine's credit, she never said a word. The heads, beautifully preserved in the tradition of Dutch anatomists observed by Peter on his travels to the Netherlands, were entered into his collection only to be discarded by Peter's grandniece, Catherine the Great, fifty years later in a fit of housecleaning. Catherine the Great preferred paintings and sculpture to natural history and decapitated heads, however eternally fresh and however historical.

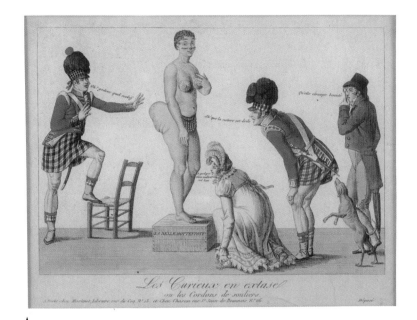

Les Curieux en extase ou les cordons de souliers ("The curiosity seekers in ecstasy," or, "The Shoelaces"). The real meaning in this nineteenth-century French lithograph comes in the artist's depiction of the onlookers; rudely staring, they are the ones who become ridiculous, while Saartjie Baartman preserves her dignity and does not reveal what she thinks of them. [Private collection.]

Collectors sometimes anticipate treasure before it becomes available. In the 1720s, the collector John Hunter sent a "resurrection man" to observe the sideshow performances of O'Brian, an Irish giant; he wanted O'Brian's bones. The presence of Hunter's henchman was tantamount to a visit from a terrible robber—a premature message from beyond the grave that frightened the giant very much. Before he died, O'Brian bribed some fishermen to sink his body in a lead coffin at sea. Just before the coffin sank, Hunter paid the fishermen a greater sum to possess O'Brian's bones at last.[18]

Collectors have long desired the physical remains of people who during their lifetimes exhibited physical oddities or mental prodigiousness: the city of Paris acquired the remains of Saartjie Baartman, the Hottentot Venus; Florence, the frieze of the conjoined twins; and Philadelphia, the death cast of Chang and Eng, the famous (original) Siamese twins, along with their conjoined liver and their specially constructed chair (see "Too Much" for more on twins). Generally speaking, before the seventeeth century, freakish beings were considered rarities or symbols of chaos within the natural order of things. What has been thought about monsters over the centuries is a very intricate historical and philosophical subject, and people have understood monstrous beings— over time and sometimes all at once— as marvelous, apocalyptic, holy, profane, and irrelevant. At times, living anomalous people have been widely exhibited and greatly extolled, and at times hidden away or killed. It was only after the seventeenth century that, "although living freaks or anomalies were usually marketed and displayed primarily as vulgar entertainments, after death they might be redeemed and transfigured by science."[19]

A unique feature of the female anatomy of the Hottentots (or *Khoisan*), from the point of view of other races, came under unseemly scrutiny by Paris society in the early nineteenth century when Saartjie Baartman, a South African domestic servant who had come to France at the suggestion of her master to earn money, put herself on display. Khoisan, or Hottentot, women have an extra mass of fatty tissue deposited above the buttocks, which may be an adaptive strategy to guard against starvation during times of critical food shortages. Saartjie Baartman was studied by the great French scientist Georges Cuvier, who took great interest in her buttocks (for possible muscle structure), in her genitals (for its apronlike folds, also a feature of her race), and in her skull (for its "primate" features). He had the satisfaction of dissecting Saartjie after her death in order to answer all his questions. Of her head, when she was alive, Cuvier said, "Her movements have something brusque and capricious about them, which recall those of monkeys. She had above all a way of pouting her lips, in the same manner as we have observed in orang utans." In fact, the skulls of the Hottentots and the Bushmen, both Khoisan, are small and delicate, with large foreheads and small lower jaws, less apelike than most of the rest of us. For Parisians to consider Saartjie the Hottentot Venus, a wild and sexy beast, was to reveal the salacious appetite and racial bias of the audience rather than the biological imperatives of the woman.[20]

In a ribald drawing, only the people looking at the featured Saartjie seem ridiculous. While she looks directly at us with quiet grace, the rude public studies her. The sword of one kilted onlooker (who refers to Saartjie's rear end as "roast beef") dangles in a skinny fashion between his legs, somewhat suggesting impotence. A dog eagerly looks up the kilt of a second gawking onlooker, while another man sits firmly on his own stalklike umbrella, creating a kind of titillating tripod. The only woman present pretends she isn't interested, though her face, in fact, is very close to the Hottentot woman and her gracelessness, though clothed, is obvious beside the statuesque exoticism of the woman on display.

Not only those—like Saartjie Baartman, Chang and Eng, and O'Brian —who earned a livelihood by putting their anomalous selves on display became valued as collected objects after their deaths. For example, even the cross-sectioned skull of an obscure madman who believed himself to be the rightful pope (see "Heads and Tails," page 92, for a discussion) was carefully collected—first by the hospital in which he died and later by the Museo Cesare Taruffi in Bologna. The skull of "Il Papa" represents both a souvenir shell of random madness and a documented artifact of experimental scientific history. The madness has vanished, of course; it never could be seen in the skull. But because of the written history of medical opinion surrounding it, the lasting value of an otherwise "vulgar" object has been assured—it has been "redeemed by science."

Often, only when the numbers of an indigenous race have been reduced to virtual extinction do their remains become suddenly precious to their captors and do the individual names and faces of each of the scarce survivors become significant: Ishi, supposedly the last of the Yahi Indians, died in 1916; Princess Angeline, oldest living member of the Seattle tribe and daughter of the king, died in 1896; and Saartjie Baartman, the "Hottentot Venus." At one end of the scale, collections become little more than the trophy cabinets of colonialism. Once the "other" kind of human—or the enemy—has been annihilated and the war against their existence is at an end, the jackals and

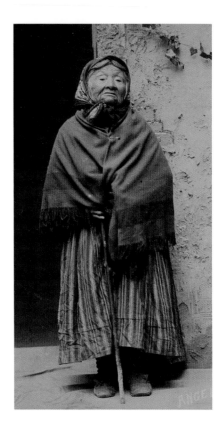

vultures close in to clean the corpses, just as human scavengers may come to collect the "spoils" and collectors vie for fragments. As game hunters fill their walls with tusks, antlers, and rhino horns, so anthropologists preserve their anatomical treasures in arsenic, mothballs, and in the dark.

In the nineteenth century, Dr. George Stokell from the Royal Society, Tasmania, and Dr. W. L. Crowther of the Royal College of Surgeons fought over the interred body of the last Tasmanian man, William Lanner. First one, then the other, dug him up and cut off pieces from his body: the head, the hands, the feet, ears, and nose. Finally, in an act of sinister one-upsmanship, a checkmate in the game of appropriation, "Dr. Stokell made a tobacco pouch out of Lanner's skin."[21] The struggle between two white doctors to possess the last tangible piece of the underdog Tasmanian carries a message: when the enemy is gone, we will collect him, first as a meal, actual or symbolic, and then as a trophy—as a heart worn around the neck, as a tobacco pouch, as a lampshade.

Among the markets in ancient Rome, Plutarch described a "monster market" where one might buy "persons who have no calves, or who are weasel-armed, or who have three eyes, or who are ostrich-headed." A great appetite existed for deformed slaves as well, and it was a rumored practice that Pygmies or dwarfs were shut into cages in order to stunt their growth even further. Anomalous people were valued for their misshapen bodies and weak minds, both sexes for their humpbacks, men for their enormous penises, and above all, for their compliance in the corrupt Roman world. The crippled and the weak became scapegoats, entertaining the rich and mean through their accommodation and their humiliation. These deformed slaves in some Roman households were valued for both their rarity and utility. They served their owners as sops for emotional and physical abuse, and even in some cases as confidants or political counselors. The Roman emperor Domitian owned a small boy with "an abnormally small head with whom he used to confabulate a great deal and often on serious topics."[22]

Princess Angeline, daughter of Chief Seattle and "the last of her tribe." It is recorded that the citizens of Seattle in the 1890s saw Angeline as an old woman wandering dignified and tireless around town. [Carte de visite, late nineteenth century. Private collection.]

The Christian church as well as the Roman temple, the medieval and Renaissance apothecaries, the private cabinet of curiosities, and museums—both ancient and modern—are places where, at one time or another, all manner of organic remains, both animal and human, have been found. The early churches possessed "the bones of giants," ostrich eggs (a symbol of Christ's resurrection), stuffed crocodiles, scallop shells (the pilgrim's badge and symbol of Saint James of Compostela), as well as the bones and relics of saints. In addition to serving as an early prototype for later natural history and ethnographic collections, the medieval church was in the particular business of collecting human remains and effigies. And, as elsewhere, the more the better. Along with fabulous collections of religious art and precious treasures, the sanctuary has long been a magnet for human remains of mystical importance.

In the Middle Ages, monasteries "stole" relics of sanctified human remains from each other in a premeditated system, lending greater prestige to the place to which the remains came. As a practice, the theft of sanctified bodies or fragments of bodies was a common and even reasonably well tolerated event.[23] The act of relocating the body of a saint from one site to another is called "translation." All the spiritual power of the saint's history shifted in translation of the remains to bring prestige of ownership to the monastery or church. Sometime before 1050 A.D., for example, the body of Saint Mary Magdalen was removed to Vézelay, determining that geographically well situated church's "must see" status as a stop on the pilgrim route to Spain.

The lives of saints end frequently in earthly martydom, often tortured to death. The histories of their tortures, borne in all humility, lend saints both grace in heaven and a place in the trophy cabinet of the sanctuary. At one time, on a secular level, and for a price, ordinary human beings could also be represented in the church alongside statues of the virgin and the saints.

For two years before he died, this young paralyzed boy could not move from a crouched position. In the nineteenth century, medical schools practiced the art of partial dissection, flaying of the skin, and varnishing of the dead in order to study intricate anatomical details. [Museo Cesare Taruffi, Istituto di Anatomia e Istologia Patologica, Università di Bologna; photo by author.]

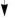

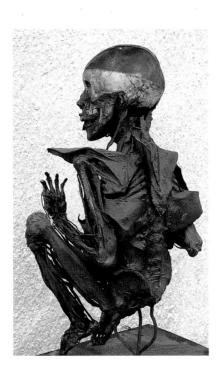

This scene shows the beheading and collecting of the head of John the Baptist. The saint and cousin of Christ was betrayed by the temptress Salome to King Herod, who ordered his decapitation. [Detail of a Greek icon, thought to be from the eighteenth century; private collection; photo by author.]

In her novel *Romola*,[24] George Eliot describes with historical accuracy the astounding collections of the effigies found in the church of Santissima Annunziata in Florence in 1492. In this scene, a crowd of citizens and distinguished visitors, each faithfully represented in wax, hangs from the ceiling, creating the strange effect of two congregations, one standing below and one hanging above:

"The whole area of the great church was filled with peasant women, some kneeling, some standing; the coarse bronzed skins and the dingy clothing of the rougher dwellers on the mountains, contrasting with the softer-lined faces, and white or red head-drapery of the dwellers in the valley, were scattered in irregular groups. And spreading high and far over the walls and ceiling there was another multitude, also pressing close against each other, that they might be nearer the potent Virgin. It was a crowd of waxen images, the effigies of great personages, clothed in their habit as they had lived; Florentines of high name, . . . popes, emperors, kings, cardinals, and famous condottieri with plumed morion seated on their chargers; all notable strangers who passed through Florence or had aught to do with its affairs— Mohammedans, even, in well-tolerated companionship with Christian cavaliers; some of them with faces blackened and robes tattered by the corroding breath of centuries, others fresh and bright in new red mantle or steel corselet, the exact doubles of the living. And wedged in with all of these were detached arms, legs, and other members, with only here and there a gap where some images had been removed for public disgrace, or had fallen ominously. . . . It was a perfect resurrection—swarm of remote mortals and fragments of mortals, reflecting, in their varying degrees of freshness, the sombre dinginess and sprinkled brightness of the crowd below."

In Santissima Annunziata, this "perfect resurrection" of still-living or long-dead subjects represented payment of a social debt as well as a testimony of fidelity. As a symbolic collector of human souls, the church stands supreme.

About the eventual fate of the figures from Santissima Annunziata, Michel Lemire, a French expert of anatomical waxes, writes that sometimes the heat of the votive candles softened the figures above, which then dropped *mollement* (limply) onto the faithful below. There were so many figures, some on horseback surrounding the statue of the Virgin, that the exterior wall of the church became covered with smaller ex-votos as well. In 1786, the Grand Duke of Tuscany ordered that the figures be taken down, melted, and made into candles.[25]

Although church collections may have a different stated purpose from most museum collections, a frequent theme of many collections, however different their mandates, is to be big—to be so big that even if the specimens in a museum are themselves unremarkable, the sheer numerousness of objects becomes its most impressive feature. A big collection may be an attempt indeed to "capture all of nature," to amass more than anyone else, to accumulate the most power, the most karma, the greatest number of souls, the largest sum. Implied in the institutional hoarding of dead things is a shoring up against mortality. Both the impulse and the achievement may be termed monstrous. For example, thousands of warriors underground in China, the anthropological collection of masks

from Nias, and the multitude of relics from the eleven thousand virgins of Saint Ursula in Cologne all signify an obsession with large numbers.

The eleven thousand virgins of Saint Ursula, kept near the cathedral of Cologne, have been immortalized in reliquaries, constituting a symbolic multitude for the purpose of contemplation by the faithful: in contemplation of the beauty, purity, and self-sacrifice of the young virgins' lives. However, it is also said, the "virgins" are actually composed of bones and skulls taken from a Roman ossuary, dating several centuries earlier than the supposed miracle of Ursula. The eccelesiatic cloth and the skulls combine to form symbols of mortality, of memory, and of God.[26]

The eight thousand inhabitants of the catacombs of the Capuchin Fathers of Palermo are dressed, as fine as they can be, in their original clothes: the priest, cardinal, and all the friars in serge or sackcloth, the general with ribbons and medals of distinction, the aristocracy in lace and silk. Spinsters, given a special chapel of honorable virginity, are dressed in white with blue silk waistbands, white gloves, flowered garlands on their heads and held in their rigid arms; children, too, stand in their daily clothes, while the lawyers, doctors, and businessmen, set on the side of the widest corridor above the finest marble floor, wear top coats, striped trousers, and sometimes a hat. Occasionally a hat has fallen over the face, and gloves hang limp on many hands. Everyone has been tied to the wall or placed behind a close-fitting screen to keep from toppling forward. When the body has collapsed altogether, sheets or shrouds have replaced the

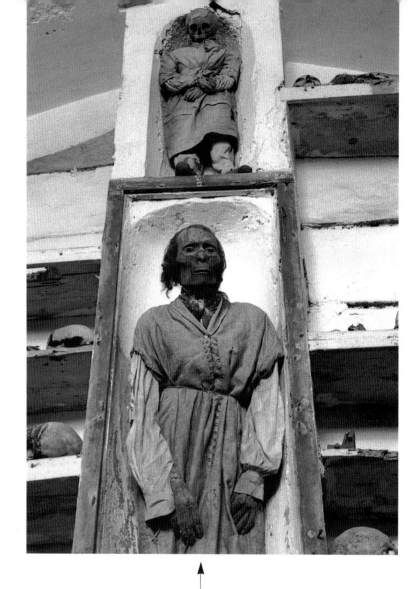

"A dwarf standing on the shoulders of a giant may see farther than the giant himself" (from *The Anatomy of Melancholy* by Robert Burton). Above a very large man in the catacombs of the Capuchin Order in Palermo, Sicily, the clearly stunted figure of an adult seems deliberately placed to emphasize the discrepancy in physical stature between a tall and a small person. The remains of more than eight thousand bodies in the sanctuary date from the end of the sixteenth to the end of the nineteenth century. [Photo by author.]

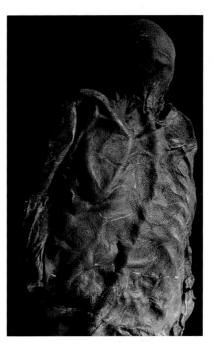

This woman was pulled from the Huldre Fen peat bog in Denmark in 1879. To the touch, her skin feels like brittle leather. Huldre is the name given to the kind of beautiful yet wicked fairy spirit that supposedly lived in this bog. [National Museum, Copenhagen; photo by author.] ⟶

clothing, and the bundle has been put to rest on a bedlike shelf. Often just the head remains, high up on a ledge among a now anonymous pile of skulls.

None of this multitude is alive, nor, unlike the figures in Santissima Annunziata, are they made of wax—they are their genuine unembalmed selves. The remains of eight thousand past citizens of and strangers to Palermo constitute an important, if grim, collection of ancestors, and along with the obligatory busloads of tourists, visitors come from very nearby; this may be the museum of *their* ancestors, after all. Perhaps their great-great-great-grandparents along with a few of their friends are here.

In any large sample of a population unusual figures will emerge. Infant twins share a wooden box; against one pillar a very tall man is propped, his hands tied together. He is so much bigger than all who surround him—clearly a giant. Against the wall a second huge man stands, and above him is a dwarf.

I catacombi began in the late sixteenth century when, in turning over the soil in the adjoining graveyard to make room for new corpses, the Capuchin fathers noticed that a great many bodies had mummified rather than disintegrated—that the dry climate and sandy soil had preserved the dead. The bodies were set upright out of the earth and eventually brought two flights down into a shady basement beneath the church. Until the mid-twentieth century, experiments were made in drying rooms to preserve the recently dead, who, thanks to the dry heat, emerged as reduced versions of themselves to be dressed and placed on display according to family, rank, and profession,

in the museum. In as much as these mummies are under the protection of the church, they constitute part of a four-hundred-year-old collection of unburied—the faithful and sinners alike.

Though seemingly fragile, under the right conditions, skin can be preserved, not only in painting, wax, or as a desiccated Egyptian or Sicilian mummy, but also in the ground. Flesh after death may not fester (like that illustrated in Zumbo's waxes). Some bodies remain uncorrupt, not only those of the pure saints who stay "forever sweet," but also those of quite ordinary mortals who cure slowly in countries with dry climates.

The ancient peat bogs of northern Europe preserved flesh on bone in remarkable fashion. The Huldre Fen Woman, found in an ancient Danish bog east of Jutland, in 1879,[27] represents one of a number of preserved human bodies taken from the peat bogs of Denmark, Holland, Ireland and England. The woman who died at the

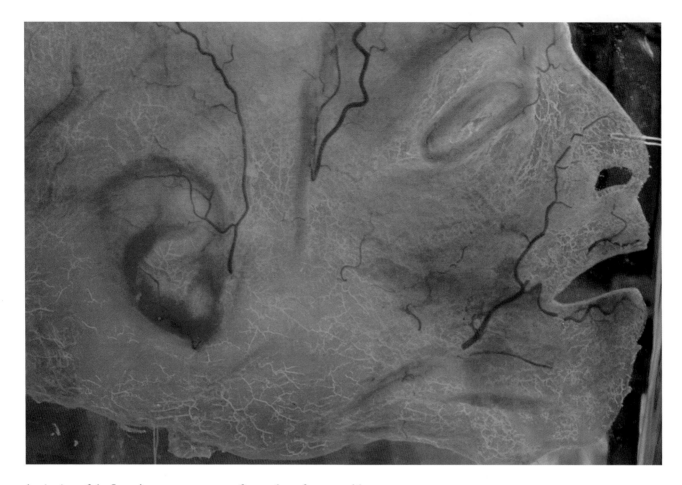

beginning of the Iron Age represents one of a number of preserved human bodies taken from the peat bogs—into which they'd been thrown either as sacrificial victims or as criminals. Some bodies have been found with a noose around the neck or garrotted, clearly murdered, whether for honor or for sin. Although she does not wear clothes now, the woman from the Huldre Fen bog was found fully dressed, wearing a "lambskin cape, a checked skirt and head-scarf,"[28] which allowed historians to analyze the fabric and make assumptions about the entire society. Her skin, very detailed and leathery, has molded around her bones. Her arm, accidentally cut off by a farmer's plow or shovel, has the look of recent amputation. The tannin in the peat preserved these bodies in the bogs so perfectly that on some palms and soles of the feet all the lines remain. Before oxidation from the atmosphere above ground smoothed away the details, each bog victim's separate prints could be read.

A transparent slice of a human face into which a contrast medium has been injected to show the map of veins and arteries. [Facultad de Medicina, Valladolid, Spain; photo by author.]

Particular souvenirs displayed as relics—associated with the martyrdom of the saints and, particularly, with Christ (". . . lance which pierced Our Lord's side a marvelous relic; the coat without a seam; one of the nails: and some thorns from Our Lord's crown with many others, such as the wood of the Cross, and the pillar at which Our Lord was scourged. . .[and] the gridiron on which St. Lawrence was roasted."[29])—constitute a collection of symbolic objects taken, supposedly, from dramatic external events. Other objects, however, have been generated from within the body, conveying the spiritual purity of the body's owner. They, too, historically, have sometimes been carefully preserved. Katharine Park writes[30] that in 1308 Chiara of Montefalco, abbess of a small monastery, died and that her body remained unchanged and uncorrupted for several days before the nuns decided to embalm her. In cutting open her body to take out the organs, objects were found that announced Chiara's special holiness. From her heart was taken a cross with Christ upon it, a tiny crown of thorns, a whip and column, a rod and sponge, and tiny nails—these last "all formed of flesh." From her gall bladder were taken three stones. In another incident in 1320, Santa Margarita of Città di Castello's opened heart yielded "three stones carved with the Holy Family."

These petrified symbols of sanctity, including gallstones, remind me of the "picture stones" taken from the earth and presented by early geologists, from medieval times on, as symbols of God's wit. God, too, could form shapes from shapeless matter. God could create a fish in rock as well as a fish in water, and this transformation from scales or carapace to rock might happen before the very eyes: the fifteenth-century traveler Pero Tafur reported that Nicolò de' Conti spoke of "a sea coast where the crabs, on reaching land, and being exposed to air, turn to stone."[31] Early geologists thought that a *vis plastica,* or shaping force, imprinted rocks with the shape of creatures, with miraculous events, holy men, birds, cats, and dogs. Collectors eagerly gathered these stones, which were then drawn, described, and entered into private collections.

Fossils, the true "picture stones," were not understood as inorganic replacements of organic material by rock until the end of the seventeenth century. Texts from twelfth-century China and fifteenth-century Italy show that long before our current understanding of the actual age of the earth and of the formation of fossils observers offered various theories about how the nature of rocks came to be imprinted with the shapes of familiar organic creatures.

Even though Kircher, forever the projectionist and well versed in illusion, wrote that people saw shapes in clouds—dragons, ships, mountains, cities—and will, therefore, in the same way, find amusing shapes in stone, and even though, in *Mundus Subterraneus,* he included drawings of actual fossilized fish, wood, and plant leaves (among other picture stones) and testified as to their organic nature, he continued to assert that other shapes, including fossilized bones and teeth, were formed by the hand of God, the Almighty Artist.

The story of Noah was in place long before Isidore of Seville (560-636), prelate and philosopher, described the Flood, but he was perhaps the first to attribute the activity of rising water to the apparent displacement of the seashore: "The first flood occurred under Noah, when the Omnipotent, offended at man's guilty deeds, covered the whole

Turbo testa subtilissimis crenis crispata, ex Monte Bonon.

Shells from the collection of Aldrovandi with the original label from Museo Diluviano, the "Museum of the Flood." [Geology Department of the University of Bologna; photo by author.]

circle of the lands and destroyed all and there was one stretch of sky and sea; and we discover proof of this to the present time in the stones which we were wont to go to see in the distant mountains which have mingled in them the shells of mussels and oysters, and besides are often hollowed by the waters."[32]

The Museo Diluviano, the "Museum of the Flood," in Bologna, founded in 1750, houses fossils, earth, and stones from the older collections of Aldrovandi, Cospi, and succeeding curators. In 1714, fossilized mollusks that contained ancient water were unearthed near the Church of Saint Luke. On display in the museum is one of these shells in a red wax-sealed bottle, labeled in fine old writing, "a drop of water from the Flood."

In 1726, Jacob Scheuchzer found a significant fossil, which he declared *Homo diluvii,* man from the Flood. "We are dealing without question, with one of the rarest moments of the Flood, which we can use as testimony that the race of the damned were buried by the waters."[33] Scheuchzer described not only the skeleton but also the muscles, brain, and liver. In the early nineteenth century, the famous French anatomist Cuvier chipped away at Scheuchzer's fossil, uncovered two amphibianlike forefeet, and declared the man from the Flood a giant salamander (see Introduction).

All stony signs of animal and human life, along with the stones depicting symbols associated with both the Old and New Testament stories, have been assiduously collected for centuries, taken from the earth long before the distinction between the appearance of a picture stone and the true nature of a

fossil was understood. In early natural history collections, all "stones" belonged together: stones from the ground, gallstones, kidney stones, fossils, the seeds of plants and fruits, as well as concretions supposedly magical in effect, like the "toad stone" that was supposedly from the forehead of a toad, or the bezoar stone, a coveted small object of apparent healing power taken from the stomach of a goat or a monkey. The ammonite, a fossilized cephalopod, resembled a snake to the early British, a ram's horn to the Greeks, and *wasigugna,* "life within the seed, seed within the shell," to the Navaho Indian. Reptile, mammal, plant: the shell of the animal turned to stone, in a purely visual way, had it all.

Reports from travelers may give rise to exaggerated amplification in illustrated "evidence." Here, the exotic fruits unknown to Europeans have become very large and most exotic. [From Athanasius Kircher, Toneel van China (Monuments of China), Amsterdam, 1667; collection of the Getty Research Institute for the History of Art and the Humanities.]

"Into a little round place at the side of the apple has been gathered all its sweetness. . . . Only the few knew the sweetness of the twisted apples."
—Sherwood Anderson, *Winesburg, Ohio*[1]

Twisted Fruit

Polonie

Arbor

Fructus

Animal, vegetable, mineral. Given the logic of a dreamer and the weight of legend, why wouldn't a man mating with a sheep produce a sheep child, a playful God make fish of stone as well as of flesh and scales, or a plant shaped like a human being grow under the gallows of a hanged man? The manifestation of the monstrous in the vegetable world appears in stories from the Old Testament and classical times. There are many folk tales about certain plants—usually sinister in nature—evergrowing, infinitely toxic, rapacious. Dubious apples, sleep-inducing rose thorns, gigantic beanstalks: filed under fact and fiction. A forked carrot may simply have grown around the sides of a random stone, but a monstrous double plant is the botanical version of a conjoined mammal. Plants have always been part of human history. We may be found admiring the rose and surviving on the potato, cutting down the rain forest and tending the garden, chewing coca and poisoning arrows. One tree could kill, but another give birth. In many parts of the world, especially in early medieval Europe, it was said that certain geese hatched from barnacle shells that grew on waterside trees or on rotten ship timber. In the fifteenth century, with the invention of printing, scholars inherited all the classical sources, and they used them in the same way I am using books written by learned persons, this year and last, to pass on some information to you. And, then as now, a great deal of information was available, which crossed and recrossed the same intellectual territory. Scholars of the past who have considered plants using the distinctive reasoning powers of their intellectual eras include Pliny the elder, who lived in the first century A.D. and remained the favorite classical source for the history of the natural world; John Tradescant, early botanical expert, traveler, and the gardener to King Charles II, and his son, John the younger; the horticulturist and traveler Nehemiah Grew, author of the first catalogue of the Royal Society of England (1795); and Rumphius, the Dutch expatriate who lived in the Moluccas Islands, an expert on the history, lore, and medicinal effects of tropical plants. There is no straight line to the truth about natural phenomena. Progress does not move in inexorable ways; discovery comes in fits and starts and from different sources. We may decide that some of our

This specimen closely resembles the description of a branch covered with shells from Coenan's collection. Note the feathery fronds emerging from each barnacle; they are not unlike the feathers of small birds. [Universiteitsmuseum, Utrecht; photo by author.]

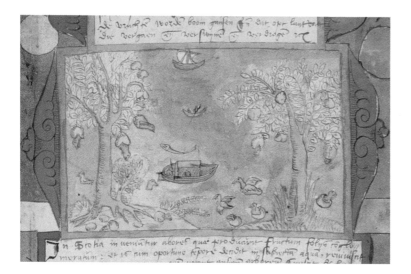

cherished "facts" resided first and were expressed with greater insight in Pliny or in Rumphius than in our own recent past.

In the fourteenth century, John Mandeville, the most famous and least authentic of all early writers (see "Boundaries" for more on Mandeville), wrote about the geese and also the sheep who came from trees. He also wrote of apple trees whose leaves were two feet long and whose branches grew one hundred or more apples, and of vines that bore grapes so large that a person could barely carry one. Of the sheep from the lands beyond Cathay (in China), Mandeville wrote: "There grows a kind of fruit as big as gourds and when it is ripe men open it and find inside an animal of flesh and blood and bone, like a little lamb without wool. And the people of that land eat the animal and the fruit too. It is a great marvel. Nevertheless I said to them that it did not seem a very great marvel to me, for in my country, I said, there were trees which bore a fruit that became birds that could fly; men called them *bernakes* and there is good meat on them."[2]

The story of the barnacle geese in Europe appeared long before Mandeville. In the thirteenth century, according to the traveler Gerald of Wales, Irish monks were well served by the claim that some birds hanging downward from tree branches hatched from shells that had dropped into the river. The birds, who then floated conveniently near the monastery, had no feet and were therefore considered of mixed origins—part plant, part aquatic, but not animal—and therefore could be classified as food allowed during Lent and on days of fasting. The monks believed in the myth; it was useful to them. Although Pope Innocent III in 1215 specifically forbade the practice of eating the birds, appetite is appetite.

Another source in the genealogy of the tree geese comes from Adriaen Coenan, a mid-fifteenth-century Dutch beachcomber and enthusiastic journal keeper, who wrote stories and gathered beautiful drawings of waterbound creatures in his *Visboek,* or "Fish Book." Coenan, a talented observer of unusual weather, collected stranded sea creatures and seashells.[3]

In some versions of the goose story depicted by Coenan, trees similar to apple and plum trees stand on the seashore in Scotland. The fruits that fall in the water become geese, while the fruits that fall on the ground waste away. A variation of this bird-producing bush calls for the birds to hatch directly from barnacles on branches that grow near the water. In his own collection of dried sea animals, Coenan had a branch with nine shells "inside [of which] was something like the feathers of a chick as can be found in eggs with full-grown chicks. And some people said that out of these shells came tree-geese, but others said, smaller water fowl because of the small size of the shells."[4]

In his *Visboek,* Coenan depends on earlier authors for the story of the bar-

Barnacle geese hang from trees, ready to hatch and swim downstream, as depicted in a detail of a plate from Visboek by Adriaen Coenan (Coenensz). [Courtesy of the Koninklijke Bibliotheek, The Hague, the Netherlands.]

This centuries-old digitated lemon photographed directly through the glass of its jar is monstrous entirely on its own merit without the benefit of optical distortion. [Anatomisch-museum, Rijksuniversiteit, Leiden; photo by author.]

nacle geese, even as he followed a personal trail of clues to find physical proof of these elusive birds. Through his friendship with "the president of the court of Holland," he met a priest who invited him to the monastery of Saint Barbara at Delft, where he inspected a barrelful of salted "tree birds," a present to the monks from a notable Lutheran sympathizer, the Queen. The monk gave Coenan a bird the size of a "widgeon," which Coenan preserved "for a long time in a small net in smoke," certain that he possessed the creature he had sought. Eventually it vanished, along with most of his dried marine collection, when Spanish forces invaded and plundered the town in the 1570s. Just as Russian Czar Alexis came to believe in the existence of the salamander (see "Generation," page 57), Coenan believed—perhaps—in the origin of the barnacle goose because he had had a bird—briefly—in hand. Aldrovandi, while not necessarily subscribing to the story himself, included a series of drawings in his *Monstrorum Historia* that shows the embryology of such creatures.

*I*n the sixteenth and seventeenth centuries, Dutch artists chose somewhat eccentric subjects for their still-life prints and paintings, such as kidney stones and a giant radish. Art historian Svetlana Alpers, in her book *The Art of*

French Rose and Common Apple by Georg (Joris) Hoefnagel, illuminator, and Georg Bocskay, scribe, in Mira Calligraphiae Monumenta, **1594–96. [(86.MV.527) Ms. 20, folio 107; courtesy of the J. Paul Getty Museum.]** ⟶

Describing: Dutch Art in the Seventeenth Century, discusses the work of Saenradam, a seventeenth-century Dutch artist. Saenradam published the *Print to Belie Rumors about the Images Found in an Apple Tree,* in which, in a logical, scientific fashion, the artist tried to discredit the mystical interpretation assigned by a fellow artist to another drawing of the cross-section of an apple tree. Supposedly, the silhouette of priests appeared in the center of the trunk, signaling the apocalyptic message that the Spanish Catholics were a threat "to the core" of Holland. Saenredam argued that the cutting showed natural-grown twists, suggestive of metamorphic impressions in the wood—beautiful, to be sure, but there was no message. By drawing the actual cut-out pieces from the tree and recording the date and location, the artist sought to scientifically debunk superstition by displaying and dissecting the source of illusion. Saenredam's print "speaks to the nature of images as well as to issues of faith. . . . It argues, in effect, that the miracle is bound to a mistake in image-reading or to a mistake in interpretation."[5]

The seventeenth-century scholar Battista Ferrari's exhaustive treatise[6] on the cultivation and history of apples and citrus fruits includes, as it must to be called "exhaustive," a number of plates and texts on deformed or blighted fruit. The text consists of a complicated intermingling of myths, recipes, remedies, and technical descriptions. A plate is as likely to show the final body parts of a nymph vanishing into a tree as a careful cross-section of an orange. Fruit, in cross-section or not, is an endless subject for the artist, and

the human who turns into a tree is a staple of literature. In Ovid the metamorphosis is used as a *deus ex machina*—a sudden solution that saves a human from danger. "As soon as she is finished with her prayer, a heavy numbness grips her limbs; thin bark begins to gird her tender frame, her hair is changed to leaves, her arms to boughs; her feet—so keen to race before—are now held fast by sluggish roots; the girl's head vanishes, becoming a treetop. All that is left of Daphne is her radiance."[7]

In an illustrated calligraphy book of 1594-96, Joris Hoefnagel, the sixteenth-century Flemish/Hungarian artist to the court of Emperor Rudolf II, painted a bisected conjoined apple in a highly realistic fashion in order to show a monstrous fruit as a worthy marvel of nature. Throughout his work, Hoefnagel, who specialized in the natural history of plants and animals and in topographical studies, expressed a fascination with the singular anomalies of nature.

For this illustrated work, the—at that time innovative—trompe l'oeil style of the painter serves to set the objects apart from the text. This bisected conjoined apple and the accompanying rosebuds seem supported by their own soft shadows, each shadow a faithful effect of contacts observed—now dark, now delicately attenuated between substance and surface. The fruit and flowers have been angled toward the viewer; although reclining, they do not recede—rather, every visual detail seems to have been set upright, pushed forward, and botanically speaking, faithfully rendered. The balance between fragility (of shadow,

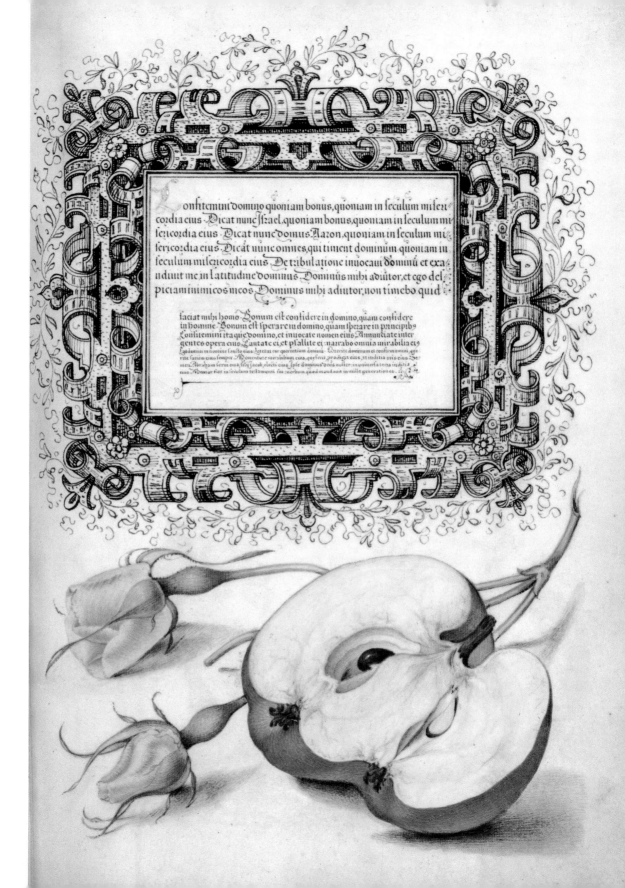

onfitemini domino quoniam bonus, quoniam in seculum miseri
cordia eius. Dicat nunc Israel, quoniam bonus, quoniam in seculum mi
sericordia eius. Dicat nunc domus Aaron, quoniam in seculum mi
sericordia eius. Dicat nunc omnes, qui timent dominum quoniam in
seculum misericordia eius. De tribulatione inuocaui dominū et exau
diuit me in latitudine dominus. Dominus mihi adiutor, et ego del
piciam inimicos meos. Dominus mihi adiutor, non timebo quid

faciat mihi homo. Bonum est confidere in domino, quam confidere
in homine. Bonum est sperare in domino quam sperare in principibs
Confitemini itaque domino, et inuocate nomen eius. Annunciate inter
gentes opera eius. Cantate ei, et psallite ei: narrabo omnia mirabilia eius
Laudamini in nomine sancto eius: letetur cor querentium dominum. Querite dominum et confirmamini: que
rite faciem eius semper. Mementote mirabilium eius, que fecit: prodigia eius, et iudicia oris eius. Se
men Abraham serui eius: filii Iacob electi eius. Ipse dominus deus noster: in uniuersa terra iudicia
eius. Memor fuit in seculum testamenti sui: uerbum quod mandauit in mille generationes. II

shading, and the colors themselves) and accuracy (of tight and loosening petals, of the cupping trailing tendrils and the thornless stem, which has been torn rather than carefully cut from the bush and which optically continues the cradling of the apple) displays the desire to be truthful as well as sentimental. What could be more obvious than the beauty of a rose and an apple? The painting conveys the desire to "know" the rose, and one feels, especially, to examine the apple.

Now a double apple has, generally speaking, the same embryological origin as a lizard with two tails and human twins who share a single lower body or whose bodies share one head. Even though a quote from Battista Ferrari's work—*Abortus et monstra in animantibus plerunque horremus amamus in pomis* or, "We find that which has miscarried and is monstrous in animals and humans pleasing in fruit"[8]—speaks of the delight people derive from monstrous fruit and the revulsion from monstrous animals or humans.

Medical reasoning has closely aligned animal and vegetable anomalies sharing the same morphological abnormalities. In the medical school museum of the Rijksmuseum Universeit in Leiden, seventeenth- and eighteenth-century teratological specimens are grouped on the shelves historically and systematically by defects, so that a two-tailed lizard sits beside (or on the shelf above or below) a jar of double apples, conjoined human twins beside a forked carrot, and the carrot, in turn, beside a two-headed cat. This antiquarian taxonomy of the mixing together of all forms of teratological life is maintained today for the sake of historical precision. And, in fact, it makes good scientific sense. Reminiscent of a Dutch "Vanitas" still-life painting, and particularly of the Dutch artists' treatment of fruit, the organization of

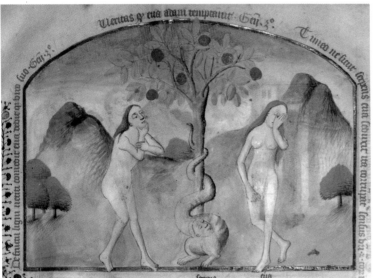

Adam and Eve (detail) from the illumination Le Miroir de Humanine Salvation. **This view records a quickly passing moment in this most influential of Christian legends: the instant in which Eve realizes her mistake, her gestures expressing confusion and dismay. Adam doesn't understand. [(83.MR.174) Ms. Ludwig XV 4, folio 118; courtesy of the J. Paul Getty Museum.]**

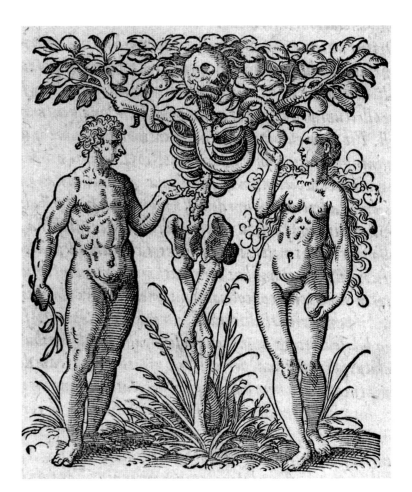

Garden of Eden, frontispiece from Jakob Rueff's De Conceptu et Generatione Hominis (1580). [Courtesy of Yale University, the Harvey Cushing/John Hay Whitney Medical Library.] ⟶

the jars reminds me how systems grow organically from cultural roots, how they depend on their culture to tend them, encourage them, or cut them down.

In an illuminated portrait of Adam and Eve (c. 1450-60), the apple has been sampled. In Genesis, Eve saw that the delightful tree gave delicious fruit. She ate and gave Adam a bite. Now, in this painting, Eve has reached a moment of truth, just ahead of Adam. As a "frozen moment," this might as well be a photograph: Eve covers her eyes and her right hand reaches to cover her sex. Her twisted limbs, the visible edge of her mouth, and half of her closed right eye just beneath her left hand betray chagrin and shame and fear. She has just, at this moment, realized that she has made one Big Mistake. Adam, watching her, seems perplexed. He has not understood. For if he had, he would see that crouching, human-headed, catlike serpent, and he would use his hand to cover his own nakedness. Eve's left foot has already

In the twelve books of The Ambonese Herbal, Rumphius explains that while he does not propose "a complete art of healing," he intends to provide a full list of East Indian remedies, for "God has certainly provided each country with its own medicines." These particular poisons were selected from the pharmaceutical collection of the Facultad de Medicina, Valladolid, Spain. [Photo by author.]

stepped out over the decorative edge of the frame, beginning to move, symbolically, out of Eden. Adam still has not yet left the top edge of the frame; his feet still face the tree and Eve as he considers the "bone from my bones and flesh from my flesh" (Genesis 2:23), the one who has already become the first human to be ashamed. It was the tree, the fruit, and the snake as agent, combined with Eve's will, that for Christians introduced the concepts of imperfection, guilt, and pain.

In another depiction of the familiar scene, the tree becomes the visible agent of mortality. It is no longer a growing thing, but dry bones, an anthropomorphic actor. The "Garden of Eden" frontispiece to Jakob Rueff's *De Conceptu et Generatione Hominis*[9] ("Of the Conception and Development of Man") represents the tree as a skeleton of a man; the arms merge into branches and the twisted legs are rooted in the ground. The fig tree *(ficus)*, the original tree in the Garden, in some species also has a twisted trunk that turns in ropy sinews round itself. The tree of life, with Eve's mistake, becomes the tree of death.

Myth describes the evils of a plant, which, like the tree of knowledge, acts upon human and animal. Erasmus Darwin, the literary uncle of Charles Darwin, wrote in *The Botanic Garden*[10] of the upas tree as a serpent-engendering plant linked to one monstrous form that, in growing, spread many miles over the ground while the top of a twisted trunk "looks o'er the clouds, and hisses in the storm." This predatory tree attacked wild beasts so that the ground was covered with skeletons.

Georgius Everhardi Rumphius described the blighted region where the upas, the "poison tree," grows. The venomous sap from the tree was used on weapons by the "Mountain People" of Makassar. Although Rumphius was

This branch might well be taken for an Asian version of the mythical mandrake root. It was found by the side of the road in the Kingdom of Bhutan and given to the author by a fellow traveler. [Photo by author.] ⟶

usually accurate in his descriptions, he actually never visited the tree and writes from the reports of native people. "Under this tree and for a stone's throw around it, there grows neither grass nor leaves, nor any other trees, and the soil stays barren there, russet, and as if scorched. . . . The branches that had been sent to me from Macassar in a large Bamboo that was tightly shut, were still powerful enough that if one stuck a hand in there one felt a tingling as one does in frozen limbs after returning to where it is warm. Everything perishes that its wind touches and so too do all animals shun it when they pass this tree, while the birds fly over it.

"No person dares approach it without having swaddled his head, arms, and legs, with cloths, or he will become aware of a strong tingling in his limbs that will make them stiff and insensible. When drops from these leaves fall on someone's body it will make it swell up; nor should one stand under the tree with his head uncovered or his hairs will fall out. And so it seems that death has pitched his tents near this tree."[11]

The true upas tree has enjoyed an apocalyptic reputation and literary mileage for centuries. Perhaps the fumes have dissipated. Perhaps recent generations of birds and animals have built up a resistance to its poison. Whatever the explanation, the tree is described now as a type of mulberry that is the source of a poisonous latex, which is used for poisoning arrows, as well as a source for lightweight building wood.

Georgius Rumphius (1628-1702) was the "blind seer of Amboma." An ardent naturalist and patient seeker of scientific and folkloric truth, Rumphius lived in the Moluccas Islands. He survived the earthquake of 1674, although his wife and daughter did not; he lost his sight; he lost his entire library in a fire; and a seven-hundred-page manuscript of his work sank at sea. He diligently continued, however, to unravel the mysteries of exotic botanical and marine specimens. He was the first botanist to discover pollen in orchids, the first to describe orchard fruit and seeds, the first to discover that edible bird nests were put together by saliva and not by algae, and the first to describe over 350 plants correctly. He also wrote with great accuracy and insight about the nature of corals and seashells, which, in the late seventeenth century, were considered extremely exotic and valuable.

Rumphius cautioned against skepticism in the introduction to his twelve volumes of *The Ambonese Herbal, Being a Description of the most noteworthy Trees, shrubs, Herbs, Land-and-Water Plants which were found in Amboina and the surrounding islands. . . .* He said, "One should

not hold it a lie or reject what one may encounter in the course of one's reading that seems incredible or at odds with the nature of European plants; for I myself could not believe any number of things until I had explored them often and diligently and had inquired after them."[12]

The plant or tree that takes the shape of a man or animal is clearly seen in the magical, mythical mandrake. As John Donne (1572-1631) wrote, it was believed to promote conception:

> Go, and catch a falling star,
> Get with child a mandrake root,
> Tell me, where all past years are,
> Or who cleft the Devil's foot.[13]

Embedded in the irritatingly tangled and misty world of Hellenistic myth (second to fourth centuries A.D.) is the story of the Mandragor, a tree frequented by elephants, male and female. Until the female has eaten the fruit and given fruit to the male, the elephants do not copulate. The eating of fruit from this tree is a prerequisite to carnal knowledge, and so the elephants become animal equivalents of Adam and Eve, and the fruit becomes the equivalent of the apple from the Tree of Knowledge. The mandrake root, is, however, unequivocally associated with fertility and aphrodisia: mimicry of the human being in its shape extends to genitalia—male or female. According to myth, the plant is alive and, screaming when pulled from the ground, causes swift retaliatory death to those who dig it up. And so traditionally a dog was used to pull it from the ground. Only when the dog had died could a person safely handle the root—the mandrake took only one life.

In German myth, the mandrake, or *Galgemannlein* ("tiny man of the gallows"), was believed to grow beneath the place where an innocent man hung as a thief. People believed that this plant—with its large leaves, whitish-yellow flowers, orange berries, and human form, complete with sexual organs—grew from the last bit of urine or semen from the dying man.

The great anatomist Vesalius, the early-sixteenth-century author of *De Humanis Corporis Fabrica*, obtained materials for his dissection and research by cutting down and stealing the corpses of criminals hung from the gallows on the edge of town.

During the worst years of racist lynchings in the American South, black men and women could be seen hanging from tree branches. Seen from a distance, their slumped corpses were terrible and were called "strange fruit." The metamorphosis of barnacles into geese, trees into people, and people into roots leaves the fluid Ovidian mists and the realm of amusing stories as soon as a real person is hung from a real tree.

These seven human embryos are displayed in order of fetal development. Their individual histories have been lost, as they express significance as morphological markers in human development for the benefit of the medical community. Infant mortality at all stages of gestation and in many countries occurs despite the will of the mother and the skill of the doctor. [Facultad de Medicina, University Complutense, Madrid; photo by author.] ——▶

"My mother is a fish."
—William Faulkner, *As I Lay Dying*[1]

Generation

The mystery of the origins of life persists, and misconceptions about the conception of human life, supposedly explained long ago—once and for all—never cease. Even today the gradualism of evolution and the mathematics of the genetic code are poorly understood, and so certain myths endure. Persistent lack of understanding gives rise to invention—in the tabloid newspaper we read, "Mother with buck teeth, eats carrots and gives birth to rabbit-eared baby." In this chapter, in a sense, we begin where all biology begins: in the primordial soup. Then we'll bypass the birds for the bees, briefly take up the politics of egg and sperm, and examine parental sin and its effects on the unborn child. According to Empedocles of Akragas (490-430 B.C.), human history passed through four stages of evolution: the first when plants and animals and people consisted of unjoined parts, the second when the parts joined together like "dreamshapes," the third when creatures were whole, and the fourth when each was made of mixed substances and formed into separate species. Thus, he describes the first evolutionary stage: "Many foreheads without necks sprang up on the earth, arms wandered naked, separated from the shoulders, and eyes wandered alone, needing brows."[2] Somehow, now that we've reached the fourth stage of evolutionary development according to Empedocles, it may be more disturbing to see a diminished human being—a person without a leg, or without a nose, and to see a leg or a nose in a jar—than it would be to imagine hopeful foreheads in the first stage of development. Many legends claim that life came slowly out of the generating muck, although in the Old Testament the mud was dry. Genesis 2:7 says: "Then the Lord God formed man from the dust of the ground, and breathed into his nostrils the breath of life; and the man became a living being." In a parallel tradition, according to Giovanni Battista Della Porta, author of *Natural Magick* (1658),[3] many classical authors believed that live animals came from "the bowels of the earth soaked in water . . . quickened by the heat of the Sun." The "slimy" tumors and swellings on the surface of the earth gradually became ripe and broke, disgorging living creatures: "they that had quickest heat, became birds; the earthy ones became creeping beasts; the waterish ones became fishes in the

Luxuria, the ancient goddess of unbridled lust, is often depicted with a skull in her lap. Here a skull has been placed on a drawing in the open belly of a woman as a way of indicating that a historical past as well as a personal one is implicit in every birth. In the beginning is the end. The anatomical chromolithograph, circa 1746, was executed by the French artist Jacques-Fabien Gautier-Dagoty as part of a series of prints on female anatomy. The skull belongs to the nineteenth-century Jakob Hyrtl collection of annotated skulls. This particular head was photographed in tribute to the Capuchin monks, whose mission is to preserve the remains of the dead. [Thomas Dent Mütter Museum, Philadelphia; photo by author.] ———▶

Sea; and they which were a mean as it were, betwixt all these, became walking-creatures." Once the sun dried the earth, all creatures born of mud had to resort to copulation to continue procreation.

In theory, in the first century A.D., Pliny said that after the flooding of the Nile, mice came in great numbers, mice whose forefront moved in a lively fashion, whose hind quarters were made of mud. Frogs who were half alive and half mud were also seen: "their foreparts moved and went about on two feet while their hinder parts . . . unfashioned . . . [were] drawn after like a clot of dirt." As Ovid had earlier said, "one part lives, the other is earth still."

Della Porta continues on to describe the generation of creatures from spontaneous generation as well as through coupling. From somewhere in the New World, where the air was "most unwholesome," a toad was born from a rotting duck; elsewhere, a woman gave birth to four creatures like frogs. Snakes were often bred in men's bodies, and the bone marrow of the spine of dead men changed into serpents.

Della Porta tells how to create bees. Take a bull and beat him to death, but do not break the skin. Place the carcass in a closed room after having stopped the nose, ears, and throat with packing. After three weeks, all that remains of the bull will be his bones, and as you watch the insects on the bones, they will assume, first one and then the next, the definition and color of the honeybee. An entire colony with a "king" bee[4] will have been born. Ovid's story of the creation of bees was clearly the inspiration for Della Porta, although Ovid's version sounds simpler. In earlier times, apparently, one simply waited until bees rose from the body of a sacrificed bull—just as one waited for hornets to come out of a dead war horse or for white webs among trees to change into butterflies. And if one depends on visual clues alone, insects might certainly seem to emerge from deep within rotting flesh as do butterflies from

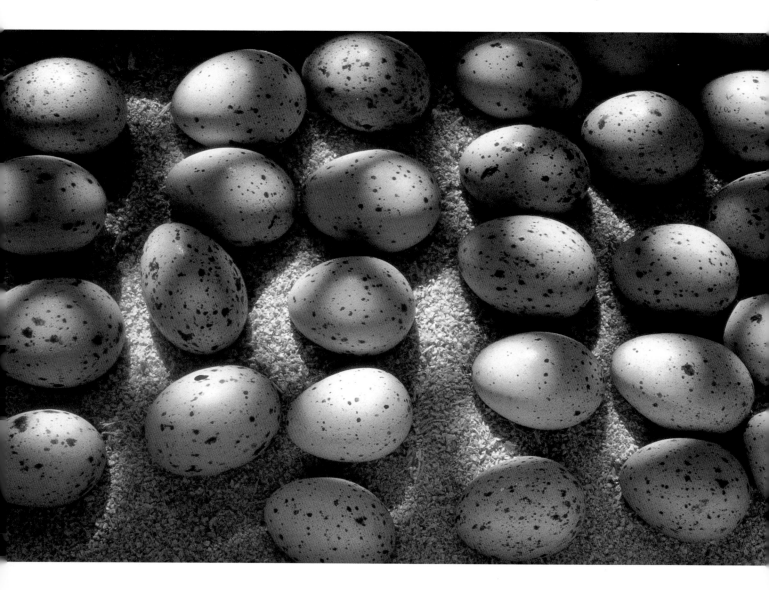

Bird eggs placed in circles of sunlight.
[Nationaal Natuurhistorisch Museum, Leiden;
photo by author.]

their cocoons. While those mud frogs, with two visible and discrete phases of development, might seem as tadpoles to "grow out of the earth."

Insects, as described by the sixteenth-century artist Joris Hoefnagel, came from fire. In a cartouche of three insects, one a bee, one a fly, there rises a perfect "dragon fly," a miniature medieval dragon with wings and six legs—like an insect. Fire, according to the classical philosophers, does not derive its life from an exterior source, but possesses life.

In order to create a scorpion, Ovid recommended tearing the claws from a "shore-loving crab" and burying the clawless body in the sand, whereas Della Porta, sixteen hundred years later, with a serene and misguided sense of the faithfulness of classical scholarship, prescribed making a scorpion by rubbing basil and covering it with a stone. Neither one of these metamorphoses would stand up under scrutiny.

In 1599, a miller named Menocchio—on trial before the Inquisition because he owned a private library and exhibited intellectual curiosity—was asked about the genesis of angels. He replied that they were "produced by nature from the most perfect substance of the world, just as worms are produced from a cheese, and when they emerged, received will, intellect, and memory from God, as he blessed them."

Menocchio, the heretical miller, told his fellow villagers (though not the Inquisitor) that the soul of a human was distinct from the body and belonged to God: "When man dies he is like an animal, like a fly, . . . and when man dies his soul and everything about him also dies." Menocchio was hanged for the sin of audacious thinking.[5]

The most enduring legend of genesis without coupling centers around the salamander, which was believed to be born from fire and indestructible in the flames. The salamander, which "not only walks through fire, but puts it out in doing so,"[6] was thought to have wool made of asbestos, which protected it from being burned. (Asbestos, which may be cleaned by flames, was supposedly made into coats for various rulers, including the legendary, mostly mythical Prester John, ruler of a powerful Asian kingdom.) Also, according to a twelfth-century bestiary, the phoenix—a creature of mythology variously identified as the bird of paradise, the heron, or the flamingo—would make a nest of frankincense and set itself on fire when it felt death approach. From its ashes a worm would come, and from the worm, the phoenix, a symbol of resurrection, would rise again to live for another five hundred years.[7]

For a long time—perhaps until the late seventeenth century—many believed that salamanders belonged to legend alone. Czar Alexis, father of Peter the Great, wrote an amazed letter from Poland stating emphatically that he had actually held a salamander—to his knowledge, a legendary creature—in his hands. His insistence on touch emphasizes the human instinct to know the truth through the hands; the eyes are less trustworthy perhaps, less capable of selecting fact from fiction.

In Greek mythology, humans often spring full-blown from body parts of the gods: Athena from the brow of Zeus, Dionysus from his thigh. Helen, Clytemnestra, Castor, and Pollux all

hatched from the eggs of Leda insemi-
nated by Zeus, the swan.

Chau Ju-kwa, a Chinese historian of
the twelfth century, wrote of a fabulous
country where "the women . . . conceive
by exposing themselves naked to the full
force of the south wind and so give birth
to female children."[8] In another account
he describes a Kingdom of Women *(Nu
kuo)* found "more than 1000 li east of
Fu-sang," where beautifully shaped
women of a pure white color dwell.
Their bodies are hairy, and the hair on
their heads is so long it trails on the
ground. In the second or third moon
they eagerly enter into the water and
thereby become pregnant, giving birth to
children in the sixth or seventh moon.

In the eleventh century, in the Baltic,
the Amazons, a race of women warriors,
were said to mate with their prisoners or
with merchants or "by other monsters
which are not rare in this place." The
female children were very beautiful, but
the males, after birth, developed the
heads of dogs.[9] Other legends tell of
women with dog-headed husbands, but
in these more domesticated versions of
the human/beast alliance the idea of the
women as warriors has vanished (for
more on dog-headed men, see "Heads
and Tails").

In the seventeenth century, the belief persisted that each of us began as a
tiny preformed perfect human being—a "homunculus"[10]—that unfolded as it
grew rather than undergoing a series of morphological changes. The Pre-
formationists, as they were called, claimed that visual evidence was not nec-
essary in order to grasp the concept that a perfect human form existed from
the beginning, whether or not it was subject to influences while growing. The
Preformationists formed two camps: the "Ovists," who believed that the pre-
formed person came from the mother's egg, and the "Spermaticists," who
believed it came from the father's sperm.

The French scholar Pierre-Louis Moreau Maupertuis wrote a book in
1745 called *Venus Physique,* a scientific work on embryology and sexual love
between all the animals, in which he describes with great enthusiasm Nature's
intention that each animal shall have the greatest pleasure in its particular
manner of sexual release, and that while mating to reproduce was the effect,
surely pleasure was the incentive. The book sold well. Beyond the actual
particulars of the act of insemination, however, Maupertius had a distinct
point of view. The author believed that the embryo was assembled piece by
piece—not all at once—and that its nature was influenced by both father and
mother. Maupertuis pointed out that if the egg cell contained a homunculus,
the tiny preformed human would contain another homunculus—and so on to
infinitesimal infinity, so that "all of human history must have been prefig-
ured in the ovaries of Eve." Also, Maupertuis reasoned, if the Prefor-
mationists were right, then the child must resemble either the mother or
the father completely, but "since the child resembles both, I believe we must
conclude that both parents play an equal role in its development."[11]

Maupertuis did not believe that so much unused sperm, carrying so many
preformed miniature humans, would be designed to go to waste. And cer-
tainly, if one believed in the homunculus theory, how could a black mother
(who supposedly had all black eggs) produce white offspring? Maupertuis
favored a theory for inherited anomalous traits, as well as favoring white eggs
for a white mother and black for black. As an Epigeneticist and a proponent
of Newton's laws, Maupertuis believed that gravity worked to bring together

the separate parts of each fetus. The biologist Stephen Gould says that Maupertuis knew that gravity was not a very good argument, but no one knew about DNA at the time. How, in the mid-eighteenth century, could Maupertuis "imagine the correct solution to his dilemma—programmed instructions—in a century that had no player pianos, not to mention computer programs?"[12]

Although monstrous births have occurred since the beginning of history, it was not until the end of the eighteenth century that teratology, the medical study of the structure of human monsters, became a science. Its founder, Isidore Geoffroy Saint-Hilaire (1805-61), began in the laboratory, to medically influence the fate of monsters by grafting anatomical parts onto people who were missing them. At the same time, doctors began to attempt to influence the course of human life through rudimentary experimentations with eggs. The perceived professional desire of doctors to take matters away from God, away from the natural course of life as well as from the dangerous forces that led to deformaties, expressed itself in fiction. In a disastrous experiment (recorded in Mary Shelley's *Frankenstein,* 1818), Dr. Frankenstein built an original mother-free monster in his laboratory. He was punished for his hubris in seeking to reanimate a singular composite corpse who had no ancestry, no innate information about human nature, no chance for love or happiness, no natural history of his own.

We have found new means to create monsters. We have managed, through the poisoning of drinking water by mercury in Japan, by nuclear accidents in Chernobyl, and by drugs like Thalidomide in Germany, to create monsters by applying new recipes to the same ingredients. And on each package we read: Do not drink this, do not eat this, do not smoke this, do not inject this, or your baby, too, will be born crosswise. In the sixteenth century, if a child emerged extra-limbed, limbless, blind, paralyzed, consumptive, or idiotic, perhaps, explained the doctor, the mother had sat pregnant with her legs crossed, or she had "not received enough seed." Or perhaps the mother had actually altered the being in her womb. The mother herself was not to blame although her imagination might be suspect.

In 1660 in Germany, a "crane-necked man" walked out of the mythology and onto the stage (see Introduction). The begetting of new creatures (for that's what the crane-necked man seemed to be) came from inventive mingling between species: a pig with a dog, a man with a horse, a woman with a sheep, a crane with a pygmy. For offspring stemming from these transgressions, society, not God, should be held accountable. This need for moral accountability for unnatural coupling continues to inform recent science fiction: a man is crossed with a fly (*The Fly*), a city's population succumbs to a robotic vegetable force (*The Body Snatchers*), and the body of a beautiful carnival queen turns into a desperate chicken (*Freaks*).

Far more plasticity and slippage between natural categories of plants and animals and minerals seemed to go on before the nineteenth century than does today. The early Greeks believed in busy interspeciation between gods and humans, as well as metamorphoses

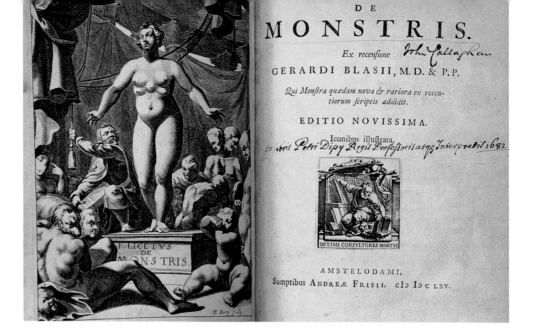

between man and beast, human and vegetable, human and stone. Zeus, the canniest seducer of all time, appeared as a bull, as a swan, even in a shower of golden rain. Until the last century, seeds were classified as stones, perhaps geese could be generated from barnacles, and the mother's imagination could imprint its delusions onto the features and nature of her unborn child, who would receive these impressions like wax. In the sixteenth century, the surgeon Ambroise Paré wrote, "We will note in passing how dangerous it is to disturb a pregnant woman, to show her or to remind her of some food which she cannot enjoy immediately, and indeed to show them animals, or even pictures of them, when they are deformed and monstrous."[13] Women were also to take care that foreign animals like tapeworms and small dragons not enter the body in the form of seed and be expelled as full-grown nastiness.

"An Infant was born with a Head like a Greyhound, whose Father was hunting without regarding to say Masse. . ."

Rarely is the child imprinted with the sin of the father, but in many of the tales from *The School of the Eucharist* from 1687, any mortal creature who does not follow the faith is subject to divine retribution: people, dogs, rats, even insects. In one account, a still-born greyhound-headed boy is buried by his mother and her attendants in secrecy. (It must be assumed that this child was born dead.) When the father, furious, asks why and is shown the child, he is "hereupon so much ashamed that he changed his course of life, and from that time forward he had such esteem of the Mass and Divine Offices that it made him frequent it daily, to the great edification of his Family and all under his charge."[14] The hunter, sinning, had slipped from the grace of God, who punished him accordingly—with a hound-headed son.

Shown here is the title page and frontispiece from the 1655 edition of De Monstris by Fortunio Liceti. Liceti's work includes illustrations ranging from wholly apocryphal interspecial monsters to the clinical reality of fully human anomalous conditions. The curtain has been pulled aside to reveal a five-breasted figure presiding over a number of crouching human and part-human monstrous beings. [Private collection; photo by author.]

In his poem "Sheep Child," James Dickey describes the fruits of careless interbreeding. In true metaphorical and false biological fashion, a boy, desperate for sex, fornicates on a hillside with a ewe who, after time, gives birth to their sheep-child. The short-lived hybrid creature has a glimpse of life, from both animal and human perspectives, before he dies. He stands now forgotten in a jar on the shelf of a museum.

> "I woke, dying,
> In the summer sun of the hillside, with my eyes
> Far from human. I saw for a blazing moment
> The great grassy world from both sides,
> Man and beast in the round of their need, and the hill wind stirred in
> my wool,
> My hoof and hand clasped each other,
> I ate my one meal of milk, and died
> Staring . . ."[15]

Although Helen of Troy was the daughter of Zeus, disguised as a swan, and of Leda, a human woman, and although she hatched from an egg, she did not look like a bird; all her qualities as a half-bird were invisible. But, as the classicist Emily Vermeule has said, beautiful Helen had a rapacious and flighty character.[16] Physically, the bird remained unexpressed in the woman, invisible, behind a screen, but the soul of a bird did cross over, silent, onto human turf and did its terrible damage through the psyche behind the "face that launched a thousand ships."

The natural philosopher Fortunio Liceti, in his book *De Monstris* (1616),[17] attempted to cover all the mythical hybrid births and natural teratological births he had ever heard of, moving in one volume from biologically impossible animal/human hybrids to laboratory dissections of conjoined twins. The frontispiece to the 1655 edition gathers both fictional and existing creatures together in one plate: the half-bird, half-man in the foreground, the double-headed "Janus" twins, and the stooped elephant man, barely visible beyond

This drawing of John Merrick by Marjory Wunsch is based on the illustration from Anomalies and Curiosities of Medicine by George M. Gould and Walter L. Pyle (1896). [Private collection.]

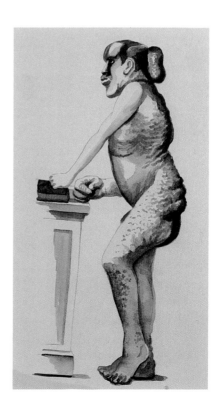

the feet of the many breasted woman on the pedestal. The woman may be a fecund perversion of Mother Nature. The elephant-headed man, on the other hand, comes, however sketchily, from biology. He might have been an earlier incarnation of the famous elephant man of the nineteenth century, John Merrick.

In a terrifying incident, depicted in both the play and modern film of *The Elephant Man* and referred to throughout his life by Merrick himself, his mother, while pregnant, was knocked to the ground by an elephant—a story told in the tradition of maternal imprinting. John Merrick's lumpy, hidelike scaly skin, great inflated tumors, and twisted human body seemed to have fused in spirit to an elephant's body, and if, underneath his deformity, we sense the deep congenital suffering of a man, it is because we manage to look beyond the horror of his mother's legacy.

Merrick's mother was a supposedly virtuous woman; no one would blame her for the disease of her child. Her accident with the elephant (or elephants) frightened her, and her memory, tragically, affected her unborn child. Merrick's condition, as analyzed by his doctor, Frederick Treves, was "a complication of congenital hypertrophy [excessive growth] of the upper right arm bones and pachydermatocele and papilloma of the skin. From his youth he suffered from a disease of the left hip-joint."[18] He also had bony tumors of the skull and "large pendulous masses in connection with the skin." The half-beast, half-man expressed somehow the embodiment of the crushing together of woman and elephant. John Merrick represented an unscientific legend and a pathological reality.

The lower classes saw Merrick as a target for ridicule and torture while the aristocracy—the self-appointed enlightened class—considered him, eventually, a wonderful anomaly, a touching gentleman full of grace inside a hideous shell. Not unlike Petrus Gonsales (see "Next of Kin," page 130), John

Merrick presented society with a conundrum: How can such bestial monstrousness be reconciled with such a high degree of (clearly) Christian goodness? Because we don't know anything about his early history, it is as if Merrick's gentle nature and his natural ease with civilized society had been handed to him whole—at an early age. He must have been influenced by his mother. How else could such moral decency be reconciled with such corruption of the flesh?

Certainly, biology does not always deliver the perfect child, and culturally, the treatment of such children has covered wide ground. They have been buried unbaptized at birth; baptized and then buried, thrown into the sea, or allowed to live if they "had all human parts," no matter how many or few. They've been shown for profit to gawking crowds or hidden from public view; when grown, they've been used as scapegoats in the marketplace, tortured to console the torturer, honored at court as rare and singular phenomena, and employed, paradoxically, as counselors to powerful emperors. Some, like John Merrick, were alternately tormented by the lower class and treasured by the aristocracy. For sheer strangeness, public reaction may exceed the biological realities themselves.

As midwives in medieval, Renaissance, and early modern times, women were often the first witnesses to birth and to

the monstrous child. Fear, astonishment, and the instinct to protect the mother by concealing such an event must all have contributed to the disappearance and burial, without baptism, of many a blighted baby.

The discovery of such a burial in his own backyard by James Paris Duplessis, age fifteen, must have contributed to his fascination as an adult with all manner of aberrations. According to his journal, written in the late seventeenth century, James's mother had allowed a pregnant woman, a Madame Souville, to deliver her child in their house in Pluviers, rue de Gastinois, "for the Conveniency of being near the Midwife, Minister, and Surgeon, the two Last Living in our House." During her pregnancy, Madame Souville had, against her husband's wishes, obtained (and had had repeatedly confiscated) copies of a French "Almanac" in which there was a picture of a monstrous child with two heads and a "Round of Excrescence of Spongi Flech between the two Heads."

In the Duplessis's house, Madame Souville gave birth to the same kind of child she had so obsessively examined in the picture. "There was Delivered of this Child who was born dead and was a Male Child. This Accident was Kept very Secret and the Child being a Monster and not having been Cristened was wrapped in a Clean Linnen Cloth and put in a littel woodden Box and Buried very Privately in a part of our

In this illustration of two Surinam toads, Frederik Ruysch's unique style as a scientist/artist is plainly visible. A master of dissection, an innovator in the preservation of human and animal parts, and a pioneering researcher of the human vascular system, Ruysch qualifies also as the creator of some of the most decorative preparations in the history of biology. A believer in the sweetness and intricacy of life, Ruysch does not stop with placing the creatures in jars; he sealed each lid with a work of art. Here we see mounds of coral, snails, shells, and leaping frogs. (Are they tiny Surinam toads gone to Baroque Heaven?). [From Ruysch's Opera Omnia, Amsterdam, 1720; courtesy of the Getty Research Institute for the History of Art and the Humanities, Santa Monica.]

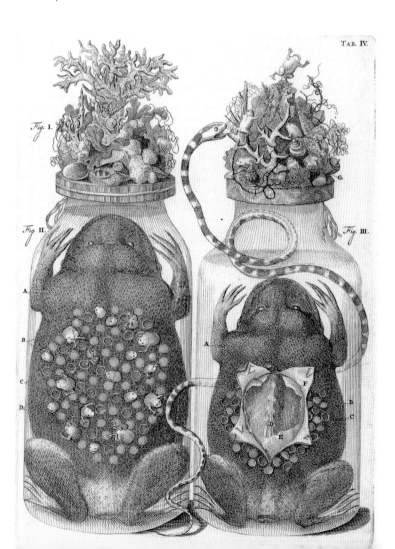

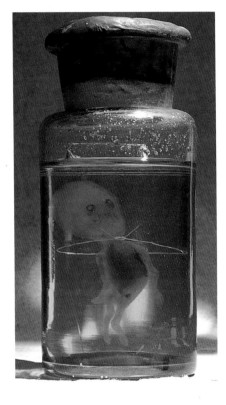

This cleared and stained human embryo in a bottle is in a very early stage of development. It is still just a shadow of its intended, failed form. [Facultad de Medicina, Valladolid, Spain; photo by author.]

Garden which I Caled my Garden, being a bit of Ground that was Given to me, to play the Gardiner in, that I shuld not wast the other parts.

"All this was kept very Secret from me. Though I was very Inquisitive and Whatchfull but having received a Great slap on the Face [in the margin it says, "from my mother"], I was foarsed to leave off my Curiosity.

"A few Dayes After being Buisy Digging in my little Garden, I Discovered a little Box, in which I found this Little Mounster, which I Buried Again and by it I Discovered part of the Mistery which I also Keept in Secret." James goes on to discover the almanac in Dr. Martels's "open closet": "I have Seen such another Child in all Respects Excepting that he had not the Round Excrescence between the two Heads; att Marybone near London he was born dead and was Shown for Mony.

"Seen by James Paris Duplessis aged then about 15 years. Finis."[19]

Aside from being a thoroughly resourceful snoop, James Paris Duplessis does not say what emotions he felt when, in casual digging, he uncovered and gazed upon the two-headed, still-born child (in fact, children). It must have constituted a seminal event, however, for as a young man—and servant to Samuel Pepys, the famous biographer of London life—James kept an illustrated journal on all manner of human monsters he had personally seen in and around London, ranging far and wide. He followed rumor eagerly to fairs and even to the bedsides of more monstrous births. He formed a manuscript that conveys the range of the author's enthusiasms, an eyewitness collection on paper entitled *Prodigies & Monstrous Births of Dwarfs, Sleepers, Giants, Strong Men, Hermaphrodites, Numerous Births and Extreme Old Age.*

*I*n seventeenth-century Holland, Dr. Frederik Ruysch worked his baroque ways on the remains of a toad not just to preserve the creature but to interpret it and to assign it a meaning.

The male Suriname toad carries through gestation many egg sacks on its back, which are fertilized by the female, until they burst open and release their young. Frederik Ruysch was given such a toad by the Lord Mayor of Amsterdam, and he preserved it in a particularly attentive fashion: the "mid-

wife" father toad has been immortalized at the moment in the reproductive cycle when the babies are emerging as fully developed toads from their egg sacks. In the illustration, the two frogs are shown preserved in a decorative jar strung round with snakes and topped with additional baby toads and flowers—done in Ruysch's elaborate signature style, a gesture of appreciation for this animal in particular.

Praelector of Anatomy in Amsterdam, Ruysch held the position as instructor to and chief of midwives. An artist as well as a physician, Ruysch masterfully arranged carefully injected animal and human parts to evoke allegorical meaning, in the style of the *vanitas* painters, although his subjects were often under glass. The seventeenth-century English physician Thomas Browne wrote of man as "a great and true amphibian whose nature is disposed to live not only like other creatures in divers elements but in divided and distinguished worlds."[20] If man may be compared to an amphibian, so a male toad whose back is full of babies, hatching and poised to hatch, must be the most appropriate symbol of one of Frederik Ruysch's professional duties that he himself could have imagined. Perhaps he felt a certain critical responsibility as the "father" of all infants in and round Amsterdam.

Through the Internet, during the summer of 1996, I met Dr. Su-Chu Hsu (Xiaoniu), professor of computer science in Taiwan. Su-Chu told me this story of her friend, which I have transcribed below.

"'Pangolin Woman' is Chang See-Moy. She is Chinese, from Malaysia—forty-eight years old (see "Boundaries" for the pangolin). Her parents were farmers. One day, five months before Chang See-Moy was born, her mother saw a pangolin on the farm, which the neighbors helped drive into a hole. Asthe pangolin hid in the hole, Chang See-Moy's mother built a fire outside the hole and tried to drive it out. The next day it had not emerged, and when the wood blocking the hole was removed, the pangolin had disappeared.

"Chang See-Moy was born with a very scaly skin; her eyes were set at a forty-five-degree angle, and she could not close them. Her teeth—when she developed them—came in as stumps. She had no eye-lids, and she had no

hair anywhere on her body. Her ears were holes, flat to her head. Her mother fainted when she saw the baby. The people in the valley said, 'You had this kind of baby because the pangolin is taking revenge on you.' And they also said that perhaps, in disappearing, the pangolin became the baby.

"Her mother hid her daughter in a small room. She had no money and could not take proper care of her. She asked that the nuns come and take the girl to the convent. Her husband came home as the child was being removed by the nuns. 'No, it's my baby—no matter how ugly she is, I will care for her,' he said, and he made them leave.

"A carnival man—the owner—came and offered a great deal of money. The mother refused, and after a couple of visits [from this man] she said that the baby had died.

"Her mother did protect her. Her skin every day fell off, piece by piece. Every day she needed to be bathed so that her skin would not bleed. It was painful and itching. Every day she hid inside; every night she worked on the farm for her parents, her head wrapped so she could not be seen.

"She learned to ride a bicycle with great difficulty. They gave her a small radio. Every day she listened to the news. She learned the Mandarin language from the radio. One day she found a newspaper on the road and tried to match character to sound. She tried to get more newspapers, and she taught herself to read. Her mother did not know she could read and understand Mandarin.

"Her story was generally known by 1982. One night, at work in the field, her head covering fell off and people screamed. 'I am so sorry. I am so ugly. I am as ugly as a snake. I am an ugly animal,' she said. She often called herself 'an ugly snake.'

"The writer Boyong met her and wrote an article about her, which captured the attention of many Chinese, Taiwanese, and Malaysian people. He said, 'The saddest stories happen to the poorest people.' Enough money was raised to bring Chang See-Moy to Taiwan for four months of medical treatment. The airlines did not want her on board, but finally they allowed her to sit in a seat at the back of the plane, well covered so that no one would have to see her.

"She had a great time in Taiwan. Many people came 'to see the animal' and some were really kind. She did not know what a friend was. She tried to give the money given to her to others. It was her first time on an airplane; her first time on a telephone; the first time she saw the sea. She wrote her name with a stick in the sand.

"Chang See-Moy has gone back to the village; she lives in the open now. She is sorry for the distress she causes others."

Su-Chu telephoned her a few years ago to record a message for the writer Boyong for his birthday. Chang See-Moy then asked, "May I sing a song for Boyong?"

Her "sound," said Dr. Hsu (meaning her voice), "is very beautiful: sweet, young, beautiful."

This carefully mounted calf (or calves) has a vestigial fifth leg near its hind quarters. Otherwise, the symmetry of the specimen is so remarkable that one is tempted to question its truthfulness and search for signs of human intervention in its creation. [Warren Museum, Harvard University; photo by author.] ⟶

"'Well, honey, talkin' about bein' pregnant an' all, you ought to see those twins in a bottle, you really owe it to yourself.'

"'What twins?' asked Mrs. Fletcher out of the side of her mouth.

"'Well, honey, they got these two twins in a bottle, see? Born joined plumb together—dead a course.' Leota dropped her voice into a soft lyrical hum. 'They was about this long—pardon—must of been full time, all right, wouldn't you say?—an' they had these two heads an' two faces an' four arms an' four legs, all kind of joined here. See, this face looked this-a-way, over their shoulder, see. Kinda pathetic.'"

—Eudora Welty, "The Petrified Man"[1]

Too Much, Not Enough, and in the Wrong Place

While the mythical monstrous races stood at the rim of the known world, so conjoined twins and children born without limbs or with a double gender stand at the rim of the natural world, at the edge of human understanding—both like and unlike us. In order to classify human anomalies, the eighteenth-century French naturalist Georges Louis Leclerc, le Comte de Buffon (1707-80)—who was in charge of the king's zoological garden (*le jardin du Roi*) and natural history collection and the author of the twenty-volume *Histoire Naturelle*—divided biological monsters into three categories: those with too many parts, those with missing parts, and those with parts in false positions.[2] Most human monsters do not survive infancy, which is why there are many children preserved on museum shelves who never caught their breath. If these children had been birds, they would have been thrown from the nest. Under early Roman law, monstrous children were put to death: "a father shall put to death a son recently born who is a monster, or has a form different from that of members of the human race." According to the Roman emperor Augustus (27-14 B.C.), humans born with extra limbs, as long as they were still recognizably human, were acceptable by society, while fourteenth-century Italian law granted civil liberties to all who were recognizably human in form, despite all deformities. Two historically renowned monstrous births occurred in Italy: the earlier one, in 1317, was a biologically plausible event, and the second, in 1512, an apocalyptic one, involving an absurd composition made from out-of-place parts attached to a single body. The apparition of 1512, the Monster of Ravenna, was assembled from various pieces of animal, fish, bird, and angel, with the parts out of place—an eye on the knee, a scaly lower body ending in a single bird claw. The various features might be translated into a moralizing *explication du texte,* as if the creature were a puzzle—a rebus figure—in which the horn on the forehead stood for pride, lack of arms for lack of "good works," the clawed foot for rapaciousness, the eye set low on the knee for an unspiritual nature, and the double sex, both male and female organs, a sign of sodomy. The whole, according to the sixteenth-century writer Multivallis, symbolized the terrible political state into which Italy had fallen at the hands

of both the French king and God. Katharine Park and Lorraine Daston point out that this composite creature resembled the "iconography of pagan idols," and so strengthened the historical association of a hybrid being with the evils of a non-Christian world. They say the creature of Ravenna "resembled contemporary images used in the art of memory, each pictorial element relating to a different item to be remembered."[3]

The Ravenna monster, however impossible, appeared in many broadsides, which were, as newspapers today, distributed to the general public. The number of reported monstrous births increased immediately and were held up as a prelude to impending political disaster—a disaster that, in fact, became reality when, one month after the monster appeared, Ravenna fell to the French. The book *Prodigiorum ac Ostentorum Chronicon,* by Lycosthenes, took advantage of the public appetite for prodigious events, which occurred at an increasingly frequent rate in the mid-sixteenth century; so many that the author conveniently supplied blank pages at the end of his enormous encyclopedia, inviting readers to record their own first-hand experiences. Today, of course, people faithfully follow UFO sightings and enjoy hearing about—even enduring—terrible storms and narrow escapes from natural disasters. Fascination with monstrous births—expecially with the appearance of conjoined twins—is universal. Hopefully (although one sometimes wonders), most of society does not attach a doomsday interpretation to prodigious events. Human reactions to extraordinary events cannot be graphed in chronological steps toward ever-increasing human enlightenment.

The second, and earlier, famous Italian birth—a child (children, really) born with two heads and one body—occurred outside Florence in 1317. As a boy, the poet Petrarch was shown a representation of this child (considered one being rather than two) by his father, who told his son to tell his sons—to have them know, sadly, "what can happen." The birth was an evil omen, indicating to the city fathers of Florence that there would be "future harm to the place it was born." But this prediction carried far into the future, as Katharine Park says, "relating. . . to the slow unfolding of generational time."[4] There is, in Florence, a stone frieze commemorating this real two-headed,

V. Monftrum cornutum, & alatum cum pede rapacis auis.

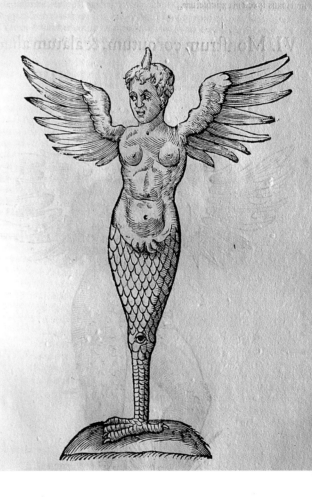

The Ravenna monster according to the illustrator of Aldrovandi's book on monsters, Monstrorum Historia, **Bologna, 1658. [Private collection; photo by author.]**

one-bodied phenomenon, while all that survives of the Ravenna monster is a series of exaggerated drawings based on hearsay, drawings that are certainly more allegorical than biological in nature.

*I*n *Treasure Island* by Robert Louis Stevenson, Jim Hawkins, son of the owner of the Admiral Benbow Inn, is paid by a rough stranger to watch out for "a sea-faring man with one leg, . . . an assignment which haunted my dreams I need scarcely tell you. On stormy nights, when the wind shook the four corners of the house and the surf roared along the cove and up the cliffs, I would see him in a thousand forms and with a thousand diabolical expressions. Now the leg would be cut off at the knee, now at the hip; now he was a monstrous kind of a creature who had never had but one leg, and that in the middle of his body. To see him leap and run and pursue me over hedge and ditch was the worst of nightmares. And altogether I paid dearly for my monthly fourpenny piece in the shape of these abominable fancies."[5]

The notion of this unknown man with one leg does have the quality of a fluid, shifting beastliness—the movement, the ever-changing placement and character of the missing leg resembles the anticipation of evil itself. Jim's only mandate is to watch out for this man, but his imagination gives way to fear, and his fear transforms the missing leg into a wandering leg—a leg whose position might shift at whim and whose quality of absence becomes a sign of infinite possibility, and of menace. It is the dream of the unknown. If the endless metamorphosing leg of the stranger would only achieve a definition, then the terror might stop.

In his poem *Das Knie,* Christian Morgenstern writes of a knee, all that remains of a soldier "shot through and through." The knee goes on by itself, alone, through the world.[6] The knee, an intricate anatomical structure, in a way seems separate even while connected to the body, and this knee of Morgenstern's assumes terrific wholeness. It becomes a determined traveler that cannot be violated or stopped.

In France and London there are special seats in the metro and the buses for the war-wounded, *les mutilés de la guerre,* and when an old soldier with an amputated limb or limbs is occupying one of these designated seats, all is

The stone frieze of the conjoined twins of 1317. The children were entrusted before their early death to the hospital of San Martino della Scala, Florence. Their picture, along with a warning about "what can happen," was shown to Petrarch as a boy by his father. [Photograph courtesy of Massimo Melandri and the Museo della Chiesa di San Marco, Florence, Italy.] ⟶

This "cyclops" child, born without a nose or normal eye sockets, is shown here in an engraving as an infant wrapped partially in a togalike shroud. The skull of an elephant resembles the head of a one-eyed giant, because the nasal passage at the top of the trunk looks like a single eye socket. This human child, in form, has the look of the one-eyed Polyphemus, of the monstrous race of *Monoculi,* and of every pachyderm. In her case, it was fatal. [From *Histoire Naturelle* by Comte de Buffon, Paris, 1778; private collection; photo by author.]

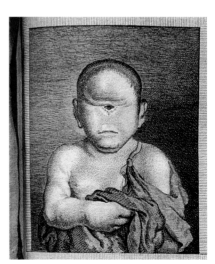

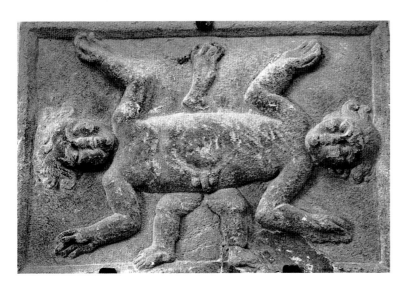

right with the world; human suffering has been granted status by being classified, not unlike a museum specimen. Once a name has been assigned and territory granted, the beast has a legitimate place and an undisputed right to occupy that place.

The remarkable Miss Beffin (born 1785) and, indeed, Mrs. Jeanie Tomaini—the "Half-Woman" wife (born 1918) of the giant Al Tomaini (see "Giants and Dwarfs," page 110)—were born without limbs, Miss Beffin without arms or legs, Mrs. Tomaini without legs. They belong under Buffon's system as *des monstres par défaut,* those born with missing parts. Mrs. Tomaini's compensation for limblessness came in acrobatics and the form of an enterprising giant husband, who carried her about. They appeared together on the sideshow stage, each increasing the visual impact of the other. The good-natured Miss Beffin developed the extraordinary ability to write and to paint landscapes with a brush held in her mouth. These women succeeded in a specialized world both because of what they had and because of what they lacked. Some do not succeed with missing parts, however. A "cyclops" child, born with a fusion of the optic cavities and the cerebral hemispheres, will not survive. This illustration of a female cyclops child was taken from a wax model made by Mademoiselle Biheron in 1766 and published in Buffon's *Histoire Naturelle.* Buffon reports that the child lived for several hours after her birth, although without a proper breathing passage it is impossible to know how.[7]

There are several common types of conjoined twins, all variations produced from a single egg *(monozygotic),* and therefore always of the same sex. Twins joined at the pelvis and incompletely separated are called *ischiupagus* (the technical condition for Ritta/Cristina and for the twins from Vézelay and Anzy-le-duc, described below). Twins joined at the head are called *craniopagus*; those joined at the chest, *throapagus;* and those joined at the bottom, *pygopagus.*

The sculpture of the capitals of Romanesque churches functioned, in part, as a kind of encyclopedia of biblical stories tempered by pre-Christian and Eastern legends. The rumored monstrous races, considered profane to more spiritual priests, were nevertheless of ecclesiastical interest to them as potential converts to Christianity. Actual biological monsters took on a more immediate signification. Careful comparison of the carvings of conjoined twins at churches at Vézelay and Anzy-le-duc to drawings and skeletons of medically well-documented conjoined twins reveals remarkable anatomical simularities.

Anomalies recorded in stone can be convincingly realistic, although history does not always record the intentions of the artist. We do not know whether the medieval sculptor obediently used his hammer and chisel to carve conjoined twins based on oral reports of a quaint monstrous race from distant lands or whether he used them to record an actual local event—the birth within the community of ischiupagus twins. A

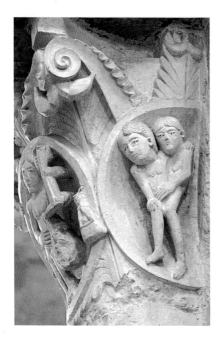

←

These conjoined twins on the capital, even if originally designed to depict Eve emerging from Adam's rib, appear to be unmistakable anatomical equivalents to actual human skeletons. They come from the Romanesque Abbey Church of Mary Madeleine, Vézelay (c. 1120–32). [Photo by author.]

→

The twins on this capital, with two heads and one body, faithfully reflect an anatomical study of actual conjoined brothers. They come from the Romanesque Church of the Trinity, the Holy Cross, and the Virgin Mary at Anzy-le-Duc (early twelfth century). [Photo by author.]

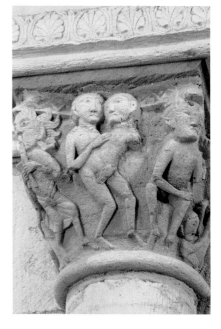

certain urgency to depict such a phenomenon came from the persuasive medieval conviction that unusual natural events—great storms, comets, and unnatural births—were portents, signs of God's displeasure with all sinners.

In 1112, just before a bloody battle in Laon in France, a series of apocalyptic events occurred, reported by the Abbot Guibert of Nogent: three wooden beams appeared in front of the crucifix, a moonlike globe appeared over the city, flames shot into the night sky, and a monstrous baby was born, a boy "double down to the buttocks." Two heads, two bodies as far as the kidneys: "Double above, he was single below." After he was baptized, he lived for three days. Laon is 150 miles away from Vézelay, where the date of a carving of similarly conjoined figures is 1120-32.[8]

On a stone capital at the Romanesque church of Anzy-le-duc, conjoined male twins are flanked by a figure with a head like the sun playing pan pipes and a seated figure, whose backward-pointing feet classifies him as either a club-footed man, the Devil with hoofs, or as a mem-

ber of the race of beings who all have backward-pointing feet. Around the corner on the same capital appears a man with a single giant foot raised as if it were an umbrella against the sun. He is a sciopod, a favorite character from the pantheon of monstrous races, and he may be modeled from a person afflicted with elephantiasis, although this seems far-fetched. I do propose that these united figures with double upper body and one set of legs bear an uncanny resemblance to human twins, and that this carving may actually have been inspired by the same rumored birth as at Vézelay.

Careful comparison between the carved figures at Vézelay and Anzy-le-duc to drawings of actual conjoined twins—such as Ritta/Cristina, the twins from Sardinia—or with the skeletons and photographs of more recent conjoined twins, shows the same configuration of joining, which, anatomically speaking, does not differ at all.

Sometimes the top of two bodies are joined together while the feet remain apart. The single head that is created is

really two heads incompletely formed from the center out. On the left appears the left side of one twin, on the right appears the right side of the other twin. Their heads, fused together, form the illusion of a single face. Carved on a capital at the Church of Saint Peter at Chauvigny, an the early-twelfth-century figure of a man dances between lions. Fully grown, he is dressed in a tunic with a V-shaped collar, two sleeves, and a skirt that, at the hips, becomes two twirling skirts, one for each set of lively moving legs. His huge face stares out without much expression.

Even if the rules of sculptural symmetry moved the artist to create this strangely divided dancer, the figure expresses with surprising accuracy a teratologically well known human monster found in many historical anatomical collections. Comparing the dancer to a nineteenth-century wax model and skeleton of conjoined twins from Bologna becomes a sad and wrenching exercise. The skeleton is set erect with iron rods, its four feet fixed to a board, while the wax model of the twins, who died at birth, is mounted on a single supporting post. The feet hang in space, while the arm of one twin clutches the shoulder of the other. They never touched the ground.

Even when not physically conjoined, twins are known to be closely linked; in many uncanny ways, they echo each other's patterns of behavior. Case studies of twins separated at birth and reunited as adults show a shared web of habits, preferences, and tendencies, quite apart from physical similarities. Conjoined twins likewise share a spiritual and emotional bond. In the twelfth century, Mary Chulkhurst, conjoined sister to Eliza, supposedly said when Eliza died, "As we came together, we will also leave together." At the end of the twentieth century, when physical separation of some types of conjoined twins

Although these twins, joined at the pelvis, have many features in common with the stone carvings at Vézelay, the skeleton represents an unusual version of this particular class of anomaly: two heads, two upper bodies, and a (very rare) third vestigial leg, a feature not present in either of the church carvings of twins. The larger twin holds onto a label board, although whatever explanatory text appears is tilted inward for benefit of the twins rather than for the reader. [Museo Cesare Taruffi, Istituto di Anatomia e Istologia Patologica, Università di Bologna; photo by author.]

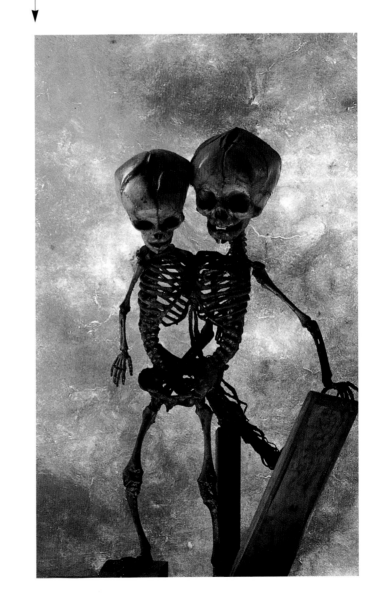

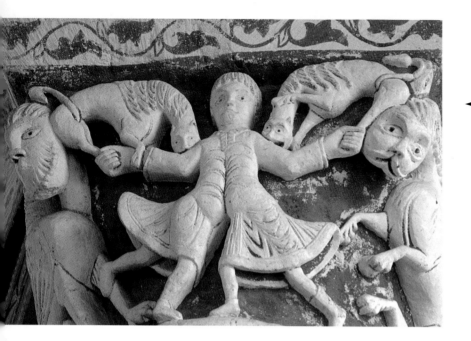

The man dancing with lions is engaged in a stylized ritualistic event. But why does he have a single body down to the chest and two pairs of legs with four feet? The sculptor left no explanation. This early-twelfth-century Romanesque capital is from the Church of St. Peter, Chauvigny. [Photo by author.]

has become possible, Brittany, one of the conjoined Hensel twins, once said simply, "I am not going to be separated." And their mother added, "If they were meant to be together, they were perfectly put together."[9] Whether or not Mary Chulkhurst's devotion is apocryphal, the reported message from the Hensel twins nine hundred years later sends an echo of having made peace with an inevitable unity.

The Chulkhurst twins, born in 1100 in Biddenden Kent, England, were as much a part of the fabric of their families and of local society as are the healthy Hensel twins today, born in 1989 in the midwestern United States. The "Biddenden maids," as the Chulkhurst twins were known, grew up in their affluent parents' house, peaceably conjoined. After their deaths at age 34, they were commemorated by their parents, who left a perpetual gift to the church of cheese, bread, and souvenir cakes that bore the likeness of the girls, side by side, joined at the shoulder (apparently) and at the hip. In the likeness on the cake mold only one pair of arms is visible—the right arm of Eliza and the left of Mary—which has provoked questions in early modern times about which category of teratology they belonged to. The drawing of the cake mold shows the shoulders seemingly fused together, but no such joining has ever been medically recorded. If their second arms are behind each other's shoulders, which in closely conjoined twins is often necessary, their condition may be described as pygopagus, the same condition shared by the famous eighteenth-century Hungarian sideshow twins, Helen and Judith. The drawing of Ritta/Cristina shows the arms between the girls placed behind their backs in such a way that their inside shoulders appear to

be joined at the top of the arm sockets. The effect is precisely the same as in the drawing of the Biddenden twins, which makes the representation on the cake mold believable from a biological standpoint.

In the Hensel twins, a third arm was removed in infancy because it interfered with the girls' comfort. It is clear in examining both the plate of Ritta/Cristina and the sculpture from Vézelay that the proper number of arms for two persons, do, when the persons are permanently joined, interfere with mutual comfort and mobility. An anatomical advantage in a single body, two arms for each body, becomes a disadvantage for conjoined twins, who have two bodies halfway down and then only one.

Mark Twain was fascinated by the enigma of twins—by the endless visual sleight-of-hand, the nature of ethical responsibility, and the struggle between gentle companionship and personal power. In *Those Extraordinary Twins* he wrote about a pair of very handsome Italian brothers, joined at the waist, who

have come to a small southern town as they travel for their livelihood. Although Twain describes a biologically plausible situation, the tale is also an allegory about being twins. Twain may have modeled the brothers on the contemporary Tocci brothers, who, however, could not have even walked on their single pair of atrophied legs, much less traveled alone as Twain's twins do.

In the story, the family with whom the twins stay go through a cascading flood of emotions when the twins arrive: alarm, revulsion, attraction, love even, as well as constant speculation about how it's done.

"Why didn't I see them take off their hats?"

"That don't signify. They might have taken off each other's hats. Nobody can tell. There was just a wormy squirming in the air—seemed to be a couple of dozen of them all writhing at once, and it just made me dizzy to see them go."[10]

The twins have a struggle taking off their "partnership-coat," which had "an abundance of sleeves . . . like skinning a tarantula." But the modus vivendi of their existence is established by an internal clock—created by "He who made us"—that turns the guiding power of one of them over to the other for

These twins with one head and two bodies echo the form if not the action of the man dancing with lions from Chauvigny. This nineteenth-century wax model of twins who died at birth and their single preserved skeleton show both the external and internal shape of all such benighted babies. [Museo Cesare Taruffi, Istituto di Anatomia e Istologia Patologica, Università di Bologna; photo by author.]

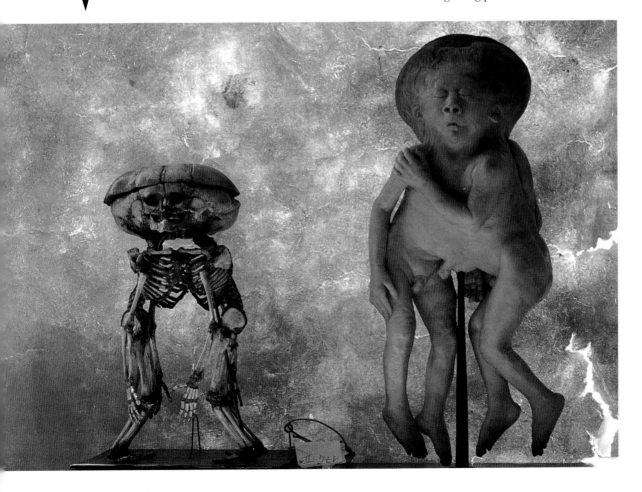

precisely one week at a time. One brother (Luigi) drinks and the other (Angelo) feels the hangover. Luigi, an indefatigable carouser, exhausts the less hardy Angelo, often mortified by his sibling's carryings-on, cannot imagine being separated from his brother. Angelo "shuddered at the repulsive thought. . . . To be separate and as other men are! How awkward it would be, how unendurable . . . [and] how lonely, how unspeakably lonely!"[11]

The conjoined twins Chang and Eng (1811-74), the renowned twins born in Siam of Chinese parents, were the original "Siamese" twins—a term that should only apply to conjoined twins from Siam.[12] Perhaps they were the most famous of P. T. Barnum's "freaks," gaining great notoriety and financial success. The twins married sisters and lived on two plantations in North Carolina, moving between them every several weeks. The Southern plantations came with all the trappings of the era—including slaves. Chang, like Luigi, drank. While Eng, like Angelo, woke up feeling the effects. They finally died within hours of each other at the age of 63. The doctor said that Eng, the second to die, died of fright.[13] The nature of their conjoining was ligamentous—by a flexible band of skin joining them at the waist. They could not have been separated and survived as two, however. The autopsy revealed that they shared a single liver, which, on permanent display at the Mütter Museum in Philadelphia (along with the plaster cast made from their bodies after death), is very large—affected perhaps by all the alcohol Chang drank over the years.

This drawing by Marjory Wunsch of Mary and Eliza Chulkhurst, the Biddendon twins, is based on an illustration of a cake mold showing their likeness. [From Gould and Pyle, *Anomalies and Curiosities of Medicine*, 1956 edition; private collection.]

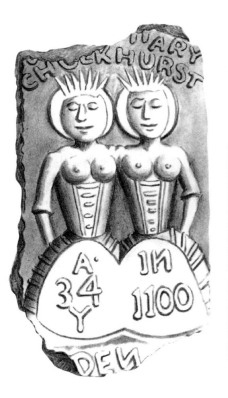

Plate from Etienne Serres's study of Ritta/Cristina, 1833. [Private collection; photo by author.]

Plaster cast of the twins Chang and Eng, with the shadow of one of them reflected in the glass of a museum display case. A flexible band of flesh joined the twins; their autopsy revealed that they shared one liver. [Thomas Dent Mütter Museum, Philadelphia; photo by author.]

The question of whether conjoined twins constitute one or two people has kept philosophers and pundits busy for centuries. In the church, the general policy has been to baptize both heads of two-headed twins. In 1830, Etienne Serres, the physician who examined Ritta/Cristina, conjoined twins from Sardinia, when they were alive and studied their structure after they died, decided that, although both girls felt physical "irritation" of their genitals equally, they had "distinctly and individually perceived the sensation," and were, in fact, two people. Stephen Gould (see "Generation") believes that Ritta/Cristina were both one and two beings simultaneously: a single organic structure with two brains, two personalities, and two souls.[14]

Katharine Park has said, "for a medieval writer like Guibert of Nogent, the birth of a double child represented a violation of the natural order, as God suspended his own rule in order to admonish or warn. For the nineteenth-century anatomist, even an extraordinary being such as Ritta/Cristina represented simply another application of natural laws."[15]

Much the same could be said about a hermaphrodite, who, according to Robert Garland, in Classical times could be represented as a conjoined figure.[16] Buffon place hermaphrodites under those with too many parts. The physical character of the anomaly itself, ambiguous sexuality, is often—to the eye—undifferentiated rather than alarming.

Aristotle believed that "extra matter" in the area of the groin would create two sets of genitals, and if that matter was cold in nature, the results would be

a double set of female genitals; if hot, male. A mixture of hot and cold, he said, would produce one of each set of sexual organs in the same individual. The Roman historian Livy characterized hermaphrodites as "the most abhorred of all portents,"[17] seen as warnings against the safety of the state. Intersexual beings were, in ancient Rome, the ones most likely to be thrown into the sea. After 92 B.C., the law relaxed, and according to Pliny the Elder (c. 50 B.C.), "The portents were now treated as pets."[18]

Fellini portrayed them as if hovering between sexes, in a perilous state, unable to breathe, as seen in the character of the dying albino hermaphrodite in the film *Satyricon*. In the decadent age in which the story is set, the hermaphrodite is managed by an impresario and worshiped as a cult god of miraculous healing power. The sickly boy—for the impression of maleness is dominant in this figure—suffers from his albinism; he dies, dehydrated, under a hot sun.

The intersexual state may have the potency of both sexes, but even if a person has a longing and bias toward one state or the other, he/she is also diminished by being both. The acknowledgment of mixed gender creates a problem of social acceptance—potentially a legal issue in the nineteenth century.[19] Then, as long as a person of indeterminate sexual persuasion, with the advice of a doctor and the authority of the court, specifically chose one gender identity over the other, that person was allowed to live at peace within society. Any action out of accordance with that choice of gender was punishable by law. The hermaphrodite functions as a signifying creature, with a leg in two worlds. But the hermaphrodite must choose a category. Without classifica-

tion, the museum will not keep the object. Something that falls between one condition or another, or has never been granted its own status, may, in itself, have no real place.

For every group of anatomical specimens, there are only a few "type" specimens, examples of such supreme normality that they are considered to be the measure of all the rest. Only a small number of genetic variations produce biological "monsters." There can be no horse with the body of a snake, no mermaid, not even conjoined triplets. But conjoined twins—with two heads, two upper bodies, and one pair of legs—can and do occur, infrequently, in many places: including twelfth-century France, fourteenth-century Florence, nineteenth-century Russia, and every year in the United States. If the geographical and historical isolation of these twins could be overcome, and if they were to be placed into one hypothetical group, one pair would emerge as an average representative of all the rest. These normal twins would then possess, as do all type specimens, a kind of neutral splendor—the unique of the extremely rare.

This beardless creature was named the "Japanese Mermaid" by its creator, the taxidermist William McGuigan of the Charles Wilson Peale Museum, in 1842 to demonstrate that P. T. Barnum, the owner of the bearded "Fee Jee Mermaid" owned an easy-to-manufacture fake, and not, as he claimed, the genuine article. Both are genuine fakes, with a tradition much older than the mid-nineteenth century. [Courtesy of the Peabody Museum, Harvard University; photo by author.] ——▶

"My father was the captain of the Eddy Stone Light,
he slept with a mermaid one fine night.
Out of the union there came just three,
a porpoise and a porgy and the other was me."
—folk song

Heads and Tails

With pen and paper the French Surrealists invented a game to create composite creatures of incongruous parts. The first person drew a head and folded the paper; the second, without looking at the head, drew a torso, perhaps with arms, and folded the paper; the third drew the legs and folded the paper; the fourth, the feet. The whole, unfolded, created *le corps exquis,* the exquisite body, or as Americans insist on translating it, "the exquisite corpse." Humans have long had the impulse to create hybrid creatures: the centaur—body of a horse, head of a man—traveling on all fours; the minotaur—head of a bull, body of a man—upright; and a manifold of sea creatures, half understood and given terrestial relatives—the sea horse, sea lion, sea elephant, and sea women, perhaps the most dreamed about and pliable incarnation in myth and biology. In describing the nineteenth-century fascination with mermaids, the cultural historian Harriet Ritvo recently wrote, "Whatever the assumption about the likely existence of mermaids, zoologists and anatomists were inevitably drawn to examine these multiply liminal creatures and by these means to reconstitute the boundaries of the natural world."[1] A fifteenth-century manuscript of the *Livre des Merveilles du Monde*—a *descripto mundi,* illustrated travel book, in which the whole world is described with the "deeply rooted ethnocentrism"[2] of the tall, handsome, strong Western traveler—includes a scene of Pygmies battling cranes, and a complicated scene of the fiery, bloody torments endured by pagans and Christians alike. In the far right-hand corner, a curious minor creature is crawling out of the water. This scene is described by accompanying text: "Italie. A noble fertile land. A certain people there called Hirpes could walk through fire unharmed. In the diocese of Saurnien [Sorrento?] a cemetery for monks only, where the earth consumes the bodies in three days. A lake filled with devils demands a human sacrifice each year, [he is] usually a malefactor. The beaver lives in the waters of the diocese of Turin."[3] The quiet hybrid, described here as a "beaver," seems otherworldly, at first somewhere between a catfish and a spider monkey with the claws of a dog. It does not belong to the traditionally documented monstrous races. Nor is it a "beaver," as in this translation of the French text. This mammal/fish bears

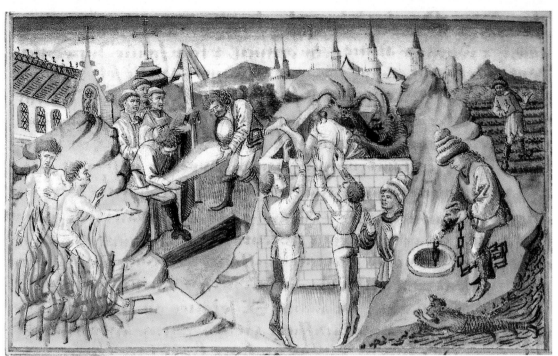

an uncanny resemblance to the Feejee mermaid of Barnum's nineteenth-century circus. We often presume that an object precedes the depiction of it, and to see this careful drawing from the mid-fifteenth century provokes (at least) three questions: Was this the artist's *idea* of a "beaver"? Was the creature, in fact, drawn from a model? Or was the drawing used as inspiration for the taxidermist?[4]

Whether this original mammal/fish came from the imagination of the French illustrator or the workshop of a charlatan, Captain Eades in the West Indies fell so hard for the claims of authenticity made for just such a creature that, in 1822, he sold his ship in order to pay for it, brought it back to London, and sought scientific opinion. He had, naturally, been had. What starts as a game of incongruities on folded paper may in three dimensions become either a ludicrous fake or a viable creature imperfectly understood by its witnesses.

The origin for the name of the "Jenny Haniver," a manufactured dragon or mermaid often seen in early collections, is not known. Traditionally, it appears as a ray cut and folded into the form of a small sea monster. The ray, with its simple large wings, lends itself to being shaped into a dragon, a monkey, or even into a woman.

Singing sirens tried to drown Ulysses and his men. Fatal enticements and seductions have long been associated with sea women, including the silkie, the seal who in northern lands assumes the shape of a woman to live with a mortal on land and bear his children. The dugong—called *Pexe-de Mol-hee*

In the lower right-hand corner of the illustration appears a possible ancestral form of the Feejee Mermaid. Artifice has its own history. Is this creature perhaps the "beaver" described by the author of the fifteenth-century *Livre des Merveilles*? [Detail of the illuminated manuscript Morgan 461, folio 76v; courtesy of the J. P. Morgan Library.]

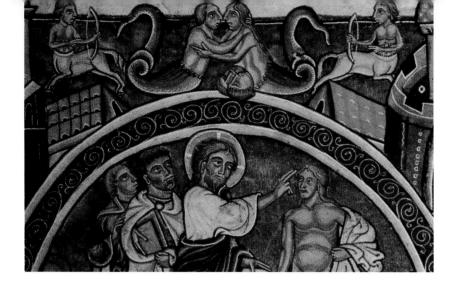

Mermaid giving birth to twins while kissing her consort, in marginalia of the twelfth-century Manerius Bible, volume 3, from the Abby of Saint Loup at Troyes. Below the border of the mermaid and merman, centaurs, battle elephants, and Sciopods, Christ, with his disciples, heals a leper. [Courtesy of the library of Sainte Geneviève, Paris.]

(sea woman) by the Portuguese, *Zeekoe* (sea cow) by the Dutch, and *Porcus Marinus* (sea pig) by the British writer T. H. White—swims in shallow, weed-choked coastal waters in various parts of the world. According to the seventeenth-century naturalist Rumphius, when the creatures lifted their upper bodies from the water, sailors mistook them for women because they had round smooth heads, full womanly breasts, and flippers "like blunt arms."[5] The dugong was said to cry, and its tears worked as a charm for love. Some Malaysians believe the dugong was a reincarnation of pork, accursed meat, thrown by the prophet Muhammad himself into the sea after he had decided it was unclean.[6]

Flanked by archer centaurs at the top of a page from a medieval Bible of Manerius of Canterbury, a merman and mermaid embrace even as the crowning heads of twins emerge from her midsection. Careful scrutiny reveals that the birth is occurring on the skin side of the mermaid, fairly high up on her composite flesh/fish anatomy, a placement that makes little gynecological sense. The human quality of the event is reinforced by the apparent affection between the parents of the twins—mer, or not, we do not yet know. The babies' large, manlike heads emerge from their mother directly over the figure of Christ, who, operating in another sphere altogether, cures a leper. The message from both atmospheres—sea and land—is one of love and birth of the spirit, both carnal and Christian.

As legends roll in over the centuries, fishes and sea animals have assumed many heads, most of which mirror their terrestrial counterparts: monkeys, horses, bulls, rabbits, owls. Some represent an honest confounding between aquatic and earthly creatures: the "river horse" turns out to be the hippopotamus; the "sea horse" is a delicate, miniature, but not quite white stallion with the tail of a boa constrictor; the sea cow, the dugong; and the sea lion has only the name. But others are absurd. Fishes and creatures of the sea

had—still have—a marvelous, otherworldly quality to all but the most intrepid of sea voyagers. Fishermen no doubt always understood their catch, but they continue—almost to this day—to find mermaids, dragons, and monsters. The messages from the sea for many centuries were delivered by people, not by satellites, and the sea was full of as much phantasmagoria in ancient, medieval, and Renaissance times as the shores of North America, which waited with its own overload of exotica—including cannibals—to be discovered.

Even though some beasts might be cobbled together—in theory at least—from genuine animal parts,[7] some natural creatures who are in fact single and whole appear as hybrids, with genuine reasons for their apparent anomalous condition. One, which began with an image of perfidy, inspired, mysteriously, a tangle of rats.

Martin Luther was the first to use the term *Rattenkonig*, or "Rat King," in 1534, although it is entirely possible that the term existed before then. Understanding people's general abhorrence of rats, Luther used the symbolism of the rodent to express his hatred of the hierarchy of the Catholic Church: "The Archbishops have above them a Primate, the Primates a Patriarch, and finally, on top of all, there is the Pope, there sits the ratking."[8] Luther persisted in using this favorite image: "ratrabble" (for cardinals), "ratnest" (for cloisters), and "ratkingdom" (for the Anabaptists in Munster).

Conrad Gesner, the great Swiss naturalist (1516-65), wrote of a Rat King, who leads a happy life at the expense of others. In 1757, the dictionary entry describes the phenomenon not as one rat but as many rats in a ring with their tails tied together. The "rat king" object as an artifact—we must assume—of human ingenuity may still be found in museum collections. The Dutch dictionary defines the term as "a now impossible to untangle, insoluble difficulty." Here, visually, the rats are trapped by the knotting of their tails.[9] The

This circle of rats comes from the Natural History Museum in Leiden. It was found at Ruophen Nor-Brabant in 1963. There seems to exist no data on how the animals came to be tied together, but there are plenty of stories. [Photo by author.]

devil, in some incarnations, had both horns and a tail; perhaps it was the tail of the rat that symbolized Luther's bile.

Certainly the rear end of every living creature and any appendage issuing therefrom tends to be a target for both lust and revulsion. As T. H. White translates from the bestiary, "A monkey has no tail (*cauda*). The Devil resembles these beasts for he has a head but no scripture (*caudex*). Admitting that the whole of a monkey is disgraceful, yet their bottoms really are excessively disgraceful and horrible."[10]

A tail, of course, may be, in and of itself, remarkable. There was a kind of fat-tailed sheep that is described in the usual breathless terms by early travelers; this sheep actually existed. The Greek historian Herodotus recounted how, in Arabia, there were "two kinds of sheep worthy of admiration, the like of which is nowhere else to be seen; the one kind has long tails, not less than three cubits in length, which, if they were allowed to trail on the ground, would be bruised and fall into sores. . . . As it is all the shepherds know enough carpentering to make little trucks for their sheeps' tails. The trucks are placed under the tails, each sheep having one to himself, and the tails are then tied down upon them."[11]

Speaking of excessive weight, and moving to the other end of the body, we have the story of the dilemma of the extinct Great Irish Elk (neither Irish nor an elk but widely European and a deer), whose magnificent colossal antlers became its downfall during the Pleistocene times. Why would large horns, so often a sign of male dominance and reproductive success, become a fatal liability? In the early nineteenth century, Cuvier used the fossil evidence to prove, correctly, both that the animal had no modern relative and that it belonged to a group of nonconnected extinct animals. The great Irish elk's demise, scientists have since concluded after years of debate, came from

Severed horns from both Indian and African rhinos are frequently found in museum collections. As trophies of past colonial game-hunters and of museum expeditions, these particular horns constitute an important if uncomfortable legacy from the past. Slaughtered rhinos continue to embody intangible hopes, discernible for Westerners in the myth of the unicorn. [Museum of Comparative Zoology, Harvard University; photo by author.]

A fat-tailed sheep with its heavy tail braced on a cart. [From *Historia Aethiopica* by Ludolphus, 1681; private collection; photo by author.]

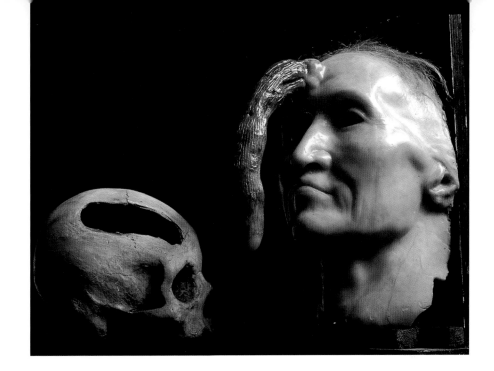

Trepanned skull photographed with a wax likeness of Mme. Dimanche, obviously before her successful operation. The artist of the wax portrait of Mme. Dimanche remains unknown but the model was made before 1856. [Thomas Dent Mütter Museum, College of Physicians, Philadelphia; photo by author.]

a change in the weather. The deer who could survive in a grassy, moderately wooded environment could not adapt to either subarctic tundra or to heavy undergrowth. In short, ninety pounds of twelve-foot-long antlers make it hard to take a walk in the woods.[12]

While Cuvier used the fossil evidence of the largest deer that ever lived to prove that it belonged to a group of extinct animals unrelated to modern deer, the Danish natural philosopher Olaus Worm (see the Introduction) used the narwhal tusk, with its delicate length and elegant twists, as evidence that the horn of the legendary unicorn came from a large mammal of the northern sea. Just before 1600, the black rhino was reinterpreted by eyewitnesses as the "real" unicorn.[13] Then, as now, the horn of the rhino was ground to powder and sold as an aphrodisiac. The rhinoceros, killed over a period of many centuries for its magic horn, is now on the verge of extinction, while the unicorn lives on in a thousand sentimental ways—all fictional.

Even though the same graceful spiral curve may inform the antlers of a deer, a sea shell, and the aberrant horns that sometimes appear on humans, seeing quaint horns on a medieval Moses or stately antlers on a Romanesque carving of Cain does not have the same effect as the apparition of the bizarre exostosis of horn on Madame Dimanche (see above) or even the sight of normal horns cut from hapless Indian and African rhinos for the sake of the hunter.

According to Ruth Mellinkoff, author of the *Horns of Moses,* a colorful interpretation of a biblical verse turns Lamech into the murderer of Cain, having mistaken him, while hunting, for a horned beast rather than a man.[14] The scene of the accidental shooting appears on capitals both at Autun and

at Vézelay. At Autun, Cain, afflicted also by skin disease, has a definite but somewhat modest horn growing on the right side of his head, whereas at Vézelay he has grown a full-fledged pair of antlers, worthy of any stag.

The growth of hornlike excrescences on the forehead or on the sides of the head is a recognized clinical condition, but the drama surrounding the surgical removal of the unwanted horns varies greatly in intensity. Around the beginning of the nineteenth century, in Paris, a Dr. Souberveille operated quietly to remove a ten-inch horn from the forehead of the eighty-year-old Madame Dimanche. The horn, placed in a local museum, was one of several on different parts of her body which had been growing since her twenty-fourth year. She lived without the horn for at least seven more years.

The story of the operation to remove the horns from the "man from Murcia ... the first dated case of a cornupete man," who was a Knight from Santiago, is no dull surgical tale but a nocturnal event, full of mystery, involving affidavits, eyewitnesses, and qualified professional intervention.[15] The event, which occurred in 1797, is certified by the presence of an original document found in the archives of the National Museum of Natural Science in Madrid, a document that includes the sworn testimony of the surgeon, eyewitnesses, and the patient himself. Formal correspondence between the donor of the horns to the museum and the director of the museum was found as well, in which the director announced his intention to install the artifacts in the *Reale Gabinette,* or Royal Cabinet of Madrid.

The man came with his head carefully covered to the surgeon Don Joseph Correa and begged him to remove from his head two spiral horns, one smaller than the other, saying: "I tell you I have left my homeland which is the kingdom of Murcia, and only with the purpose that they cut them off me. . . . I have been in various places, with many people, where skilled surgeons pondered over me, and none dared to do the operation fearing I would be hurt but I consent that Correa perform the operation and I would be entirely relieved."

The surgeon testified: "Don Joseph Correa, surgeon in this court, I say that it is appropriate for me to verify how on a day last April a distinguished gentleman arrived at my house, who was from Murcia and was about 67 years old, more or less, and with the desire that one acknowledge the monstrosities that as they had made evident, two horns, or horns of the same color, hairdress, substance and shape as those of a ram, which I recognized. . . . Which gentleman said he had gone to various places in order that someone cut the horns, and no surgeon wanted to take on the operation, for which reason they were separated by me with the amputating saw, which I swear by God."

Candida Trijueque, an astonished witness of the marvel, then declared: "On a day in April, a man arrived, muffled up with a large hat and was talking for some time with Don Joseph Correa who lives in Caravaja Street, and I saw that this man was asked to sit down and he sat on a chair and he took off his hat and immediately one saw the horns, and Correa said to the subject (who wore a military pearl-colored uniform and on his chest a scallop shell of the habit of St. James with a red cord), "Do you want to have them removed?" and he answered, "That is my desire." The aforementioned Don Joseph Correa took out a saw steel blade and wooden handle and with the help of the above named who held him to relieve the pain, he cut them off and this act took more than a half hour."

The assistant surgeon also testified: "He saw a man of good size and muffled . . . bumps which everyone said were horns, which was not said in his presence, and he asked Correa if he dared to remove them."

The document is signed by all who gave witness, but not, it is noted, by the patient, who remains anonymous. The story may be true, but the trappings—the soldier as a member of a brotherhood, the exclusive, almost secret nature of the operation, the testimony of all concerned as if before the Inquisition, along with the sudden appearance and immediate disappearance of the patient—lend a strong impression that the participants sensed they were engaged in an unholy event, one that, no matter how beguiling and eager the patient, hinted of the devil. The amputated horns passed from the surgeon to the director of the museum, where, as curiosities among so many others, they were eventually lost. While the well-documented story of the event remains, the evidence has vanished.

Athanasius Kircher gave the heads of animals to humans as part of an optical joke. In his theater, and in myth, a change of head can seem as casual as changing hats, whether it's head-switching for the sake of spectacle or to

Mandeville uses the dog-headed man as a symbol of the infidel, who might be won over to Christianity. More hungry dog than hopeful saint, this scantily clad cannibal devours the soldier/crusader. [From *Mandeville's Voyages*, Strassburg, 1484; courtesy of the Chapin Library, Williams College.]

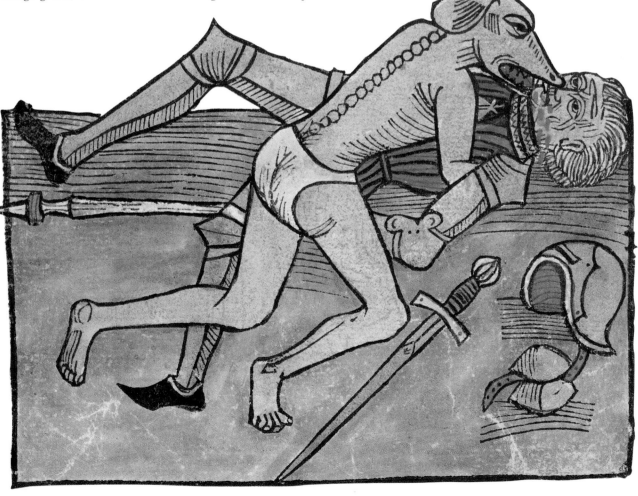

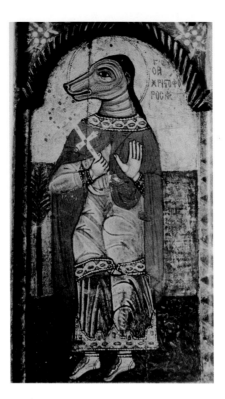

St. Christopher depicted as a benevolent dog-headed saint, from a 1940s postcard from the Byzantine Museum, Athens. [Private collection.] ◄────

Hydrocephalic child whose skull has opened like a flower. [Universiteitsmuseum, Utrecht; photo by author.] ────►

suggest a particular metamorphosis. The casual sticking on of heads or tails, however, may easily become confusing if it isn't seen firsthand. Hearsay may lead to mistakes. "Dante, who was familiar with the writings of the ancients but not with their coins or monuments, imagined the Minotaur with a man's head and a bull's body,"[16] as is seen in Canto XII of the *Inferno.* The manifestation of a dog-headed race of men, more or less parallel to the human race, was the outcome, like the sirens of the sea, of a tangled history of half-truths and mis-sightings.

In the eleventh century, dog-headed men were thought to be the male offspring of Amazons, who had mated with their male prisoners or merchants. In northern Europe, it was believed that a princess lay with a dog to create an entire new people. Professor of religious history David Gordon White recently wrote that "we also find accounts of the human race arising from the penis (or tail) of a dog who had stolen Adam's rib from the Garden of Eden!"[17]

The giant Nimrod (see "Giants and Dwarfs") who "hunted against the Lord" was, according to Saint Augustine (354–430) in *The City of God,* the true ancestor of the monstrous races. Augustine recreated monstrous races for the early Christian world—*Cyclops, Pygmies,* etc., and he placed them conveniently outside of European society under God's protective sphere, offering symbolic monsters perhaps as a reference for distraught parents who produced a monster of their own at home. Augustine annointed the *Cynocephali*

as the leaders of this pack of "fairyland monsters," and in medieval texts—both on stone and on paper—the *Cynocephali* appear as creatures of potential faith. In a carving at the Church of the Madeleiene at Vézelay (1150), sophisticated dog-headed figures in pilgrims' robes stand on human legs, talking. Calm conversation and the wisdom to wear clothes (for natural shame at nakedness was acquired in the Garden of Eden) indicated that even beasts could be groomed for rational human discourse and that their souls could be saved. The *Livre des Merveilles* shows a group of dog-headed men from the Nicobar Islands near India wearing idols of miniature oxen and sheep on their heads. Civilized enough to have an organized religion, it is nevertheless the "wrong" religion—worship of pagan idols. Saint Christopher, the dog-headed saint, made the leap of faith away from his idol-worshipping roots. An Eastern painting revealed a creature of such purity that in baptism Christopher's head turned from black to white, indicating that conversion to Christianity can not only save a doubtful hybrid, but change the color of his skin as well.

Dog-headed men may be cannibals as well as "dogs of war." Hound-headed spirits are associated with bloodthirsty warrior Lombards in the eighth century,

with "werewolf" warriors from early Germany, and, in medieval Rome, with "ghosts," dog-headed souls of the dead.

Such stories may represent an ancestral memory of an extinct animal (see "Next of Kin") or constitute a report of foreign men with craggy faces, poorly seen. Anthropologically, dog-headed men have been variously identified as the hairy Ainu off the coast of Japan or—and here we come almost full-circle to a possible mermaid—to the sea lion.

In the desert, according to the Ethiopic *Gadla Hawaryat*,[18] a dog-headed man lived in the City of Cannibals. When God saw that his apostles, Andrew and Bartholomew, needed help in winning converts, he sent the Angel of God to surround the dog-headed man in a ring of fire and granted him both "the nature of the children of men" as well as the nature of the beast. The man, named Abominable, went to meet the apostles, at which point he grew four cubits in height. His face was even more doglike than ever, his eyes were like "lamps of fire," and he grew tusks, great hooked nails on his hands, claws on his feet, and hair like a lion. God removed

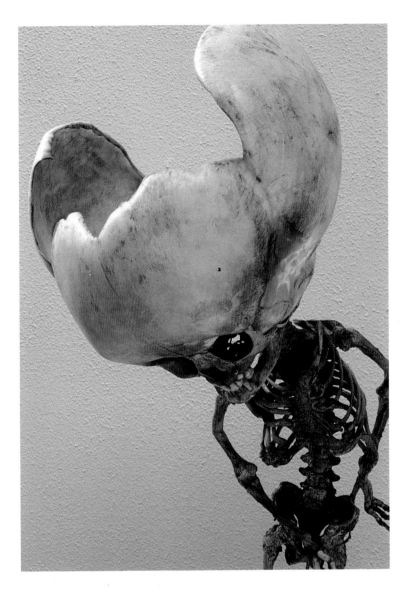

This cast of a skull of a man who suffered from Paget's disease feels like a rock to the touch and looks more like a head formed from lava than simulated human bone. The layers of abnormal accretion of bone mass so enlarged and blurred the man's features that the replica of his head resembles a crude carving of a toothless nonhuman carnivore. [Museo Cesare Taruffi, Istituto di Anatomia e Istologia Patologica, Università di Bologna; photo by author.]

the fear from the hearts of his apostles: the three went forth. Abominable attempted to win converts by fiercely slaughtering "seven hundred men and thirty nobles" of the city, his gentle nature returning when the townspeople had had enough and converted to Christianity. Thus, the twofold nature of Abominable served the cause of the apostles.

Pathological conditions in humans have been given the names of beasts—the lobster man,[19] the elephant man. The "lion-head" condition attributed to Paget's disease (named for its discoverer, Sir James Paget, in the mid-nineteenth century) renders the sufferer cold, deaf, blind, with a curvature of the spine, lack of balance, headaches, and a greatly thickened skull. The skull bones, growing out of control, form massive features, overwhelming the human sufferer with a heavy catlike appearance. According to the Old Norse historian Jesse Byock, Egil, a Viking warrior and a fine poet from the early tenth century, whose exhumed remains were examined and described in the early Middle Ages, showed remarkably clear signs of Paget's disease. By translating and analyzing the

crippled Egil's poetry, written as he sat freezing by the fire, Byock (both a literary and medical detective) seems to have discovered in the warrior's lament the nature of his affliction. Byock explains that "brow-plains" in the poem below may refer to headaches or to blindness.

> I flounder blind by the fireside,
> Ask females for mercy,
> Bitter the battle
> On my brow-plains.[20]

Even if a human skull did not specifically resemble that of a wild beast and had not been distorted by disease, experts in cranial morphology of the eighteenth and nineteenth centuries tried to locate the "bestial" instinct in the shape of the head. The degree of difference and the line of demarcation between human and beast depends a great deal on who is doing the measuring. Cesare Lombroso, an Italian physician of the late nineteenth century, believed, when holding the skull of a famous criminal, such as Vihella, that he could connect "the ferocious instincts of primitive humanity"[21] to an atavistic apelike face and body. Amoral, unscrupulous behavior, Lombroso reasoned, manifested itself physically, by changing the ordinarily refined features of a good man or woman into coarse and brutish ones. Lombroso's approach is reminiscent of Della Porta's studies of human physiognomy of the seventeenth century, which linked a person's visual appearance to a specific animal, so that, in character, the qualities of beasts discernible in personalities would be mirrored in the features of their human counterparts.

A collection of skulls belonging to insane patients of the early nineteenth century who died in the Madhouse of Sant' Orsula in Bologna are now

This shows a detail of a clean bisected skull with its simple label "Il Papa." The doctor, Domenico Gualandi, had cut the skull to determine the source of his patient's madness. [Museo Cesare Taruffi, Istituto di Anatomia e Istologia Patologica, Università di Bologna; photo by author.]

Casts of Peruvian skulls showing trepanning, shown at the World's Congress of Anthropology, Chicago, 1894. [Thomas Dent Mütter Museum, Philadelphia; photo by author.]

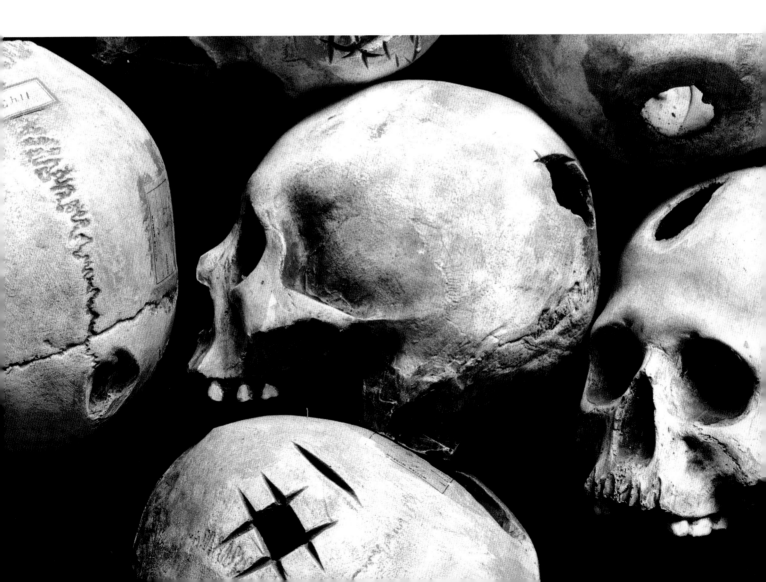

Hydrocephalic child whose enormous head
seems supernatural in scale. [From Frederik
Ruysch's Opera Omnia, 1720; courtesy of the
Getty Research Institute for the History of Art
and the Humanities, Santa Monica.]

housed in the Museo Cesare Taruffi. They demonstrate the manner in which two doctors from successive generations evaluated morphological signs of madness, since the careful data associated with each skull have also been preserved. An ideal candidate for this study was the skull of "Il Papa," a patient who led a noisy life in the madhouse, convinced to the end that he was the pope and the pope an imposter. The first doctor, Domenico Gualandi (1788-1861), director of the hospital, performed careful autopsy reports, accurately measuring every dimension of the skulls. In 1882, the second doctor, Giuseppe Peli, filed inaccurate autopsy reports and remeasured the skulls in a clumsy fashion. Both men were familiar with the "science" of phrenology, a descriptive system that held that personality traits could be found in different parts of the skull. The shape of the skull—with all its bumps, crevasses, and individual anomalous features—was to be read as a physical contour map of organic conditions indicative of character and talent. Phrenology, the invention of nineteenth-century quantifiers, reveals nothing about the nature of madness. The reading of skulls does, however, reveal the prejudice of late-nineteenth-century scientists, who, like the careless Peli and the presumptuous Lombroso, demonstrated marked racism in their results and an absolute bias against the insane and criminals.[22]

Dr. Josef Hyrtl, professor of anatomy in Vienna in the mid-nineteenth century, formed a huge private collection of injected placenta, genital organs, microscope slides, organs of the ear, and over 139 skulls, mostly from central Europe, an extraordinary anthropological collection, all of which he sold to

the Thomas Dent Mütter Museum in Philadelphia in 1874. Hyrtl believed that while the body developed according to the environment, the mind developed according to Divine Will, "therefore the relationship of the external and internal measurements of the skull to the intellectual development of the individual was totally random." His collection demonstrated the variety of cranial shapes within ethnic groups. On the side of each skull is written in ink the birth date, name, age, religion, occupation, and cause of death of the person. One can read between the inky lines, as it were, how each person lived and died, a biographical synopsis, often tragic. Mütter Museum director Gretchen Worden advises, however, that not all the data on the skulls matches the descriptions left by Hyrtl.

These stolen skulls (for such they were) came, in Hyrtl's words, from "semi-savage tribes of the Balkans and the Karpathiens"—the very lands of current strife between Bosnians, Serbs, Muslims and Croats, Russians and Russians—and from Czechoslovakia, Austria, Romania, Hungary, Italy, Egypt, Albania, Iran, and Armenia. Sixty-one of these people had died from trauma or disease, including gunshot and broken bones; sixteen committed suicide. Among the reasons given for suicide were unhappy love affairs, "weariness of life," "extreme poverty," and "discovered thefts." Eleven were executed, and cause of death of the remaining fifty-one is unknown. Means of death included potassium cyanide (twice), hanging (three times), throat cutting (one), and gunshot (one). One death came unintentionally, after a member of a fanatic religious sect (the Scopzis) cut off his own testicles. "Occupations include soldier, maidservant, sailor, painter, stone mason, cabin boy, herdsman, bandit, and prostitute. . . . Diseases include tuberculosis, typhus, pneumonia, diphtheria, puerperal fever, cancer and smallpox."[23]

This litany of the grimmest of fates did not lead Hyrtl to any grand conclusions about the nature of humanity. A true collector, his interest in the data lay in its descriptive rather than in its argumentative power. Unlike the sentimental texts taken from headstones in a New England cemetery of the seventeenth and eighteenth centuries, which also include family lineage, birth, death, age, and sometimes cause of death, these appropriated skulls lack any significant evocation of an after-life. The scientist provides no pious speculation on the brevity and sorrows of life. It was Anthropology, after all, not a true mourner who created these morbid haiku.

The skull of an immature person may be easily reshaped. Head-binding still occurs among some cultures today, resulting in various flattening and elongating distortions. An older skull may also bear traces of trepanning, a historical method of drilling into the skull to remove headaches and pressure on the brain that has been practiced in many

cultures. Unlike the anthropological practice of cutting into the skull after death to examine its shape, trepanning occurred while the person was still alive, and it left neat borings in the skull.

Trepanning leaves a visible scar, a sign of a person's suffering. Suffering does not always leave such evidence. The needles from the body of the insane woman (see "Collections," page 26) are another physical manifestation of obsessive anguish, but many who suffer madness or melancholia die without leaving tangible traces.

In 1709, as medical discussions were held at the Academie des Sciences in Paris, Bernard de Fontenelle wrote, "Even monsters are not to be neglected"—the debates covered, among other topics, the place of the soul in children born without brains and the extremely vivid imaginations that children of enormous heads must possess.[24] The fatal condition of anencephaly, in which a child is born without a brain stem, has left forlorn, froglike skulls in many museum collections. The second condition, hydrocephaly, allows the skull to fill repeatedly with fluid from the spinal column, fluid that seeps in between the skull and the brain and slowly pushes the skull outward until, without relief from a draining device, an enormous circumference is reached; the child—usually a child—dies with God knows what sound of rushing water in his or her ears. Infant skulls, not locked in by bone (as an adult skull would be), are malleable until the age of two, when the sutures finally close around a normal-size brain. If the brain case fills with fluid from birth, however, the skull will not close. Made thinner and thinner under the weight of the fluid, it will eventually either disintegrate or collapse.

A drawing from Frederik Ruysch's *Opera Omnia* shows an extreme case of hydrocephaly at an early age. The portrait of this otherworldly child is, for his book, a rare example of teratology, the study of monsters. Ruysch was not so much interested in anomalies as he was in the sentimental moralizing power of human and animal remains. In his pioneering work on techniques to preserve human parts after death, he chose to embalm and use parts of the body to show the perfection of God's work. Although he knew all too well about the nature of mortality, he wanted to show the promise of life. He might not have enjoyed the game of the "Exquisite Corpse" as the Surrealists would have played it, but he would, I think, have appreciated Andy Warhol's comment on the subject of death: "I'm so sorry to hear it. I just thought things were magic and that it would never happen."

The Laughing Fool has the blunt teeth of a herbivore and the sly self-deprecating gesture of one accustomed to both ridicule and self-ridicule. [Laughing Fool, c. 1500, oil on panel; courtesy of the Davis Museum and Cultural Center, Wellesley College, Museum Purchase.] ⟶

"The Giant rears His head against the Stars. Oh heaven, spare earth a scourge like this—unbearable to see, Unreachable by anything you say."
 —Virgil, *The Aeneid*[1]

"We consider as a monstrosity one who has a very large head and short legs and as a monstrosity also one who is in great poverty and has rich garments; we should therefore deem him well-proportioned in whom the parts are in harmony with the whole."
 —Leonardo da Vinci, on dwarfs[2]

Giants and Dwarfs

The French natural historian Buffon (see "Too Much . . ."), at the end of the eighteenth century, made a list of giants whose height was seven feet or taller and of "nains," or dwarfs, whose height was three feet or less. The word "nain" refers here to dwarf, midget, or pygmy, three distinct anatomical types. Buffon's real concern here was with setting the scale of absolute permissible height, and not with defining morphological or pathological differences. A dwarf is similar to a midget and an average pygmy only by the most superficial calculation, that of relative measurement from head to ground. Anatomically, a dwarf has a genetically inherited condition that, generally speaking, shortens the limbs and enlarges the head, while a midget is diminutive in size with normally proportioned limbs. A pygmy is, properly speaking, a member of a small-limbed race of people from Africa. Buffon calculated the appropriate weights of a man of average height as well as those of a dwarf and of a giant. Often a dwarf will have a heavy head and short, stocky limbs, and therefore weigh more, he declared, whereas a giant could be very thin. Having heard that an individual giant upon death and dissection was found to possess more than the average number of vertebrae, Buffon guessed, incorrectly, that perhaps a dwarf, being small, would have fewer vertebrae. He figured the average size of a man to be five feet, a giant to be seven feet, and a "nain" to be three feet, but he allowed for shorter dwarfs and taller giants. He was prepared to reset the figures at even greater extremes than he had actually witnessed to reflect the true "limits of Nature." He then conceded that a giant might measure as much as eight feet, a dwarf as little as two feet, with the ideal five-foot human standing firm. Buffon comforted himself with having permitted such extremes by saying that, after all, there are far greater intervals in size among some species of animals than between humans, be they giants or dwarfs: so, for example, a newborn, normal human child is bigger in relationship to a giant than an adult Maltese terrier is to an Irish wolfhound.[3] Giants and dwarves are equally substantial in reality and fiction. In almost subliminal ways they are interchangeable, the literary dwarfs and giants for the biological dwarfs and giants—we feel we know somehow of one because of the

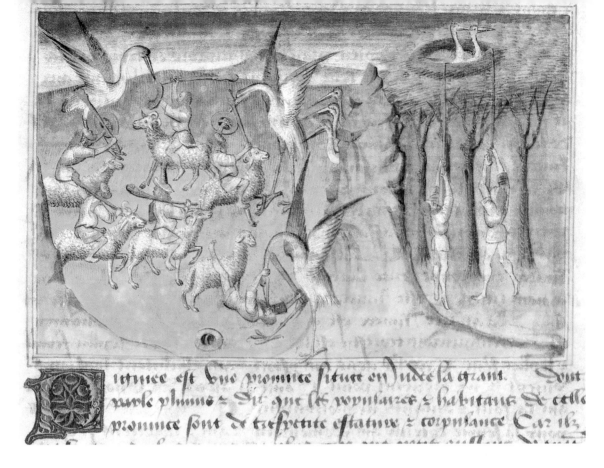

other. Real giants are rare and, except on the basketball court, almost invisible, while dwarfs, to average people, although more frequently encountered, also remain mysterious. We recognize many names: Tom Thumb, Toulouse-Lautrec, Grendel, Saturn, Aesop, Rumplestiltskin, Dopey, and less familiar but no lesser icons, Steinmetz (see Afterword) and Tomaini (see below). Atlas held up the world. The Colossos of Rhodes straddled a harbor. Gulliver was also a giant, but only in relation to the Lilliputians.

Races remarkable for uncommonly large or small statures—the Patagonians, the Masai, and the Pygmies—belong in this company only for the purpose of the eternal measuring game. Measurement of stature, of brain size, and—not the least—of cultural sophistication has been the territory, in the West, of the scientist, the statistician, and the racist.

> "the cranes fly noisily to the streams of the Ocean
> bringing death and destiny to the Pygmy men."
> —Homer, *The Iliad*[4]

The story that pygmies (first reported to live in Nubia), mounted on rams, staged an annual battle with long-legged cranes to win back the beautiful

"Pigmee. A province of India. The inhabitants are the size of four-year-old children and become old when they are seven. They are intelligent and brave. They have a feud with the cranes and storks and break eggs and nests. They ride on sheep." [Text translated from the illuminated manuscript Morgan 461, folio 61v; both detail of plate and text courtesy of the J. P. Morgan Library.]

pygmy maiden Gerana, stolen many years earlier by one of the birds, goes back to ancient times. Because of this famous ritual, along with their reputed bravery in war and their reportedly tiny stature, pygmies were carved in stone and described by early travelers in the Middle Ages as one of several of the rumored "monstrous races." While the *cynocephali,* or dog-headed men, may be actual animals originally mistaken for hybrid ones, and while other mythological beings may well have had teratological counterparts, of all the monstrous races, only the pygmies as a viable biological group—however reshaped by the words of travelers and philosophers—are real.

Aristotle attested to their existence: "It is not a tale, but plain truth, small people, just as it is said, both themselves and their horses."[5] Pygmies ride on neither rams nor horses, but Aristotle was not wrong about their size relative to Europeans. According to the medical historian Véronique Dasen, "pygmies have a short stature without any disorder of the skeleton. They are thin and muscular, with lighter skin color than their negroid neighbors, but similar facial characteristics. Their upper limbs are large in relationship to their size while the volume of their skull and the breadth of their hips are only mildly reduced. The persistence of these specific physical features suggests that pygmyism may be due to a genetic adaptation to the equatorial environment."[6]

The exact location of the pygmy territories, the nature of their apocryphal battle with the cranes, and their status as members of the human race were all widely debated subjects over several centuries. First, where did they live? And what did they do?

All early authors represented pygmies as forming their own nation. The geography, however, shifts around. The author who reported pygmies in the far north, said historian Leo Africanus in the sixteenth century, was mistaking them for Laplanders, who were merely "shorter than usual."[7] The ambassador to Emperor Justinian, in the sixth century, reports that he came upon pygmies "in the farthest of islands, and they had human shape and appearance except that they were very short in height, black and all hairy in their body." A second early Roman, Thevenotius, reported that he had seen little

black slaves from Nubia at the palace of the king of Abyssinia and sent as well as to the Turkish emperor, where, "castrated, they guard the royal concubines of the Harem." Described in another report, a "dwarf from Ethiopia, three spans tall, was sent as a gift to the Duke of Savoy, to be married to his daughter, by the King of Portugal." Was the small bridegroom a dwarf who was the product of a genetic mutation or was he a "dwarf" because he was a pygmy?

The tentative acceptance of the pygmy as human was based on theoretical arguments about the outer limits of the smallest size a human could be and still be considered human, the accumulated factual evidence about the group being so fractured as to resemble rumor. Although Aristotle granted pygmies existence as "small people," in a discussion of the embryological development of the fetus, he placed pygmies one stage after the ape and one stage before the perfectly formed human. Albert the Great, Aristotle's medieval commentator and author of *De Animalibus,* ranked the pygmy above the animals but below humankind. Medieval scholars debated at length the relative closeness of humans to the pygmy. The argument went like this: while pygmies had mastered speech, it was only through imitation, not through strength of intellect. As Nicole Oresme put it in the fourteenth century, "Though the pygmy seems to speak, he does not dispute from universals, but rather his words are directed to the particulars of which he speaks. Thus

the cause of his speech is as a shadow resulting from the sunset of reason." The humanlike behavior of the pygmies was only an imitation of humans, who are capable of abstract thoughts and of philosophical arguments. Oresme believed that pygmies also lacked modesty, reason, and art.[8]

Peter of Auvergne, the late-thirteenth-century author of "Whether Pygmies Be Men," in contrast to Oresme, felt that pygmies shared the form of humans, showed reverence at the rising of the sun, and art in their warfare. He pointed out that they sow seeds to rejuvenate nature. Some had heard them sing—as indeed they do today: "The pygmies of the Ituri forest, when misfortune befalls, say that the forest is in a bad mood and go to the trouble of singing to it all night to cheer it up, and that they then expect their affairs to prosper."[9]

In 1867, over four hundred years after Oresme, the Swiss naturalist Louis Agassiz used similar language to express his views on the inferiority of the black race (see "Conditions of the Skin"). And almost a century after Agassiz (and at the same institution, Harvard University), the anthropologist Carleton Coon wrote of the pygmies, "They do not count time; they simply respond to the practical needs of the moment, the way the lower organisms respond automatically to changes in the intensity of light."[10] Like Oresme, Coon added that pygmies had no religion.

The distant pygmies have provided fodder for centuries of high-minded speculation, while dwarfs, a more familiar presence in society, have historically provoked more of a utilitarian response: "How can we use this dwarf?" Aristotle thought that dwarfs, like children, sleep a great deal because their large upper bodies cool their food, inducing sleepiness, and that they have poor memories and intellectual strength because of the size of their heads. He said the genitals of dwarfs, like those of mules, are over-large, a feature that was well exploited in the cult of Priapis, god of fertility.

The Romans are famous for their use of freakish beings as targets for abuse. In Rome "the derision of the disabled was an everyday occurrence."[11] They forced the ritual of the scapegoat onto deformed, ill-favored people. The chosen victims were literally forced to assume the burden of their torturer's misery, and many public ritualized attacks on the deformed led to death. During the Roman Empire, at court and in many aristocratic households, not only were entertainers with physical and mental handicaps strongly favored for their qualities of monstrousness, bought and sold in specialized freak markets, but hunchbacks, dwarfs (often artificially assisted toward a deeply crippled, diminished state by confinement in cages when young), and cretins (a condition resulting in stunted growth and retardation) satisfied a great range of truly sadistic appetites of many of the elite class.

According to Robert Garland, on one occasion in ancient Rome an adulterous couple took the fondling of a "diminutive cretin" to perverse limits: first the woman, in full sight of her husband, fondled and kissed the slave, then she handed him to her lover to fondle, kiss, and pass back, and thus the monster became a messenger of illicit love passed from hand to hand. The distortion of the messenger and their titillating game amused the lovers very much; the reaction of the compliant tiny man is not known.[12]

The renowned dwarf Josef Boruwlaski (1739-1837), commonly called Count Boruwlaski, was raised and admired by companies of aristocratic and royal people throughout Europe for his entire life. Known for his good health (he lived to be ninety-eight years old), "sound judgment," "excellent

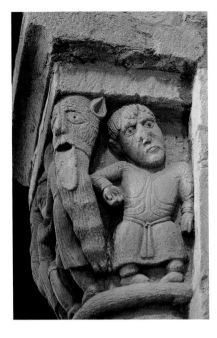

This dwarf on a Romanesque capital is located near the apse of the church deep in shadow. He has been carved in the company of discord; around the corner to his right two men pull on each others' beards in energetic wrath, while wrapping round the corner, a demon head with a long beard glowers in the direction of the congregation. [From the Church of Saint Peter, Anzy-le-Duc; photo by author.]

memory," "fiery eyes," "graceful manner," and "spirited repartee," he played music and made conversation in the court and in the drawing room. Although Boruwlaski was admired and respected, even supposedly polite people felt entitled to physically accost the dwarf whenever they chose. At times Boruwlaski was obliged to endure, in his own words, "cruel torments" when ladies would take him on their laps and "fondle him as if he were a prepubescent child."[13]

In a publicity stunt designed by the financialist J. P. Morgan's detractors, the midget Lia Graf, height two feet, three inches, sat on the lap of the millionaire at a public meeting before the U.S. Committee on Banking. Afterward, when asked how it felt to hold such a tiny woman, Morgan said, "unusual and somewhat unpleasant."[14]

A great many statues of small deformed persons were made in classical and Hellenistic times, some life-size and others small enough to hold in the hand. The ancient fashion for collecting repre-

sentations of the handicapped addressed both the impulse to have charms against the evil eye and the desire to fascinate one's visitors. In both Egypt and ancient Greece, in contrast to ancient Rome, dwarfs were treated with tolerance and respect. The Egyptians valued dwarfs highly, associating them with the Sun God, Ra, and retaining them as jewelers, attendants, and dancers. A dancing dwarf from the south gave great pleasure to the Pharaoh Pepy II, himself a dwarf. The dancing dwarf is represented widely in ivory, porcelain, and in tomb paintings. In a wall painting at Beni Hasan from the Middle Kingdom, a club-footed man and a hunchback accompany a dwarf. The historian Veronique Dasen identifies these dancing figures as pygmies rather than dwarfs, and writes that "the Egyptian draughtsmen used a common model to depict dwarfs, a model based upon the features of short-limbed people"; that is, the draughtsmen drew pygmies as if they were dwarfs.[15] Dasen points out several iconographic features in these Egyptian depictions of dwarfs, all reflecting an attitude of respectfulness rather than derision. Often clothing hides the deformity of lower limbs, and they all have "normal" rather than hideous or distorted facial features. They are shown as very short in proportion to the average Egyptian (34½-43 in.; 65-67 in.). The flatness of the skull in some figures may represent the divine aspect of human dwarfs. Ptah, a dwarf elevated to divine status, represented youth and old age at the same time.

In Greek art, by contrast, all pygmies and most dwarfs are depicted as achondroplastic dwarfs—a genetic mutation that occurs once in every 34,000

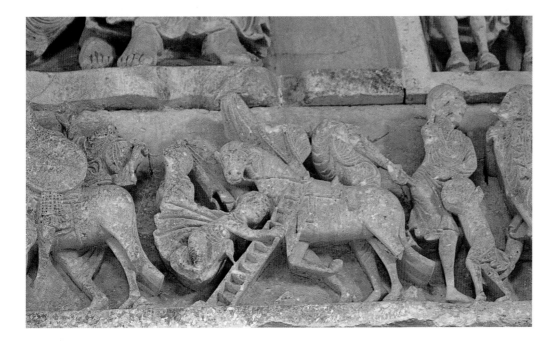

Even though the livestock of the Pygmies (in their incarnation as a monstrous race) were sometimes scaled down to be in proportion to their owners, here, in the carving at Vézelay, a Pygmy must use a ladder to climb onto his horse. The Pygmies are shown here beside two of the Sciritae, a noseless group. Of all the monstrous races only the Pygmies actually existed. [Detail of the tympanum of the Abbey Church of Mary Madeleine, Vézelay; photo by author.]

live births and causes disproportionately short limbs, a large head, bowed legs, and a prominent abdomen and buttocks. This inauthentic vision of the pygmy most likely came about because the Greeks had never seen pygmies, and so they used their conventional model for "short people," with which they were familiar. Dwarfs, and foreigners, in classical Greek art are often shown as bald with the exaggerated sex organs much favored by the Romans—an anatomical feature associated more with the satyrs of Dionysus than with actual clinical evidence. Female dwarfs are rarely depicted: "The notion of female deformity seems to have been more disturbing than that of male abnormality which was valued for its dionysiac connections."[16]

The twelfth-century dwarf on the capital in the church of Anzy-le-Duc seems constrained by the conventions of Romanesque sculpture; which style created an entire vocabulary/language of deformed bodies. Because the stone has pressed in against the dwarf's left arm, the wedging of the rest of his body between the demon head and the inside wall might appear at first as sculptural accommodation to the church capital rather than as a natural contortion of an already twisted human frame.

But why are the dwarf's feet turned in, his legs underneath the robe so obviously stocky, his torso long, and his arms so stiff? Even the right arm bent up at the elbow to brace itself against the demon's beard seems rigid. In fact, all of these are normal achondroplastic features, including the depressed nasal bridge and the short, broad fingers. If it seems strange to talk about

Gigantis Sceleton in monte Erice propè Drepanum inventum. Boccatio teste 200 cubitorum.

Homo Ordinarius Goliath Helvetus Gigas Gigas Mauritanicus

stiffened limbs in a stone figure, it is because this man's lack of alignment—his turned-in feet, squat hips, and especially his huge head—does not seem to be justified as much by the sculptural style as by singular biological conditions. The constraints of the dwarf's niche as an artistic device are easily accepted, but it is difficult to see how these constraints have molded this man. He looks like an actual person, braced against his own discomfort rather than forced against an artificial frame. Compressed energy and pain reflected in his turned-down mouth, and particularly in his eyes, convey an attitude of constant corporeal weariness: *sunt lacrimae rerum*—"these are the tears of things."[17]

If the biological dwarf—even in representation—conveys an impression of physical pain, the fictional Dwarf brings to mind the idealized group of hunchbacked miners plucking away in tunnels where most canaries would die—hi ho hi ho—or the stout warriors wielding battle-axes who hew stone caverns in mountains, a legacy of Tolkien.[18] Although both giants and dwarfs are, in some incarnations, associated with the underground, the dwarf can make himself both more accessible than the giant and less noticeable. A dwarf has a greater range of freedom than a giant. Light of foot, a dwarf can move along under cover, unperceived. He can travel great distances. Literary dwarfs show endurance, physical hardiness, and good metabolism, which, in fact, for a healthy achondroplastic dwarf, is also true. Though there are other small people in fantasy and fiction—elfs and hobbits, for instance—all they really share with dwarfs is size. The midget's literary ancestors, according to Susan Stewart, are the fairies—over hill and dale, sparkling in starlight.[19] The dwarf may stir up trouble and might come from demonic stock—the dwarf of legend and of the earth can occasionally wreak havoc, like Rumplestiltskin—while the miniature being, the fairy of the air, represents perfection.

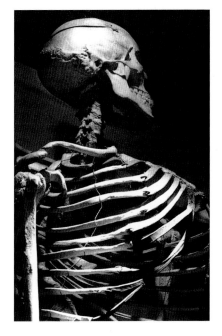

Skeleton of a seven-foot six-inch giant who died in his early twenties in the latter part of the nineteenth century. He suffered a curvature of the spine that caused his ribcage to bow out much like the ribcage of a bird. [Thomas Dent Mütter Museum, Philadelphia; photo by author.]

Fictional, biblical, rumored, and actual giants participated in this chart of relative statures published by Kircher. Probably some animal giants contributed to this assembly of tall men; bones from dinosaurs or large mammals were often mistakenly reclassified as human. [From Kircher's Mundus Subterraneus, Amsterdam, 1664; courtesy of the Getty Research Institute for the History of Art and the Humanities, Santa Monica.]

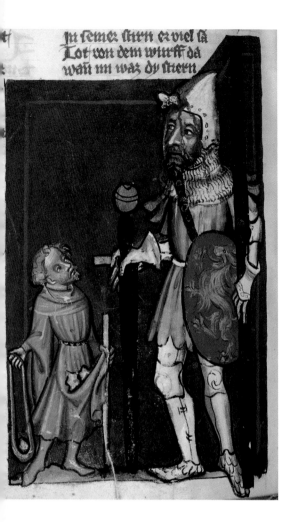

Ju ferner ftern er viel fa
Lot von dem wurff da
was in was dy ftern

David and Goliath assume a noncombative stance that allows the viewer to compare their relative size. [Detail from the illuminated manuscript Weldchronik, Ms. 33 (88.MP70), folio 164v; courtesy of the J. Paul Getty Museum.]

There may be a genuine physiological justification for locating giants in legend outside—in the landscape. Enclosed in legends, giants become vulnerable: in *The Odyssey,* the cyclops in his cave, although a voracious cannibal, is outwitted by Ulysses and his men. Giants, for all their mythical brute forcefulness, may in real life be internally frail. Alive, giants suffer the mental anguish of simply *not fitting in;* again, inside or into chairs, beds, rooms, houses, or into any environment designed for normal-size people. Giants suffer the physical anguish of diseases of the skin, spine, and lungs; they suffer wounds from unfelt abrasions, which may fester and even kill.[20] Emotional sensitivity to aggression may run deep.

"Guy Patin, a celebrated French surgeon, relates that in the seventeenth century, in order to gratify a whim of the Empress of Austria, all the giants and dwarfs in the Germanic empire were assembled at Vienna. As circumstances required that all should be housed in one extensive building, it was feared lest the imposing proportions of the giants should terrify the dwarfs; and means were taken to assure the latter of their perfect safety. But in confirmation of the proverb 'A dwarf threatens Hercules,' the result was very different to that contemplated. The dwarfs teased, insulted, and even robbed the giants to such an extent that the overgrown mortals, with tears in their eyes, complained of their stunted persecutors. As a consequence, sentinels had to be stationed in the building to protect the giants from the dwarfs."[21]

In the mid-seventeeth century, Athanasius Kircher published specific statistics on giants in his book *Mundus Subterraneus.* His chart of the relative size of Goliath, the giant reported by Boccaccio, and tiny *Homo* seems like a quaint prototype for the kind of growth chart made by many

proud American parents of their off-spring—usually with a pencil mark, often on the edge of a kitchen door. But the upright figures here, taken from the Bible and from archeology, and drawn so that the minute *Homo sapiens* will be visible in the line-up, seem deprived of their elemental setting of mountain peaks, caves, and canyons. Only one of them hangs on dutifully to a tree—to support his weight. Aren't giants usually concealed in, if not formed by, part of a landscape? And in their traditionally violent fashion, don't they hurl rocks, devour villagers, carouse, and lay waste? Aren't giants usually crouching, looming, towering, or sprawling as impedimenta of fallen body across the land? Giants as the Old Testament children of fallen angels have no moral compunction. In the statistician's chart, the giants have been driven from their hiding places and are standing still, up against the wall. A giant is a giant only in relation to his surroundings.[22]

The Nephilim, from Genesis 6:4, angels and the sons of God, became distracted from their duties and seduced terrestrial women, who then gave birth to extremely large sons—some, it is said elsewhere, three thousand cubits high. God cast these angels from heaven, and the deluge took care of their monstrous offspring. Races of giants come and go throughout the Old Testament. The

greatest survivor, Goliath, measured "four cubits and a span" (1 Samuel 17:4), which, depending on how the cubit is estimated, makes him either nine feet, nine inches high or eleven feet, five inches high, in either instance too large to qualify for Buffon's chart. Saul himself towered head and shoulders above all his people.

In the eighteenth century, the French philosopher Henrion attempted to show that according to the Bible human beings had decreased dramatically in size between the Creation and the beginning of the Christian era, ranging from Adam and Eve, who measured, respectively, 123 feet, 9 inches and 118 feet, 9 inches, "and nine lines"—without shoes—to Moses, who was a mere thirteen feet tall. The steady decrease in height finally subsided after many generations—which was a good thing, Henrion observed, otherwise he and his contemporaries would have been "mere atoms on the earth."[23]

Many nations have a tradition of early giants: the Greeks had the Titans, and colossal statues of their gods were placed in temples. The Trojan War featured some enormous soldiers, such as Termus of the *Aeneid* who hurled huge rocks at the enemy. Virgil speaks of how people in future times would marvel at the huge bones of Roman warriors now dead in civil wars. Legends

The skull of a pygmy hippopotamus from the Liberian forest beside the skull of a hippo from the Nile. In a sense, forests are islands, and over many generations, larger mammals isolated in a remote interior may develop into more diminutive forms. [Nationaal Natuurhistorisch Museum, Leiden; photo by author.]

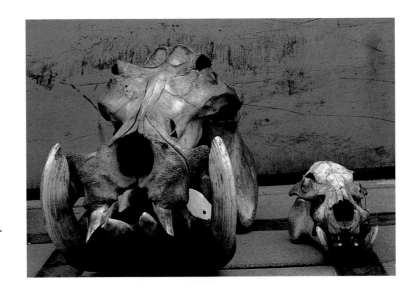

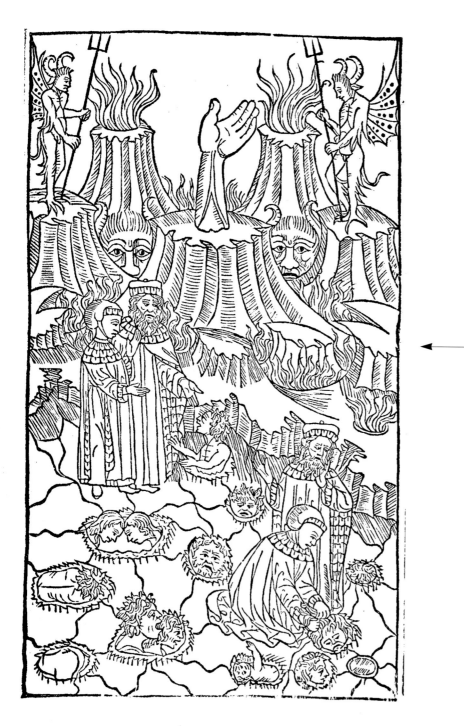

The disgraced giants and the political traitors trapped in ice from canto XXXII of Dante's *Inferno* [Brescia edition, 1487; courtesy of the Chapin Library, Clark Institute, Williams College.]

of huge men (rarely, if ever, women, except for Grendel's mother, or the mother of Gargantua) connected to the landscape have been perpetuated throughout the centuries: preserved in huge rock slides, rock formations, and the inevitable stash of bones (usually misinterpreted elephant bones or the fossil remains of dinosaurs). In ancient Greek tradition, Mount Etna on Sicily was the dwelling place of the giant cyclops Polyphemus, the classical personification of the fiery "one-eyed" volcano.

> "here was a piece of work, by god, a monster
> built like no mortal who ever supped on bread,
> no, like a shaggy peak—a man-mountain
> rearing head and shoulders over the world."[24]

Unless, as the spirit of the volcano, he moved, and the earth blew.

In the mid-fourteenth century in a cave near Mount Erice, Giovanni Boccaccio reported finding large bones, which he declared to be the remains of the race of Cyclops, a violent group of one-eyed cannibal giants.[25] Three hundred years later, Baron Georges Cuvier, in *Recherches sur les ossements fossiles des Quadropédes* (1824, "Research on the Fossil Bones of Quadrupeds"), proved conclusively that these particular bones were the remains of elephants. Indeed, historically, elephants were often transported through Sicily from Africa to train for the Roman circus, even crossing the Alps with Hannibal in 217 B.C. to fight against the Romans. Wherever animals and men go— especially in battle—bones will be left behind. Boccaccio, believing that he had found evidence of the race of "circle-eyed" giants, who supposedly grew to an absurd three hundred feet high, had, in fact, two good reasons for mistaking the skull of the elephant with the skull of a one-eyed giant.

First of all, a tuskless elephant skull is shaped rather like a shovel-fronted human skull, with a huge nasal cavity, which when taken down to the bone and viewed head-on looks very much like a large, single eye socket—very much like a cyclops. Secondly, *tres dentes monstruosae grandi* ("three enormous teeth") remained among the bones. These "teeth" were most likely the tusks of (at least) two individual elephants, and while tusks can be used for piercing and goring, they cannot be used for eating. They are not the incisors of a carnivore or even of a genuine cannibal. But because Boccaccio believed in an old tale of giant, lawless, one-eyed men, he could not assess the true nature of the elephant bones.[26]

It is not strange to find very small versions of large terrestial mammals on isolated islands. Biologists have determined that when animals live for tens of thousands of years on islands without interruption from the outside world, they radiate into unoccupied niches. Over time, birds and reptiles tend to grow larger while large mammals—like elephants—tend to grow smaller. The skull of a miniature extinct elephant from Sicily might measure only somewhat larger than the skull of a very large man. Elephants have been known to be small indeed. There is, in the Sedgwick Geology Museum at Cambridge University, a painting of a small pond in prehistoric times showing an elegant floating swan. On the edge of the water, measuring no higher than the top of the head of the swan, is a full-grown elephant.

The tortoises on the Galapagos Islands, the Komodo dragon (a lizard that can grow to ten feet), the giant salamander of Japan, Scheuchzer's *Homo diluvii*, and the extinct moa of New Zealand—a giant bird that measured twelve feet and up—are all examples of creatures given unchallenged time and

space to grow. The "pygmy" hippo, probably the mythological "Tzombe-tzombe"—the "cow yet not a cow" of Madagascar—descended from a full-size hippo. The huge, flightless aepyornis—the "Elephant Bird," "Ruhk," or "Roc" in early travel accounts, especially those of Marco Polo—was called the bird who "carries off an elephant as a hawk flies off with a mouse."[27] The aepyornis occupied a niche left vacant by larger mammals.

At the beginning of the fourteenth century, Marco Polo wrote, "It is in the China sea that Ibn Batuta beheld the *ruhk*, first like a mountain in the sea where no mountain should be and then, 'when the sun rose' says he, 'we saw the mountain aloft in the air and the clear sky between it and the sea. We were in astonishment at this and I observed that the sailors were weeping and bidding each other adieu, so I called out, "What is the matter?" They replied, "What we took for a mountain is the *Ruhk*. If it sees us it will send us to destruction." Fortunately God was merciful and the bird—a ship under sail suspended above the horizon by illusionary refraction of the light, ten miles distant, eventually disappeared.'"[28]

*I*n literature punishment against even elemental forces may be exacted. Dante's lowest circle of hell features giants in deep trouble. Enormous, earthy, arrogant, and powerful beings of incredible carnal strength, they now lie bound and helpless. Nimrod, the first responsible for creating many languages and thereby discord among people, speaks unintelligibly. "His face appeared to have the length and breadth of the Saint Peter's pine cone in Rome."[29] Another, Ephialtes, had challenged Jove when the giants fought against the gods. A third, the bully Antaeus, bested by Hercules in the battle against the gods, now lifts Dante and his companion, Virgil, lightly in his hand and sets them down before a pit of ice. These giants are chained outside the pit. As bodyguards of the devil, they watch over the traitors frozen in the ice, and like these sinners, the giants are part of hell's landscape, bound to it and appearing to grow from it, like "the towers of Montereggione."[30]

Treachery was, to Dante, the worst sin of all, and so he placed all who were guilty of this benumbing heartlessness in the lowest depths, into an ice pit, where the heads and bodies of sinners lie frozen, fanned by Satan's wings.

Bocca, whose treason almost brought disaster to his own city of Florence, lies frozen here, and Dante grabs his hair in fury.

In the Chinese province of Fukien, as reported by Kircher on his book on travels in China, the god Fe is the benign king of the Mountain. Kircher wrote that while historians claimed this stone "idol" was built by man to qualify as a "wonder of the world," he believed the shape of the giant to be naturally present in the rocks—just as, he says, a coin with the likeness of Julius Caesar appears large in the cliffs in Sicily, and an alignment of peaks near this very idol mirrors the Big Dipper, Ursa Major, as if the configuration of these stars had determined the actual distribution of the peaks. The statue, "not strange but mountainous," rises from the mountain peak, arms crossed upon its breast. The figure may be seen from a great distance of "two or more milestones." The text does not mention the clearly visible second head on the side of the mountain, which may reflect the human tendency to see faces in inanimate forms as much as it may actually represent a second "idol." The head of the stone giant alone would be large enough, wrote Kircher, for both a city and a lake to hold water for that city. Even though he is made of stone, this god seems to generate growth. High on his head, above any "tree-line," trees grow in a sturdy group and function as a kingly crown.[31]

As the scholar Susan Stewart has said, "The giant of natural forces . . . is the giant in Blake's prophetic books (the

Idolum FE in Monte expressum.

Stone idol in Fukien, China. While dwarfs appear as social beings, anomalous measuring tapes, and artistic artifacts, giants are often equated with the immensity of nature. Two giant heads appear on this mountain although only one is described in the text. [From Athanasius Kircher, *Toneel van China* (Monuments of China), Amsterdam, 1667; courtesy of the Getty Research Institute for the History of Art and the Humanities, Santa Monica.]

giant without constraints—prolific and producer) and the giants of Goya (both creator and destroyer). . . . The giant is frequently seen as a devourer and even, in the case of the Cyclops, as a cannibal. In Esquimo and other North American Indian mythologies, the giants may be either human, animal or bird in form; usually they are males and they are almost always cannibalistically inclined."[32]

One of the most robust and obscene of fictional giant families comes from *Gargantua and Pantagruel* by the French writer and physician Francois Rabelais (1490-1553). These books are boisterous chronicles of an age when laughter was meant to be so important. The characters exhibit enormous appetites—gorging on wine and food and games and books and life—in an exaggerated fullness. All manner of intestinal activity is central to joy (and misery). These giants living in our midst convey boundless joy at being alive and revel in their—usually out of control—appetites. Rabelais uses his immoderate protagonists to reflect the carnival spirit of the end of the fifteenth century. Uncivilized in the midst of "civilization," Gargantua expresses all society's excesses and exposes all its hypocrisy. Both Gargantua and his son, Pantagruel, are accommodating giants: huge when the plot requires immensity and of human scale when they are among people. Even though they live at the heart of society and embody all its ideals, they represent the end-game of social excess.

Often when anomalous humans are put on display they come with fabricated exotic histories, so that their origins as much as their freakishness will inspire befuddled wonderment. Hucksters and promoters "keep alive" many half-remembered myths and fragments of information about uncivilized and untamed ancestors who come from rugged landscapes and unknowable terrain.

But not every show person relied on fiction. For instance, Tomaini, a real-life giant who appeared before the public professionally, was also an expert promoter. He and his legless wife produced a pamphlet of their story called "A History of Glands," which anticipated the questions—"all you care to know"— an inquiring public might ask of such an odd couple.[33] He sold souvenir rings so that the crowd might have proof of what they'd seen. When Czar Alexis actually held a salamander (a creature he had thought only existed in mythology), he could assure the folks back home that this animal did exist. If holding a salamander or having a souvenir ring is out of the question, the spectator has only to look up to a giant or down at a salamander, look long and hard, and commit the wonder to memory.

Painting by Lam Qua of the patient Wang Ke King for Dr. Peter Parker. The patient, the son of a tea broker in Canton, suffered from an enormous congenital tumor. He died at a young age after refusing an operation. His wives would not allow an autopsy. [Courtesy of Yale University, Harvey Cushing/John Hay Whitney Medical Library.] ⟶

"They're five or six kinds of black. Some silky, some wooly. Some just empty. Some like fingers. And it don't stay still. It moves and changes from one black to another."
—Toni Morrison, *The Song of Solomon*[1]

Conditions of the Skin

From white to albino to piebald to black, the color—let alone diseased condition—of skin provokes fascination, disgust, xenophobia, and personal despair. Skin—so thin—is the first thing you present to a world full of prejudice. Leo Africanus, a sixteenth-century historian of northern Africa, expressed a cosmopolitan and measured attitude in his acceptance of all forms of people. He wrote that "Nature walks in one same way but different conditions produce different people: black, white, brown. As Tacitus said about the Germans: 'in every house naked and filthy they grow into these limbs, these bodies that we are astonished at.' And who nowadays finds the bodies of Germans to be so unusual?"[2] Skin color differences between, and within, racial types are too varied and subtle to be designated hues, yet in the past we used "yellow," "red," "white," "black" as simplifying labels for these elusive chromatic effects. Shortly after World War II, the anthropologist Dr. A. Leib did a survey of the cultural attitudes of the people of Madagascar toward various colors.[3] While not particularly conscious of primary colors, the Malagasy, Leib said, showed great sensitivity toward subtle tonal values. "The color of a dead grass-hopper" referred to a sick person, "red that has red over it" meant a powerful man working for one still more powerful. Of the recent world war, the Malagasy said, "I hate the dark. I hate the black!" and "Man is like a black bottle, one can not see inside." Although the quality of blackness was associated with suspicion, theft, and guilt, in Madagascar the traditional color of mourning is white, and the term "black soot" referred to an honorable person of long patriotic service. The "black soot" meant that the person used his chimney fire very often, that he stayed loyally at home. Not quite clean laundry became the white of "pounded red rice color," but if a man sent a white cock to his wife, he was politely informing her that he had taken an additional wife, which in northern rural regions of the country remains the practice. Much is bound up in the Malagasy system of metaphysical association with colors, while European and American perception of color, especially color of the skin, runs along optical and emotional rather than along mystical lines. The nasty tendrils of racism and prejudice insinuate themselves into almost every story

in this chapter. Diseases of the skin appear in the second part of the chapter. The first part follows a chromatic progression from white to black, starting with the albino and ending with the doomed Tasmanians.

"Animals not far remote from ordinary form prepare the transition from light to darkness. Next follow those constructed for twilight and last of all those destined for total darkness."[4] In albinism skin, hair and eyes are deprived of pigment, leaving the body susceptible to sunburn and the eyes to blindness. In creatures where albinism is a natural adaptation to the environment rather than an inherited affliction, even vision becomes unnecessary. Certain albino creatures, rarely if ever seen, live in deep underground caves in total darkness. These mostly aquatic creatures—fish, reptiles, spiders, and insects—have, over tens of thousands of years, lost the need both for pigmentation and for vision. They no longer need protection from the sun, and in the darkness they need only olfactory and auditory "markers."

The value of having "white" skin from a European imperialist standpoint cannot be overestimated. British, French, Spanish, Dutch, and American explorers, missionaries, colonizers, and conquerors have all at one time or another recorded their impressions that darker skinned people were somehow lacking in intellect and moral judgment. Natives of invaded territories were, traditionally,

The Albino Musical Family, from a print by Currier & Ives. [Private collection.]

according to the European and North American code of entitlement, often in need of cultural and spiritual redemption. In the hearts of European missionaries, natural fairness moved one closer to heaven. The painting entitled *Un Padre Nuestro y Ave Maria par las Almas* shows a nineteenth-century colonial view of purgatory. Five Indians and seven white men and women are depicted in the painting. A single native female has made it to the top rung of the hopefuls. The remaining ruddy-skinned Indians, with straight hair held back by head bands and with one hand folded over the other in prayer, gaze upward hopefully from the lowest level. They are farthest from the heavenly host. After the crusades, Ethiopians moved from the status of a monstrous race by virtue of their conversion to Christianity. In isolated cases, Europeans overlooked the darkness of their skins in favor of the lily-white purity of their souls.

A pale skin, even if the pallor signified an inherited anomalous condition, met with European favor. In a detail of the large painting of the natural history of the kingdom of Peru, 1799, by Oleo de Thibeault, in the Museo Nacional de Ciencias Naturales, Madrid, are two native Indians, each

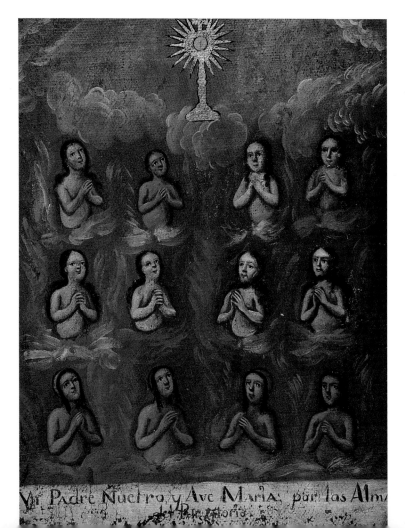

Un Padre Nuestro y Ave Maria par las Almas (or Las Almas del Purgatorio, "The souls in Purgatory") instructs viewers that diligent prayer will help los Morenos (the dark-skinned) to rise closer to the cross of Salvation. An elaborate castas system prevailed in seventeenth- and eighteenth-century Mexico, in which various permutations of intermarriage between Spanish peninsulares (Spanish born) and criollos (Americans of Spanish ancestry), Indians, and zambas (West Africans) yielded white, black, or mulatto offspring. Many beautiful family portraits of racially mixed consanguineous parents and children appeared in the eighteenth century, with elaborate hierarchical implications for each group. Throwback progeny, often black, were occasionally born to white parents, revealing ancestral blood not visually apparent in either mother or father. [Oil on canvas; private collection.]

These members of two of the tribes native to Brazil are just two panels from a multipaneled painting of the inhabitants, birds, animals, and fish of Peru. [Quadro de Historia Natural, Civil y Geografico del Reyno del Peru, año de 1799 **by Oleo de Thibeault; Museo Nacional de Ciencias Naturales, Madrid; photo by author.**] ➤

described in text below each portrait. One can see, on the right, a "female Carapacho Indian of the Pachitea region. The marvelous tribe is known for its white skin, similar in color to that of albinos whom the Conte[sic] de Buffon met in the provence of Panama. . . ." This desirable whiteness had an anomalous biological basis: the San Blas Indians who live off the coast of Panama have a high incidence of albinism. The darker native in the left panel of the painting comes from the Yapura River and is identified as a cannibal. The text expresses disapproval for this tribe's custom of eating their enemies and stringing enemy hearts around their necks.[5]

Prejudice based on skin color is not exclusive to the white race. For many native peoples of darker skin, white skin may seem thoroughly repellent—pale, scentless, nasty. Albinism, when it occurred among brown-skinned Malaysians in past centuries, seemed a terrible curse. Children born during a lunar eclipse were said to risk suffering from albinism. In Malaysia, albinos were "cockroaches": "They are nearly as white as a Dutchman, although to someone else it is a hideous faded color or a deathly pallor especially when one sees it from up close. They have very yellow, as if singed hair; many large freckles on their hair and countenance, and have a scaly, rough, and wrinkled skin. By day they are purblind, nay, they are almost half-blind, so that their eyes seem to be almost closed, leering constantly, but they can see very well at night. They also have gray, where other natives have black eyes, and though also born from black parents, they are despised by their own Nation more than other natives, and also considered hideous by them. I have known a King of Hitu and his brother, who were cockroaches, [though] they had several black Brothers and Sisters, and had themselves black children, and [have seen] others of the female sex, but not many. One will also find such people in the Realm of Lovango, in Africa, and other places."[6]

The lens of literature can sometimes magnify an anomalous condition in a way that medical pedantry cannot. The aberrant albinism of Moby Dick, the elusive whale, nemesis of the vengeful Ahab, allows the author to release a flood of poetic and philosophical associations about whiteness. The author's decision to deprive the whale of color turns him into a *tabula rasa,* a creature upon whom many ideas or thoughts may be projected, as on a screen. The choice of generalized "whiteness" magnifies the madness of the hunter while preserving the mysterious quality of his prey. Not unlike the disembodied leg in Jim Hawkins's dream in *Treasure Island* (see "Too Much"), the whale keeps moving, out of reach, beyond definition, and for all that's said and thought about him, he is never clearly seen.

"Albinism is well-known among most or all dark-skinned races and species; albino blacks, paler than Caucasian, are not rare, and the trait is inherited in family lines."[7] In the mid-eighteenth century, the scientist Pierre-Louis

Mary Sabina as depicted in Buffon's *Histoire Naturelle*, Paris, 1778. [Private collection; photo by author.]

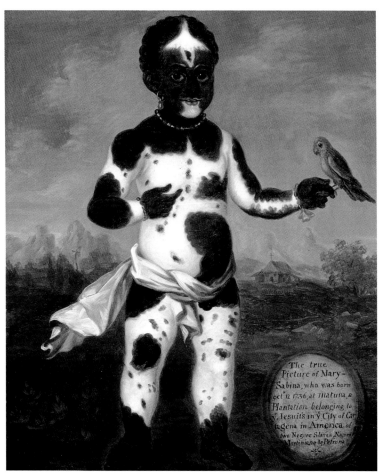

Portrait of Mary Sabina by unknown British artist, 1740–45. [Courtesy of the Colonial Williamsburg Foundation, Virginia.]

Maupertuis, who had already concluded that parents contributed equally to the development of an embryo (see "Embryology"), decided to trace unusual physical traits through family descendents. He found evidence of polydactyly (extra fingers) in three generations of a German family, and with further research he determined that anomalous conditions and features could be inherited from both male and female sides of the family. After seeing an albino child of black parents on display in Paris, Maupertuis wrote a paper "inspired by the white Negroe," in which, in part, he argued that albinism had been traced through family lines in Senegal, and that it could be inherited through either parent.

Although Maupertuis had made an important discovery by taking the burden of exclusive inheritance away from one parent, his conclusion did not keep him from perpetuating white racial superiority. In his paper on the white negro he said that the white race expelled from temperate climates all who had not belonged there. (He also believed that albinism and polydactylism were as much a sign of a monster as conjoined twins.) As Stephen Jay Gould has said, progress in understanding new frontiers does not proceed at an even pace on all fronts.[8]

Along with Lionel (see "Next of Kin"), John Merrick (see "Embryology"), and Ritta/Cristina (see "Too Much"), the Albino Family of New York parlayed their affliction into a living, creating a musical talent show with Hungarian overtones. Their audience was not interested in the clinical details of the family's affliction, the photophobia, or the associated astigmatisms. They came to witness a spectacle. They could see how the condition had been passed to the children; the family as a unit must have evoked the same response as a litter of albinos, in festival clothes.

Albinism need not be total. It's not so rare to find a person with both dark and light skin, although the dramatic piebald appearance of Mary Sabina, born October 12, 1736, who appears in two portraits, must qualify as one of the more sensational distributions of black and white patches of flesh in the history of this always striking phenomenon. In his *Histoire Naturelle*, Buffon carefully describes Mary Sabina, the "Piebald Black Child," whose portrait was sent to him by a friend, as the daughter of a dark negro and a "whitish" negresse. Buffon wrote that the piebald condition did not come about as the result of the union of a whitish mother and a black father, but that it was a congenital condition, independent of the color of the parents. He argued with his friend, who had a theory that a child from light and dark parents might be, as a puppy or kitten from a litter of dark and white siblings, piebald. Buffon was curious, above all, to know whether this child had hair or wool on the white part of her skin. (She had hair.)

The engravings in Buffon's *Histoire Naturelle* show his often anomalous subjects—conjoined adult twins, an albino negress, Mary Sabina—in contrived environments: an examining room or, more frequently, a Paris bedroom. The rooms often look as if they have been hastily arranged in artful ways with birds, books, drapery, fruit, a ship's anchor, and exotic baskets. In the case of Buffon's New World or African subjects, the props chosen by the artist resemble recently acquired museum objects: spoils from Brazil or Hawaii on display to give a more naturalistic feeling to the portrait of the captured subject. Mary Sabina is shown here with New World trappings in a European-style portrait—nude to show her anomalous clinical condition—caught between worlds, neither black nor white.

This same charming girl, with her very distinctive markings, appears in an original color portrait by an anonymous painter, upon which Buffon's drawing was surely based. Mary Sabina was born in Matuna, a plantation belonging to the Jesuits in Cartagena, on the Caribbean coast of Colombia. Here she stands in her own tropical setting, an exotic creature on display. The painter conveys the unaffected alertness of the girl's character along with her strangely theatrical affliction. The white birdlike shape between her brows looks like a dove, a bird of peace. On her outstretched left hand she holds a Carolina parakeet (species now extinct). Its soft green and yellow feathers and the red cap on its head represent the lush natural environment of the plantation. In the background are the volcanic peaks and houses of the tropical island. Modestly draped with a loosely tied cloth and adorned with bright beads, necklace, bracelet, and earrings, the impression is that of a cherished child in her natural environment.

In 1813, Dr. William Charles Wells gave a paper before the Royal Society in London: *Account of a female of the white race of mankind, parts of whose skin resembles that of a negro, with some observations on the causes of differences in color and form between the white and negro races of men.* His patient, Hannah West, had a black hand, arm, and shoulder while the rest of her was as pale as all her family. Wells did not invoke the traditional excuse of maternal imprinting—in this particular case, that Hannah's mother, before her daughter was born, had stepped on and been frightened by a lobster. Rather, he examined the melanism and noted that it was "darker than the corresponding part in any negro whom I have seen."[9] Wells discredited the possibility that Hannah's condition reflected hidden black inheritance by adding to the assessment of her dark limb that "the palm of her hand and inside of her fingers are black whereas these parts in a negro are only of a tawny hue." Dr. Wells stopped at a simple description of Hannah West's affliction, but he did go on to speculate on the nature of the effect of natural selection, saying that African skin, perhaps originally light, might over time have become better suited for life in Africa with steady darkening, a thought that anticipated by several decades Darwin's theory of adaptation to the environment by all living organisms.[10] Wells recorded his observations without any evidence of emotion-connected racial bias.

A number of wax heads show miserable conditions of the skin. This boy suffered from "leprosy of Commacio," named for the region from which he came. Because it is a slow-acting disease, leprosy has the ability to gradually infect many people within the same community. According to Jared Diamond, the first recorded case of leprosy occurred around 200 A.D. [Museo Cesare Taruffi, Istituto di Anatomia e Istologia Patologica, Università di Bologna; photo by author.] ⟶

This late-nineteenth-century wax model of a child with syphilis, syphilitic leucoplagia, shows the effects of the disease on the tongue. Syphilis was first recorded in Europe in 1495. [Thomas Dent Mütter Museum, Philadelphia; photo by author.]

*I*n 1920, Hugh Lofting published *Doctor Doolittle,* the first in a series of popular children's books about a modest English doctor remarkable for his ability to understand and speak the languages of the animals. The original edition includes the unexpurgated version of the story of Prince Bumpo, a gullible African prince who wanted desperately to be changed into a white man so he could marry a beautiful princess. Doctor Doolittle, in Africa along with several of his animal friends, had been imprisoned by Bumpo's despotic, bad-tempered father. To win his freedom, Dr. Doolittle struck a bargain with the prince for their release in exchange for a wonderful new white skin. The doctor—a good man, we are told many times over—concocts a temporary potion, fools the prince, and flees before the dye wears off. The tale, although relatively benign for its time, is in the long tradition of using humor to belittle and trick characters of darker skin. In 1990, a new edition of *Doctor Doolittle* appeared in which the publisher decided to delete the racially biased text, rather than risk losing library sales, by reworking the chapter. The clumsy rewriting fails to capture the clever but callous literary nuances of the original. History has been revised—whitewashed.

Louis Agassiz, the Swiss naturalist who immigrated to the United States in the 1840s, never managed to overcome his feelings of revulsion toward the negro race, remaining both deeply fearful of mixed sexual unions and convinced that black people belonged to a separate species, which he said was "by nature . . . submissive, obsequious and imitative." Here, as described in a letter to his mother in 1846, he is being served in a hotel in Philadelphia by a black waiter: "Nevertheless I experienced pity at the sight of this degraded and degenerate race, and their lot inspired compassion in me in thinking that they are really men. Nonetheless it is impossible for me to repress the feeling that they are not of the same blood as us. In seeing their black faces with their thick lips and grimacing teeth, the wool on their heads, their bent knees, their elongated hands, their large curved nails, and especially the livid color of the palms of their hands, I could not take my eyes off their face in order to tell them to stay far away. And when they advanced that hideous hand towards my plate in order to serve me, I wished I were able to depart to eat a piece of bread elsewhere, rather than dine with such service.

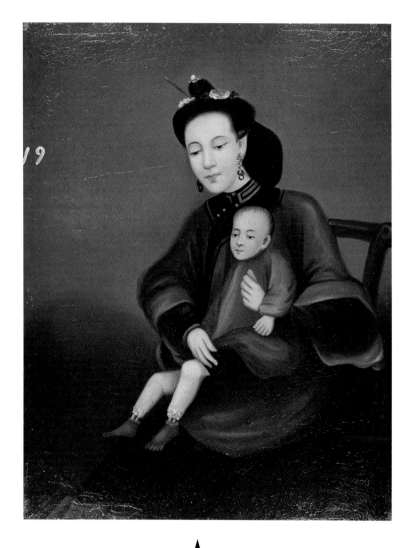

Painting by Lam Qua of a mother holding a
child afflicted with gangrene of the lower
legs. [Courtesy of Yale University, the Harvey
Cushing/John Hay Whitney Medical Library.]

What unhappiness for the white race—
to have tied their existence so closely
with the negroes in certain countries!
God preserve us from such a contact!"[11]

While Wells, the man who suggested
the theory of natural selection to the
Royal Society years before Darwin,
spoke of the simple blackness of Hannah
West's palm, Louis Agassiz, the man
who resisted the notion of evolution
long past rational resistance—so afraid
was he of challenging God's Divine plan,
which included, by inference, the natu-
ral superiority of the white race—was
undone by black skin, woolly hair, and a
"livid palm."

Outspoken sentiment against races of
dark-skinned people was frequent dur-
ing the time of Agassiz among men who
should have known better. For instance,
Anthony Trollope, the Victorian novel-
ist, stated simply, "of the Australian black
man we may certainly say that he has to
go. That he should perish without un-
necessary suffering should be the aim of
all who are concerned in the matter."[12]
While the Australian aborigines have
not yet been decimated, the native Tas-
manian people were all eventually killed.
Incentives for extinguishing the Tas-
manians included "black catching," or their
live capture in exchange for a bounty.

The color of skin is one thing. The fes-
tering of skin quite another. As a culture,
we have become accustomed to the hor-
ror of the slightest blemish. Acne, shin-
gles, herpes, warts, boils, and melanoma
fill us with worry, apprehension, and
revulsion. The epidermis, that thinnest

layer between the person and the world, can bear tell-tale signs of excess, bad fortune, and perversion. But how many today recognize the signature of leprosy, small pox, and syphilis?

The infection associated with leprosy may flare up, heal, and arise again. This disease, which incubates slowly, produces terrible lumps and lesions, a voice made hoarse by rashes in the throat, blindness, and mutilated limbs. Most frighteningly, all sensation of pain may vanish so that the afflicted cannot feel burns, abrasions, or broken limbs. Incurable until the late 1940s, evidence of the infection goes back to Roman remains, and colonies of lepers existed in Finland, Hawaii, and Crete until the twentieth century. In medieval England there were two hundred leper houses, although it is not clear how many lepers actually occupied them. The church built these leper hospitals to contain the disease and catch souls for God. With its twofold purpose, the well-endowed hospitals attracted charitable contributions from benefactors hoping for spiritual salvation for themselves.

The stigma of disease evokes the same prejudice as the stigma of color, of race, of behavior. As a disease, leprosy is slow-moving and not highly infectious. Treated as pariahs, lepers shook clappers as they passed by; they were isolated and feared. In his novel *The Name of the Rose,* Umberto Eco writes of "rags, stuck to groaning wounds." The lepers were, he writes, "misshapen, their flesh decaying and all whitish, hobbling on their crutches, with swollen eyelids, bleeding eyes. They didn't speak or shout; they twittered, like mice."[13] Suffering drains away humanity. As time went by, partially as a result of episodes of bubonic plague, the numbers of lepers declined. Eventually mad women and men were sent to live in the "lazar" houses, named for and dedicated to Lazarus, and left empty by the lepers.

Many have had tumors, lesions, and boils, but who among us has had a *bubo,* the dreadful boil associated with the bubonic plague? Abbot Gaetano Zumbo (1656-1701) became well acquainted with the horror of this disease, having lived through epidemics in Naples and Milan that decimated the population and left in its wake festering piles of cadavers. Zumbo, a sculptor with an urgent artistic message, recreated the horror in wax; the Catholic Church in Italy had a long tradition of using wax representation of parts of the body as ex-voto offerings. This tradition began in the thirteenth century and culminated in the religious fervour expressed in the life-size portrait figures of Santissima Annunziata in Florence (see "Collections").

As a medium, wax has a translucent, silky quality that in the hands of the master artist both imitates and elevates the splendor and, in this case, the misery of human flesh. Zumbo made perfect miniature replicas in wax of scenes from the plague. It is the flea who bites an infected rat before it moves on to bite a human that causes infection, and Zumbo has, here and there among the accurately represented dead, dying, and decaying people, included rats, one rubbing up against a decomposed skeletal arm and another walking across the bloated, gray belly of a corpse. Zumbo's mastery of physical anatomy along with the tragic spiritual intensity of his plague tableaux single-handedly changed the use of wax from a votive medium to wax as a medium of art—capable of astounding anatomical realism.

Michel Lemire, the French expert of wax anatomies (see "Collections"), explains that while Zumbo worked in the tradition of the artisans of small religious tableaux, he developed an entirely new style in his accurate portrayals of the natural processes of decay.[14] Encouraged in his efforts by his amoral, "decidedly sinister" patron Cosimo III to express all phases of mortal putrefaction of the skin just after death, Zumbo found, fortunately, the financial support to continue his work, expressing the torments of the flesh and the horror of death without the

least signal of heavenly redemption—except for one winged figure of Father Time, placed in the foreground of one of the tableaux "in triumph." Zumbo's obsession moved the representation of human anatomy into the realm of medicine.

Just around 1490 in northern Italy there was a great surge of interest in human anatomy, both in research and in public dissections.[15] Many highly realistic wax models of skin diseases, made in the tradition of early religious wax making, were used by doctors as teaching models so that students learned to recognize the afflictions they would encounter in their patients. The art of making wax models of clinical studies of dermatological conditions flourished, particularly during the eighteenth and nineteenth centuries. In many northern European anatomical collections, one can still find wax replicas of patients suffering from various diseases: syphilis, pellagra, leprosy, eye disease. The desire to link a specific person with a general affliction, to memorialize a remarkable pathological condition, as well as to produce mythical figures of moralizing power, like Adam and Eve, produced some extremely fine portraiture as well as persuasive teaching "texts."

In the early 1830s, the American Reverend Dr. Peter Parker opened a hospital for ophthalmology in Canton, China, near the American factory district. Thousands of Chinese citizens came from near and far, in desperate need of medical attention. Many who suffered from eye diseases, including cataracts, which were treated by Parker with great success. His patients worshiped him, though he would have preferred their conversion to Christianity over all their personal gratitude. Of him, his patients said, "Canton hasn't got no such pigeon." As his reputation grew, so did the range of diseases he treated. Patients with tremendous tumors came to him. He treated sarcoma, elephantiasis, and leprosy.

In gratitude, Lam Qua, an uncle of one of Parker's star students, offered to paint the hospital's patients. Lam Qua had learned to paint portraits in both English and Chinese fashion. His style was both elegant and realistic,

so that, as the writer and artist Peter Josyph says, "The faces of his subjects are quite serene with rarely a hint of pain, shame or discomfort of any kind. But their malformations are rendered with an unblinking clarity and directness which, in the context of such stillness of human spirit, conveys a sense that it is an aberrant force of element Nature, and not the patient out of which these repulsive grotesques are blooming."[16]

In a portrait of Wang Ke King, the subject calmly displays a gigantic tumor, which measured 4 feet, 3½ inches and weighed sixty to one hundred pounds. Although Dr. Parker offered to remove the tumor, Wang Ke King's two wives refused. Upon King's death, Parker asked again—for the sake of medicine—to excise the tumor. The widows again refused: they were afraid to cause pain to their dead husband.

Another portrait of a young woman and her child is also calm, quiet, elegant. Less surreal than the other-worldly portrait of Wang Ke King, all seems well until the eye drops to the boy's lower legs. He has gangrene. The effect of Eastern serenity coupled with the horror of the disease elicits thoughts both of the timeless relationship of mother and child and of the immediate: What will happen to this boy? Eternity and decay come together in this representation. There is no record of the results of Dr. Parker's treatment of this boy. But he cannot be separated, even by the artist, from his affliction.

Three human anencephalic skeletons. [Museo Cesare Taruffi, Istituto di Anatomia e Istologia Patologica, Università di Bologna; photo by author.] ⟶

"It is indeed desirable to be well-descended, but the glory belongs to our ancestors."
—Plutarch, *Morals*[1]

Next of Kin

To the medieval sculptor of Vézelay, the dog-headed men represented a far-distant and pagan race. If the creatures could only learn to hold their muzzles toward God rather than toward the ground, they would show themselves as civilized, capable of reason, ready for Christian redemption. To the modern biologist, the "dog-headed men" reported widely by medieval Chinese and European explorers may have been African baboons or lemurs, a group of ancient prosimians with doglike muzzles from the island of Madagascar, sighted at some distance, on the shore. The name *Indri* in Malagasy means "there he is!" and the voice of this now highly endangered black-and-white lemur sounds "like the song of a humpbacked whale or the wail of a loon."[2] Subfossil evidence found in the northern part of the Ankaratra Mountains and also very near the coast shows that the indri may well have lived in those areas four or five centuries ago.[3] Even at a moderate distance, the lemurs—with their long limbs, short-haired bodies, hidden stumplike tail, pointed face, and eerie mesmerizing cry—have a startlingly human effect. While the range of the indri has now moved inland to a forest where they are rarely seen, it is possible that during the voyages of Marco Polo and others they were visible loping along the shore—a strange group of dog-headed barbarians—whose plaintive wail persuaded sailors passing close to land to travel on. What these medieval sailors couldn't see—because the creature was, by then, extinct—was the Archaeoindris ("old Indri"), a sloth-lemur and the cousin of the indri. Old Indri, the size of a gorilla, lived as recently as eleven hundred years ago. Had the sailors seen *this* creature wailing on the shores of Madagascar, news might have reached Europe of a colossal dog-man—perhaps Abominable himself! The baboon has also been mistaken for a dog-headed man because of its anthropomorphic qualities. The head of the baboon has been used frequently as the head of the deity: Anubis in Egypt, Hermes in Greece. Conscious above all of occupying the number one spot as God's greatest achievement in the scheme of Life, Western scholars have also been conscious of the ape's and monkey's undeniably humanlike mannerisms. For centuries they have tried to determine just how the primates next door are and are not like us and just which

Not content with mistaking apes for human beings in the wild, nineteenth-century taxidermists persisted in endowing the artificially resurrected skins with theatrical gestures and quizzical expressions. Many primate mounts reach forward offering fake fruits or look out in a wild glass-eyed gaze at the world. This bearded Monk Saki from Brazil, no relation of the Indri (a prosimian), has an uncanny humanlike presence: more like a circus "wild man" than a monkey. [Nationaal Natuurhistorisch Museum, Leiden; photo by author.]———➤

niche the ape must assume. No one, until Darwin, dared to suggest that "next door" implied kinship.

Carolus Linnaeus (1707-78), the founder of the first binomial classification system that embraced all plants, animals, and humans,[4] classified *Primates* in general and *Homo* in particular into various groups. *Homo sapiens* he divided into "knowing" and "wild"; *Homo monstrous* he divided into "natural" and "artificial." Under *Homo sapiens* "knowing," he placed many examples, including: "Man by day" (that is, culturally assimilated man), "Young Lutheran" (about whom he wrote, "works like a bear"), and "Young Irishman" (who "looks like a sheep"). Under the heading *Homo sapiens* "monstrous by artificial means," he places "a woman from Vienna who is thin like a reed and has flattened her stomach." Under *Homo sapiens* "monstrous by nature," he places "a man who lives . . . in the tropics and comes only by force to another place" (namely, a black slave!). In a separate category, *Homo troglodytes*, Linnaeus places those "active at night, speaking in hisses." The only entry here is *Homo sylvestris,* the orangutan. The other great apes, chimps, gibbons, and gorillas would have qualified for this slot, had they each been more accurately described, which they had not in 1758 when Linnaeus was writing the tenth edition of *Systema Naturae.* The class of *Simia,* which includes monkeys, is separate from the class of Primates. In a revolutionary stroke, Linnaeus placed both *Homo Troglodytes* and *Homo Sapiens* under *Primates. Homo Sapiens,* he advised, should therefore *nosce te ipsum* ("know thyself").

Jared Diamond has simplified the list into three species of *Homo: Homo troglodytes,* the pygmy chimp, *Homo paniscus,* the chimpanzee, and *Homo Sapiens,* humans.

In 1826, Isidore Geoffroy de Saint-Hilaire, the founder of teratology, received a mummy of an anencephalic human child that was found in a group of embalmed primates from the catacombs of Hermapolis in Egypt. The seated child was buried with its knees raised and its hands tucked under-neath, in the same posture as a baboon on an enamel amulet found near the child. Saint-Hilaire wondered whether a deliberate comparison was being made between the "accidental inferiority" of the child and the "normal inferiority" of the "most degraded animal among animals with a human face."[5]

In 1699, an unknown type of monkey was brought from Angola to England, where Edward Tyson, a respected anatomist and former director of the hospital for the insane at Bethlehem (later "Bedlam"), eagerly determined the "Pygmie's" classification in the Great Chain of Being: "Our pygmie is no man, nor yet a common ape but a sort of animal in between." The Great Chain of Being, the mantra of early natural history, ranked creatures from the smallest insect in an unbroken line of ascending glory to God's finest creation—man. The title of Tyson's treatise, *Orang-Outang, sive Homo Sylvestris;* or, *the anatomy of a pygmie compared with that of a monkey, an ape, or a man,* reveals the lack of substantive information about the great apes at that time. Tyson was, in fact, studying a chimpanzee and not, as he thought, the "man of the forest," an orangutan.[6]

Tyson worked hard to stress the human qualities he saw in the chimp before and after its death, which came

"Esau was a hairy man." In this plate from Johannes Jacob Scheuchzer's Natural History of the New and Old Testaments,1731–33, Esau stands dressed in animal skins. His hairiness (assumed rather than anomalous) is augmented by his outcast state. As a suitable companion (perhaps as a symbol of how far he has come from his own kind), he has been given a sleeping Orang-utan as a companion. [Courtesy of Houghton Library, Harvard University.]

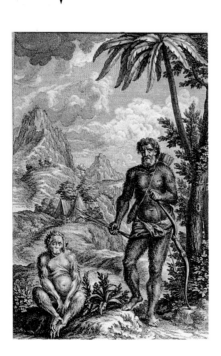

soon after its arrival in England, in order to place the creature in an empty classificatory slot. The anatomist cited the "Pygmie's" interest in clothes, his decision to refrain from drinking liquor after an initial brush with inebriation, and his upright posture, the last testifying to a higher degree of intelligence, raising him to a status closer to humans. Tyson explained that the chimp walked on his knuckles only because he was ill and weak. After the death of the chimp, Tyson mounted the skeleton in an upright posture, and in drawings the chimp holds a cane or staff because, of course, a chimp cannot stand without support.

Buffon, in his *Histoire Naturelle,* referred to *"demi-hommes"* from the interior of Madagascar, and in one of the editions of his book on monkeys he juxtaposes a plate of black natives holding onto spears as if supported by them with a plate of apes standing upright holding sticks to support themselves.

In a plate from Jacob Johannes Scheuchzer's *Natural History,* Esau, a "hairy man," stands dressed in animal skins. By leaving civilization behind, he has descended to the level of the beasts. His hairiness (assumed rather than anomalous) is augmented by his outcast state. As a suitable companion (perhaps as a bit of a warning that he has come further from his own kind and closer to the beasts), he has been given the sleeping orangutan.

The orangutan *(Pongo Pygmeus)* from Sumatra and Borneo, sometimes referred to as the "man of the forest," is the most arboreal of all the great apes. The weak-legged orangutan becomes highly acrobatic when swinging from vine to vine. This ape has the distinct silhouette of a long-armed man. A classical illustration of the mythical "man of the forest"—the same one used by Scheuchzer in his portrait of Esau—has descended into the works of many authors, who used it to their own ends. Nicholas Tulp, however, was the first scientist to classify the mythical "man of the forest" as an orangutan, and he made the original drawing.

Recently at the American Museum of Natural History, I heard two children discussing the dioramas of early humans. Before the Neanderthal, they

Tarzan with the apes. Cover of *Tarzan at the Earth's Core*, 1929–30. [Edgar Rice Burroughs, Inc. Publishers, Tarzana, California; photo by author.]

agreed they were looking at neither man nor monkey but at some other hairy form of life. "Look," one of them said, "it's naked." Before the second exhibition case of ancient Europe, the boy continued his train of thought. Looking at the fur-clad man and woman outside their hut of mammoth bones, he said, "See? Inside the clothes the monkeys turn to people."

The saga of Tarzan among the apes is a classic example of how popular mythology has characterized the differences between humans and their closest biological relatives. In the books, Edgar Rice Burroughs places great emphasis on and repeatedly refers to the excessive hairiness of apes. Tarzan— who has been adopted by the apes and now straddles the worlds between animals and humans—has to learn to suffer for his hairlessness. As a small boy he feels great shame when he realizes that his own body, compared to those of his adopted group, is "entirely hairless, like some low snake, or other reptile." When, as an adult, Tarzan falls in love with Teeka, an ape, his hairless looks become, to him, an insurmountable barrier to romantic success. When Tauk, an ape rival for Teeka, compares his own charms with Tarzan's, he comes up gorgeous: "How could one compare his beautiful coat with the smooth and naked hideousness of Tarzan's bare hide? Who could see beauty in the stingy nose . . . after looking at Tauk's bare nostrils? And Tarzan's eyes?

Hideous things, showing white around them, and entirely unrimmed with red. Tauk knew that his own bloodshot eyes were beautiful for he had seen them reflected in the glassy surface of many drinking pools."[7]

But what would have happened had Tarzan and not Tauk won the hand of the lovely female ape? The difference, for example, between human and chimpanzee DNA is a mere 1.6 percent,[8] which may be close, but it's not close enough, and the chimpanzee is characterized as an evolutionary detour and not one of our direct ancestors. Since in the original stories it's clear that Tarzan was adopted by gorillas, which are even further removed from humans on the evolutionary tree, there would have been no chance for offspring from such a union.

It is also clear from the novels that with the exception of Tarzan's nurturing group, all other apes are blood-thirsty and powerful but not clever. In the endless battle between all brutish bad animals and the man, Tarzan seems to become an animal. He engages in battle not *mano a mano*, but tooth and claw. He neither uses nor condones weapons made by men. If he lost long ago in love because of the snakelike smoothness of his skin, he wins almost every fight against wild beasts because of his inbred superiority; human strategy and agility always win out against brute force. In one scene, having conquered the aggressor, Tarzan retreats to make—in short order—a knife from a piece of shale, bow and arrows, and a house from which he swings "through the upper terrace of the tree-tops," a resourceful man-who-travels-like-an-ape. "Could his fellow peers of the House of Lords have seen him then they would have held up their noble hands in holy horror." Burroughs repeatedly sets and resets the scale of judgment: Tarzan must always remain the closest human ever to the jungle animals, but never of them.

That Tarzan loved an ape is just a literary secret—the cinematic world does not, and should not, know of his near brush with conversion. There is never any hint of interspecial eroticism. In the movies, the relationship of Tarzan to the animals is based on strictly bloody business or on loyal friendship. The films provide Tarzan with a resourceful and ever-clownish sidekick, Cheeta,

Lionel, the hirsute man of P. T. Barnum's circus. [Carte de Visite; courtesy of the Museum of the City of New York.]

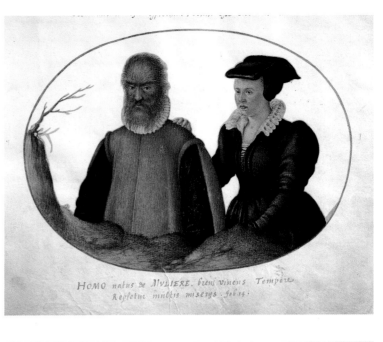

HOMO natus de MVLIERE, breui vinens Tempore
Repletur multis miserys. Iob 14.

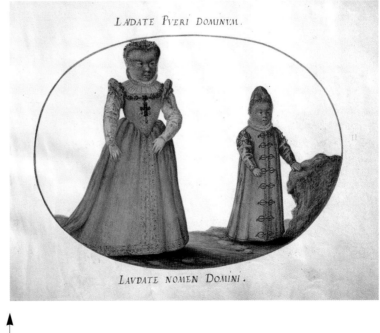

LAVDATE PVERI DOMINVM.

LAVDATE NOMEN DOMINI.

Top: Portrait of Petrus Gonsales and his wife; bottom: portrait of two hairy sisters, the daughters of Petrus Gonsales, both by Joris Hoefnagel in Ignis. Animalia Rationalia et Insecta. [Courtesy of the National Gallery, Washington, D.C.]

a chimpanzee. Tarzan swings between the jungle and the British House of Lords, and although he communicates with and is understood by both "brutish" beasts and men, he is no "signifying monkey."[9]

The signifying monkey, an important trickster figure in many African cultures, known as "the divine linguist," is related to Hermes, the messenger god of the Greeks, who delivered and interpreted messages. Known as Esu to the Yoruba people of southwestern Nigeria, the monkey straddles the world between the gods and humanity. One leg is shorter than the other; he is crippled, but he has assumed power over language. His speech is full of metaphor and meaning —of signifying ways.

Our generation's most famous dog/lion face must belong to Han Solo's companion Chewbacca, from the *Star Wars* films of the 1970s. Chewbacca comes from a race of Wookiees, whose hairy winsomeness—we assume—is a normal state, not an anomalous one. He is far from home; his race lives on some intergalactic edge, and although his hairy hugeness is taken for granted, he moves as an original through a crowd of often singular creatures, many of whom, for all we know, are also on foreign ground. It is as if Chewbacca, a member of a monstrous race, has entered a society to which none of the other denizens

belong—as if in a frontier town or in a refugee camp. All have come from the farthest reaches of the universe, finding themselves together from necessity and not from genetic consanguinity.

In Aldrovandi's *Monstrorum Historia,* a version of the Wild Man, a well-established Renaissance and medieval figure of the uncivilized people of the forest and of strange natives, is described thus: "It is not necessary that Forest Men be totally covered with hair. [They have been seen] . . . coming out of their mother's womb, clean, white, slightly downy."[10] But what happens if a particularly hairy man is born into a group of average hairiness?

Although Petrus Gonsales could perhaps be considered a distant ancestor of Chewbacca, he occupied quite a different position in sixteenth-century Bologna. Gonsales, a hirsute man from the Canary Islands, was placed with a kind of muted awe into the upper echelon of Renaissance society, and under the painter Joris Hoefnagel's intense scrutiny. Because of his extreme hairiness, Gonsales became an object of social fascination, a cultivated man who was somehow not a man. Hoefnagel saw him as a creature who came from the furthest reaches of the "marvelous," someone who expressed at once a touching humanity and human estrangement from the world. The portrait of Gonsales and his wife appears as a frontispiece to Hoefnagel's *Ignis,* "Insects from Fire." The artist considered insects and Petrus Gonsales equally rare and strange creations of nature. The mayfly, for example, lives for one day, while we go on for years, and still we say, "Man born of woman lives a short life full of misery."[11]

In 1650, Aldrovandi wrote about a young girl brought to Bologna from the Canary Islands who was covered with golden hair, including her entire face except for her lips and nostrils. Her throat, chest, arms, and hands were free of hair, and they were scaly, "like the skin of a young bird whose feathers had not yet grown."[12] This girl, who without question came from the same genetic strain as Petrus Gonsales (from Tenerife), might well have been one of his daughters or cousins. Hoefnagel also painted Gonsales's daughters, shown here, graceful and covered in hair.

The rare gene that produces excessive hairiness and no other coexisting abnormalities may be an atavistic expression of a condition once necessary for mammals surviving in the wild. Scientists have suggested that the hereditary condition, congenital generalized hypertrichosis, is a "reemergence of an evolutionarily ancient trait that is normally suppressed." Further, this condition, which leaves only the palms of the hands and feet free from hair, refers to an ancient time before modern chimpanzees and apes, who have relatively little hair on their faces compared to people afflicted by this condition.[13]

Jennifer Miller, a bearded woman from New York who stars today in her own circus as a feminist artist, is determined to "defreakify" her own anomalous hirsute condition in the context of the time-honored sideshow. Ms. Miller does not shave, hide her beard, or retreat from public scrutiny. Often accosted by strangers, she is asked impertinent questions: "Like, what is it that you are?"

Ms. Miller seems keenly conscious of her status as a performer with a powerful "transgressive" act. Although she does not enjoy the kind of honor accorded Petrus Gonsales—as an exquisite rarity of the natural world—she must by all counts be classified as a survivor, not as a victim. Embracing her bearded "gender-bent" condition, she brings it before the world: "I live in a very liminal place," she says. "It's a lovely place. In the theater it's when the lights go out and before the performance begins."[14]

These three insects are anatomically beautiful; although the perfect miniature "dragon fly" has the proper number of legs for an insect—six—its body and head look more like a medieval version of a damsel-kidnapping reptilian monster than like an ephemeral water-skimmer. [From Joris Hoefnagel's Ignis. Animalia Rationalia et Insecta; **National Gallery, Washington, D.C.]** ⟶

"Life is fire burning along a piece of string . . .
[and] History . . . the trail of ash."
—Robert Penn Warren, *All the King's Men*[1]

Boundaries

PRIVS LOCVSTA BOVEM.

XXXXIV.

I saw an incredible number of attentive men and women. . . . They had a mappamundi and spoke eloquently of prodigies, . . . of the pyramids and the Nile, . . . and of the Troglodytes, of Himantopodes, of Blemmyae, . . . of cannibals. I saw Herodotus, Pliny, Solinus and many other ancients . . . all writing beautiful lies."
—Pantagruel in *Gargantua and Pantagruel* by Rabelais[2]

Here, Rabelais (1483-1553), the French novelist and physician, expresses his disdain for the gullibility of the populace toward classical tales of foreign lands and monstrous creatures. During the time of Rabelais, great explorers reached the "East," bringing back news that they had reached the edges of the world and gone beyond—that there were, in fact, no edges to restrain them. Although they found no men with heads in their chests, they had seen—again—dog-headed men barking on the shore, and there were often cannibals. The world beyond the safety of home was full of danger and crowded with groups who lived like savages—if, indeed, some could be classified as human at all, being clearly some hybrid mix of human and animal—with customs almost too terrible to speak of. Rumor lasts longer than truth, and so, if reports arrive that an amazing animal or hybrid human/animal exists, belief in the creature as a marvel will linger longer if it does not actually appear. Any animal—even an impossible one—will shed its fictional skin upon examination. It must be kept moving, just out of sight, if the mystery is to last. And if explorers chart the world and the creature is still not found, then the boundaries have become exhausted. For awhile, at least, the game is up. But sometimes the supposed creature can then be moved by force of the imagination from the edge of the world to a central wilderness—to the heart of Africa or South America, for example—to interior regions of unknown dimensions. From "darkest Africa," even today, occasional reports filter home of dinosaur sightings. Even though we know better, rumors persist. Throughout time, boundaries and perspectives shift back and forth as people struggle to redefine their territories in order to better determine the "center" of the world and to declare who should occupy

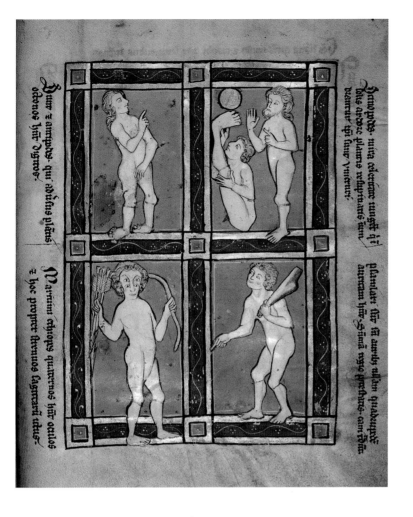

Monstrous races: upper left panel, **a member of the Antipodes, men who walked upside down**; lower left, **a member of Maritimi, with four eyes and a bow and arrows—the extra set of eyes underscored this group's superior sense of vision**; upper right, **two Sciopods, one lying down, one standing**; lower right, **the Troglodytes, who live, without speaking, in holes in Ethiopia and move very fast**. [From De Natura Avium: De Pastoribus et Ovibus: Bestiarium. Mirabilia Mundi: Philosophia Mundi: On the Soul **by Hugh of Fouilloy and William of Conches (83. MR.174), Ms. Ludwig XV 4, folio 118; courtesy of the J. Paul Getty Museum.**]

it. These struggles have created, but mostly destroyed, entire groups along with entire periods of history. Early medieval maps showed Jerusalem, the Holy City of the Crusades, in the center of the world, and on the extreme eastern edges of the world lived the monstrous races: Pygmies, Cyclops, Blemmyae (men with heads in their chests), Sciopods (men, each with one enormous foot shielding the sun)—surrealistic creatures depicting the limits of God's ingenuity. As scholar Ranulf of Higdon, author of *Polychronicon*, wrote in the fourteenth century, "Note that at the furthest reaches of the world often occur new marvels and wonders, as though Nature plays with greater freedom secretly at the edges of the world than she does openly and nearer us in the middle of it."[3]

Sir John Mandeville was the author of the most popular travel book of the fourteenth century. Considered a nonfiction, true-life, adventure travel writer, Mandeville was in fact an irredeemable fraud, hitching a literary ride on the accounts of others, pushing the limits of exaggeration and sensation. However, travel writing need not always be accurate, and, as the poet and cultural historian Mary Campbell has written, Mandeville "was up to something novel."[4] He was the first author since Rome to write "realistic prose fiction." Accumulating all the ancient tales he'd ever heard of travels to the East—from Pliny, Marco Polo, Odoric—and augmenting them with more contemporary accounts—from the early pilgrims to those of the Crusades—Mandeville invented a fabulous journey and published it under a pseudonym. By Mandeville's time the fabulous tales from the East had already been contaminated by actual travel accounts from pilgrims and from crusaders.[5] By taking all the sources known to him, Mandeville

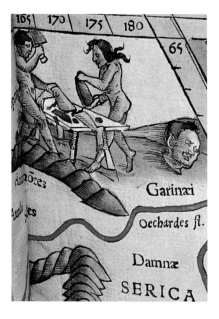

Ptolemaic map of the monstrous races showing cannibals. [Courtesy of the Map Collection of the Nathan Pusey Library, Harvard University; photo by author.]

embellished, exaggerated, and invented every "fact," writing a story that became—for its time—a runaway best-seller, taken for truth by many and passed down through the ages as a thoroughly reliable source.

No matter when a book is written, no matter how "objective" the account, there is always a cultural filter through which the story seeps—whether it's the fourteenth century, the nineteenth century, 1930, or today's newspaper. There were no copyright laws in the sixteenth and seventeenth centuries; stories and illustrations were traded from one to the next. Many versions of "truth" appeared, ever variable, from otherwise supposedly reliable authors, and many of us reading these texts now would become restless and sceptical —wanting to brand it all as myth and ancient superstition. However, as Rumphius (see "Twisted Fruit") said of the legends of the Moluccas Islands, "There always lies hidden among these fables a modicum of truth or latent attributes as is true of the fables of Ovid or other poets."[6]

In between the monstrous and ourselves we have constructed many walls. We always drive the monster out—to live beyond geographical boundaries of the known world, to be set out, figuratively, upon the water as on a ship of fools, to be ostracized on the street, treated as insane, or as a singular being who truly has no group at all and who is forced to live like the Minotaur, Grendel, or Caliban—in a labyrinth, on the edge of town, or at the far end of the island. Alexander built a mighty gated wall to keep Gog and Magog at bay, and he wrote home to his mother boasting of his feat. He wished to save the world from ungodly forces by fencing them out. The first Chinese Emperor, Shih Huang Ti,[7] built the great wall of China and burned the country's books at the same time; history shall begin with me, he said, and the past no longer exists. There have been many erasures of history through fire: the library of Alexandria, the purging of information by Savonarola in fifteenth-century Italy, and book-burning by the Nazis.

Michael Camille writes that, in medieval times, children were taught about the edges of their own villages in a ritual called "Beating the Bounds."[8] In this ritual, children were physically bumped up against trees and plunged into the bordering streams and rivers, by which graphic game they learned the boundaries between domestic and foreign. Travelers, pilgrims, and lepers, Jews and madpeople, might range in and out of this territory—pilgrims on their sacred quests and the insane either on their own ungovernable track or

World Map from *The Beast Is Dead* by Edmond-François Calvo and Victor Dancette (1944–45), English translation by Charles Kingston. This is the twentieth-century counterpart of a Ptolemaic map, showing the continental location of various bestial/human groups. [Private collection; photo by author.]

banished by society from the town—but children needed to understand the limits to their safety.

The late eighteenth and early nineteenth century, according to Foucault, was a time of overt brutality to the insane. They were locked away in institutionalized madhouses, sleeping in stone cells and wooden cages full of rats—and in time, another animal emerged: "Those chained to the cell walls were no longer men whose minds had wandered, but beasts preyed upon by a natural frenzy Madness did not join the great laws of nature and of life, but rather the thousand forms of a bestiary."[9]

This theory of the metamorphosis of man to beast implies a kind of release from the human condition; a new identity for those who have reached an animal state. In 1770, a Scottish farmer, Gregory, proposed the yoking of the inhabitants of the madhouse to his plows, as if they were oxen or mules, to work as "beasts of burden" on his land—for the sake, he claimed, of the "art of curing insanity." The beast in man, Gregory claimed, could be developed by further subjugation, "unchained animality could be mastered only by *discipline* and *brutalizing.*"[10] Beating is a time-honored option for the bully with the upper hand. "You've got your whip," says the Englishman to his more compassionate compatriot in the film *Tarzan the Ape Man* when cowardly natives theaten to run away. "Give them something else to think about."[11]

One of the purposes of maps is to delineate boundaries. A map of the African country of Guinea of 1771 shows an interior quite sparsely drawn and the south coast full of notation. The towns along the Ivory Coast were named *Côte des graine ou Manigrete, Côte de l'or, Côte des dents ou l'ivoire,* and *Côte des esclaves* (coasts of grain, gold, ivory, slaves). The accompanying text explains that the west coast of Guinea was crowded with Europeans doing business in rubber, ivory ("dent," elephant tooth), gold dust, and above all in slaves—a hundred thousand of whom were purchased in Africa in exchange for gun powder, grain alcohol, fabric, and mirrors made of glass "in which to see oneself more clearly." A century later on a new map, the label for slaves had been removed, although the other divisions remained the same. By the mid-nineteenth century, "The Slave Coast" had been renamed "New Port." A mirror had been held up to the face of propriety and a bit of cover-up cosmetics applied.

Early cartographers, Ptolemy among them, often included both fictional and real creatures in their maps of the world. The map of the world from Sebastian Münster's *Cosmographia,* based on Ptolemy's studies of the interior of Africa, shows the traditional figures of the Blemmyae and Sciopods outside the map and the cannibals deep in the interior (deep also in the gutter of the book).

Any vast, uncertain continental interior must feature man-eating animals and peoples. To go to the "heart of darkness" is to risk being devoured. The sight

of the men in the Ptolemaic map, briskly hacking off the limbs and heads of their victims on their handy work bench, recalls a painting from another "dark" country, South America, and another strange land, Peru, where the races of Indians from the interior include the "anthrophagus—who has around his neck the hearts of his enemy, finds human flesh a great delicacy—this is both his habit and the error of his ways."[12]

Animals occupy certain continental positions in medieval and early Renaissance maps: the elephant in Africa, the dragon in China, and sea monsters or whales off every coast. At the eastern and western edge of these maps are found the monstrous races. The 1944-45 cartoon map of the world from *The Beast Is Dead,*[13] shows world leaders—as animals—placed in their separate countries on separate continents, gesticulating, talking on the telephone, planning to put an end to the "power of the mad beast." At the bottom of the page is written, "All had sworn not to rest until the Barbarian hordes had been wiped out; until the millions of their brothers oppressed or held captive had been freed."

On this map, the creatures at the edge of the world—the kangaroo in Australia, the monkey in Japan—communicate with those in the center, the English bull dog, the Russian bear, and the American buffalo. To the east of center, a dragon stands in China, and a white elephant, on his hind legs, faces northeast and turns his back to the tip of Africa. This elephant occupies an honorable ancestral site: Ptolemy would have cheered. In the middle of the map, the enraged Nazi wolf faces south, threatening small, refugee animals on a forced march. A lean dog turns his back on the North, covering Italy with his shadow, while finally, the last player, like Lawrence of Arabia, comes up from Africa, swinging a sabre, getting nowhere. And all around in the Mediterranean and Atlantic are sunken boats and black crosses. The screaming wolf occupies the center of this map—and the center, as it has been throughout this book, is Europe. It's 1944, the walls are down, and the monster in the middle threatens to destroy everyone in his path. Nature stands aside.

Although this is a "time-sensitive" drawing, it conveys a recurring theme—a yearning to fix the center of things, to force evil out, to build barriers against monstrous beings. We have small aptitude for keeping the enemy at bay. There are so many. We turn outsiders into aliens so that once they have penetrated our domain they become the enemy. The tiger at the gates. The worm in the apple. Have we asked for this? Something always to threaten our hard-won stability? Perhaps fear is inevitable—along with our recurring desire for an endgame. We anticipate, perhaps invite, what Derrick Walcott calls the "fear of annihilating power leashed upon all of us If you need an Attila the Hun, why not? Everybody needs an Attila the Hun; every country after a while says, 'Hey, where's our Attila the Hun?'"[14]

*I*n the eleventh and twelfth centuries stonemasons carved many stories from the Old Testament and from ancient legends on the facades and on the capitals of columns in Romanesque churches in France, Spain, Italy, and throughout northern Europe for the mostly illiterate populace to "read." Included are sculptures from three of these: Vézelay, Chauvigny, and Anzy-le-Duc (see "Too Much" and "Giants and Dwarfs"). The carvings in medieval churches, once brightly painted, functioned as entertainment for the worshipers—cartoons of an early science-fiction world. Together with carvings of biblical stories—Adam, Eve, Cain in the wilderness, the Nativity, the boys in the fiery furnace—there were those of both fictional and biologically viable monsters: the Sciopods, Cynocephali, Cyclops, conjoined twins, giants and dwarfs.

On the tympanum of the church of the Madeleine in Vézelay is a ring showing the geographical distribution of the monstrous races, separated from the Christian world of the apostles and the anointed by a ring of water. The carving functioned as a guidebook in stone depicting the relative distribution and the condition of the various races vis-a-vis the Christian world. The four groups who receive the Word of the Lord across the water are the Cynocephali (dog-headed men), the Sciritae (men with flattened noses), the Pygmies (one of whom is busy using a ladder to mount a horse), and the Panotii (men with ears enormous enough to cover their bodies when they sleep). The monstrous races, heathens, unintelligible, and strange in aspect, existed as a colorful imaginary border applied to reality.

The Lausanne Cathedral's rose window is divided into circles and semi-circles, within which is depicted a map of time. The year lies in the center, surrounded by night, day, moon, and sun. Around these circle the twelve months of the year, as well as the seasons, the four elements, and the signs of the zodiac. Around the edges of the window run the four rivers of Paradise and the monstrous races enclosed in half-medallions. They compose the outer edges of the rose, with only the winds outside their confines.

Ignorance of the nature of foreigners, the same that informs the medieval stone carvings of monsters, is timeless and universal. In New Guinea, for example, highland tribes were isolated from white explorers and from each other. Some of the Dani believed that another group ate grass and that their hands grew together behind their backs. They believed that white men wore trousers because their penises were so long they had to be coiled around their waists—the trousers were worn for modesty.[15] For people of the Amazon, the conquistadors of Spain were monsters with wart-covered penises who could do great harm to their society.[16] How different is this is from Blemmyae—men whose heads grow beneath their shoulders—or the islanders who speak all languages so as to beguile with well-chosen words and kill the traveler, or from the mermaids who, in Alexander's letter to Aristotle, "caught and drowned strange men, or dragged them among the reeds where because of their beauty they either killed them in rage or forced them to have intercourse until they were dead?"[17] In every culture, it seems that what is foreign is either reprehensible, dangerous, ludicrous, or simply wrong.

Animal and human parts united in imaginary creatures often consist of no more than limbs and paws, jaws and teeth, fur and scales, taken from various existing animals and people and scrambled together to produce new ones. The Ravenna Monster (see "Too Much") may be ominous as a political scarecrow, but it's assembly-line silly as a viable biological being. The chameleon, however, a real animal, as described by Mark Twain, sounds highly unlikely:

"He has a froggy head and a back like a new grave—for shape; and hands like a bird's toes that have been frost-bitten. But his eyes are his exhibition feature. A couple of skinny cones project from the sides of his head with a wee shiny bead of an eye set in the apex of each; and these cones turn bodily like pivot guns and point every which way, and they are independent of each other; each has its own exclusive machinery If something happens above and below him he shoots one eye upward like a telescope and the other downward—and this changes his expression but does not improve it."[18]

Although Twain has been known for his tendency to exaggerate, he was at least *there,* whereas Mandeville was never there at all. With energy, however, he writes a fine tall tale. In his *Travels,* he goes on and on. In

Ceylon, he writes, "are great hills of gold which ants busily look after, purifying the gold and separating the fine from the unfine. Those ants are as big as dogs are here, so that no man dare go near these hills for fear that the ants might attack them."[19] So does Alexander the Great, here in a letter to his tutor Aristotle: "We saw emerging from the deep a number of hippopotamuses bigger than elephants. They are called hippopotamuses because they are half men and half horses. We could only watch and wail as they devoured the Macedonians whom we had sent to swim the river." Alexander, angry at his guides, ordered one hundred of them into the water, "then the hippopotamuses began to swarm like ants and devoured them all."[20] Certainly some creatures are unmistakable: "Even when a bird is walking we know that it has wings."[21] But others are peculiar; geographically inaccessible or balancing on the edge between one species and another, they resist scientific classification.

Take those gold-digging ants, for example. In 1996, a group of explorers to the Dansar Plain on the Indus River near the Pakistan-Indian border has confirmed the existence of marmots who in digging bring up gold-bearing dirt. For many centuries, the Minaro people, local Tibetan-speaking villagers, have mined the gold uncovered by the marmots. According to Michel Peissal, the French ethnologist who searched long and hard for the marmots, the isolated villagers have always known about the large, aggressive, sharp-toothed animals, who resist the humans seeking to take their gold. Peissal believes that confusion about the nature of the creature arose from a literal reading

Pangolin with two pinecones. [Museum of Comparative Zoology, Harvard University; photo by author.]

Jaws of a crocodile. [Museum of Comparative Zoology, Harvard University; photo by author.]

of the Persian word for the marmots: "mountain ants." The real marmots took refuge under an old word. The story vindicates many texts, from Herodotus in the fifth century B.C., who was the first to describe the "ants" as "bigger than a fox, though not so big as a dog," to Mandeville in the fourteenth century. The animals, the gold, and the robbers share a long history unknown to the outside world, apart from the stories "passed . . . along the ancient grapevine."[22]

Occasionally, animals already well known to humans preserve an obstinently mysterious power. The pangolin, a scaly anteater from Africa, has many anomalous features, both biological and cultural. Biologists were unable to classify the animal—in Linnaean terms—until the twentieth century. It is a mammal with its own order, *Pholidota Manidae,* which includes seven species. Aelinus, a Roman writer after Pliny, mentioned an animal from India "somewhat like the land crocodile. The scales that cover it are so rough and of such close texture that when flayed, they perform the function of a file. They can even cut through bronze and eat their way through iron." He called the creature a "phattage," but most likely it was a pangolin, which eats insects, not bronze or iron.[23] Visually (and here I speak as a photographer), the pangolin is a changeling: its sharp-edged scales, formed of a kind of horn, looks like other things—a pinecone, overlapping seashells, or an artichoke. But beyond all visual strangeness the creature possesses a metaphorical intensity. Many African groups have chosen watery animals with scales as powerful intermediators between the natural and spiritual world. The pangolin, whose habit of curling into a tight fortresslike ball appeals to rulers as a symbol of power, has been made in hats for chieftains and aristocratic older men in groups throughout Zaire: the Lega, the Gombe, and Vili.[24] The Lele tribe of the southern fringes of the Congo forest near the Kassi River have said of the pangolin, "In our forest there is an animal with the body and the tail of a fish, covered with scales. It has four little legs and climbs in trees." Earth, water, and sky: "all the categories of the Lele's universe are brought together in this liminal being. . . ."[25]

The Lele have attributed the power of fertility to the pangolin, who, similar to humans, bears one offspring at a time after a gestation period of five months. Calmly curling itself into a ball when hunters approach, it allows itself to be used as a sacrificial victim without a struggle. The creature possesses, beyond all visual strangeness, a metaphorical intensity. The Lele treat

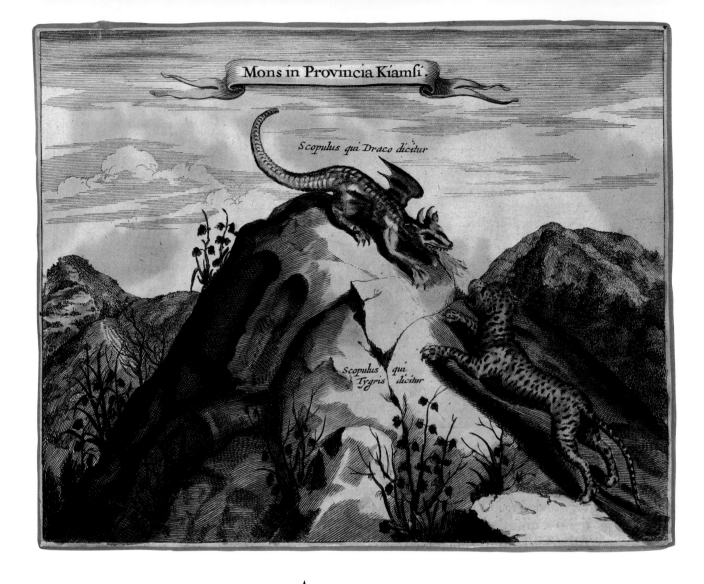

The dragon, emerging from his "nest" within the mountain, confronts the leopard.
[From Athanasius Kircher, Toneel van China (Monuments of China), Amsterdam, 1667;
courtesy of the Getty Research Institute for the History of Art and the Humanities,
Santa Monica.]

the pangolin as a counterpart for any parents of the village who have produced twins. The Lele respect their chosen mascot and sacrificial victim of the all-male Pangolin Cult, formed to encourage the fertility of their people, and rejoicing especially at the birth of twins.[26]

More widely known than the pangolin but no less provocative, the often ferocious, continuously growing crocodile has exercised great influence over people's lives and imaginations. In Sumatra, according to Rumphius, the Bataks believed the crocodile was an ancestor.[27] In Makassar (now Ujung Pandang, capital of Sulawesi in Indonesia), natives believed that crocodiles ate people only by mistake, implying that the animal was not inherently an enemy. The ancient Egyptians thought the teeth of the crocodile were an aphrodisiac, but only if taken from the live animal. And, "Its dung provides an ointment with which old and wrinkled whores anoint their figures and are made beautiful, until the flowing sweat of their endeavors washes it away."[28] Above the confessional and near a statue of Joan of Arc in a church in Oirons, France, hangs a crocodile. This reptile supposedly ate the mother of a local duke several centuries ago. A number of apothecaries and early collections include crocodiles, displaying them in a prominent position on the ceiling.[29] Does the crocodile serve as the collector's substitute for another desired but unobtainable reptile, the dragon?

The Chinese believed in "cloud dragons," and that all "dragon" bones and teeth came from animals who had wandered inadvertently in the realm of people. The poet Marianne Moore, in the poem *Oh, to be a dragon*, speaks of the dragon as "a symbol of the power of Heaven—Of silkworm / size or immense / at times invisible / Felicitous phenomenon!"[30] Kircher believed that dragons lived in subterranean caves and came to the surface of the earth infrequently and by mistake. In one of Kircher's plates, a dragon and a tiger face each other across mountain ridges—in eternal stasis, in eternal combat. According to a medieval doctrine by Fong-chouei, these beasts are always found together rising out of the same rock forms. Traditionally, in oriental landscapes, mountains assume zoomorphic forms; in both East Asian and Islamic landscape paintings, animate beings are formed entirely of minerals, and hills or mountains are shaped like large animals—either whole or in part.

Crucularum Prodigium.

The metamorphosis of a dragon into fire and monster into mountain, either in myth or as a natural illusion, speaks to the notion of fluidity between all natural forms.

The Chinese believed that rocks and earth were comparable to the flesh and bones of a person. In this cosmology, the rivers that lead to the sea become the circulation of the blood, and the tides of the ocean the breath.[31] Ovid, who wrote that the earth and beings could change their shape at anytime, told of stones changing into bones, people into trees and animals, and even, as Echo, the maiden unrequitedly in love with Narcissus, into a sound.[32] Ovid thought that the earth was like a "living animal" equipped with breathing holes for flames (Etna), while much later, but drawing on ancient instincts, Ambroise Paré, the French surgeon, argued for an inner world—a wild landscape inside the body that resonated with the external, terrestrial model. Perhaps these various metaphors are symptomatic of a human desire to transcend flesh, to cross over into the larger world of nature, or transcending matter altogether, to pass beyond the rocks and roots into soul.

Volcanic events seem especially to embody both the force of creation and the destruction of life. Long a source of superstition, the artifacts of an eruption may be taken as a trace of divinity, as in "Pele's tears" (strands of threadlike glassy rock named for the goddess of the volcano) from Kilauea on Hawaii, or as a message from God, as in the rain of small black "crucifixes" that fell in 1660 on villages near Mount Vesuvius. Actually small crystals joined in the shape of a cross, they were interpreted as a miraculous intervention by the patron Saint Janarius between the destructive power of the volcano and the threatened villagers.

Aristotle believed that the volcano had an animate biological rhythm to its existence: birth, life, and death. Katya and Maurice Krafft, Belgian volcanologists who spent their lives studying the phenomena of volcanos, and who died in an eruption in 1992, spoke in highly evocative ways of the power of the stirring mountain: "We are butterflies from Alsace," said Maurice Krafft, "but instead of going from flower to flower, we go from crater to crater."[33] Insects, we recall, according to Pliny and to Hoefnagel (see "Generation" and "Next of Kin"), were thought to be engendered by fire.

Butterflies are drawn to light and color. Moths are drawn to light and heat. The Kraffts could not stay away from the mesmerizing eruptions. "Very often, on volcanos, we live like wild animals. That means you have to sleep on the ground on very spiny soil. . . . What is nice, when you sleep on the ground of an active volcano, you have just the vibrations of this big elephant. You are living on the back of this animal. You have the feeling you are of something alive. [sic]"[34]

Catastrophic natural events are monstrous. The volcanologists riveted by the sight of fire rivers, drawn to danger, seek an ecstatic experience with nature—in the violence, fury, and beauty of an eruption come forces beyond human understanding, the shaking ground like "the back of a huge beast"—has deep atavistic roots. Fire consumes and cauterizes, and yet, from lava's rich soil, plants will grow. The force of colliding subterraean plates, in addition to a geological reality, feels like the wrath of God—the volcano exhales like the breath of Shiva.

Smaller and closer the notion of monstrous comes, from the rim of the unknown flat world to the schizophrenic men and women on the street who speak in different broken-hearted voices. There are many defining edges to all worlds, both artificial, as in legal boundaries set between private and municipal property, and spiritual boundaries, like the space between the shore and the ocean waves, "where wisdom revealed itself,"[35] or the transition between the setting sun and the night—*entre chien et loup* ("between the dog and the wolf")—which is neither day nor night but both, and like all transitional stages, not entirely safe.

"The world's more full of weeping than we can understand."
—Yeats, *The Stolen Child*[1]

Afterword

When I first heard of Charles Proteus Steinmetz, I spoke to my physicist father-in-law, Edward Purcell. I proposed that Steinmetz was like Stephen Hawking: physically damaged and yet a popular figure in an arena where not many scientists succeed. The differences between them, Edward said, "are so wide, so far, so deep." He, of course, was referring to the work of each of the men; the first, Steinmetz, used analytical mathematics to solve electrical engineering problems. In the 1920s, Steinmetz's name was the icon for General Electric, for whom he developed alternating current. He was a small, crippled physicist, nicknamed "Jove," and his familiar hunchbacked form with a huge cigar, Edward said, was a better-known icon to many than was Einstein. And Hawking is no dwarf; he has a congenital condition of the nervous system, while his work—nothing to do with AC/DC electrical currents or Maxwell's Equations—concerns the nature of black holes and the creation of the solar system. Still, the notion of mental grace under physical hardship persists: pioneers first, crippled victims second, even when intellectual endeavors are light-years apart. After the conversation with Edward, I realized that while I had planned to fashion Steinmetz into a "dwarf" for the sake of a chapter on "Giants and Dwarfs," by aligning Steinmetz with Hawking, however frivolously, an alternative possible category arises, and that Steinmetz, whose form, however superficially, might have supplied a good companion note to the chapter on "Giants and Dwarfs," shifts now to a more persuasive category (outside the scope of this particular study): "all those who have studied the nature of magnetism and the effect of light who are physically or mentally impaired." Onto that list goes Steinmetz, Hawking, Rumphius (blind but persistent in his *lucubrationes,* a metaphorical term for "studies at night by lamplight"), and Benji from *The Sound and the Fury,* observing light off a golf ball, flashing and failing. A list of others drawn to light expands beyond literal physical infirmity to include Emperor Nero (who burned Rome), Dido (who jumped onto the pyre), and Icarus (drawn too close to the sun like a moth to the flame). To a list of Remarkable Persons who Have Studied Light, add the painters Rembrandt, Manet, and the poet Goethe, who in dying, asked for "more

light." The bearded Jennifer Miller (see "Next of Kin") welcomes the dimming of theater lights. Albinos suffer from too much light. Blind albino animals deep in caves no longer need the light. Cockroaches, to whom albinos have been compared, flee from light. In drawing up this list, light has gradually become the determining point around which animals and humans revolve. In an associative list walls eventually collapse as each entry, drawing from the previous one by virtue of its similarity, stands alone by virtue of its differences. Eventually the game grows old; with a different hand the deck would be dealt anew, a new set of cards—the list might so easily have been drawn up differently.

On the street sometimes there seems to have been a change of plans: Here comes a woman, a perfect Venus de Milo, a lovely body and no arms. There goes a badly burned girl whose reconstructed noseless face is a smooth surface behind which eyes move and a mouth opens. There goes that tall blind boy, on two canes, his scarred agitated face lifted high and his voice shouting at his companion. And I remember, at three in the morning on a Greyhound bus in Tennessee, a man climbed aboard whose incomprehensibly arranged face knocked my fatigue sideways in the struggle to understand what I had just seen.

Skeleton kneeling and peering into an open book: The Latin text beneath the plate warns mortals about inquiring too closely into the secrets of the universe, for knowledge may be monstrous. The book in which the image appears, a combination of an anatomical atlas joined to the theater of human experience, depicts skeletal figures determining the fate of the living. If war and art and all activities are to be populated by figures of the dead, even human curiosity into forbidden books may lead to fatal consequences: "Be careful how you look," the picture warns. [From Nouveau recueil d'osteologie et de myologie by Jacques Gammelin, Toulouse J. F. Declassan, 1779; courtesy of the Getty Research Institute for the History of Art and the Humanities, Santa Monica.]

A friend told of a girl who could not close her eyes when she slept until doctor sewed buttons and fasteners to the top and bottom of her eyelids. Someone else reported a legless beggar in Haiti who had sewed a wooden board directly to his trousers. In Helsinki, a girl with a plastic face was shielded from view by her mother in the rear of the airplane. Sewing and attaching, and shoring up. Baby girls, joined at the waist, with three legs walk in swaying accord. A delicate blind giant continues to grow, pithy tendrils inside his bones.[2] A crippled dwarf shifts his upper body, with its lumps and enlargements, from side to side like cargo on an ill-balanced boat. When I consulted my friends about their gut-level *ur*-feeling at the sight of a deformed or damaged human being, they variously admitted to feeling appalled, dismayed, sad, embarrassed, afraid. One mentioned Konrad Lorenz, the twentieth-century ethnologist, who wrote that we are programmed to reject the abnormal—probably because they serve no useful evolutionary advantage. One spoke of the possibility of "error," of not being certain exactly *what* one has seen, while another admitted to impatience, of "wanting to get out, to get on with life," as though the sight of an aberration threatened life itself. Another mentioned seeing a young woman whose extreme *beauty* somehow made her monstrous. A friend saw an older person with blue eyes in a baby carriage, singing. She said there was no visible body. The combination of high resolution in one part of a body without the rest sounds terrifying—like the living leg in Jim Hawkins's dream, it has already escaped definition. Now what if "it" jumps ship? Perhaps the most tragic anomaly is one of a clearly resolved consciousness constrained by an unfairly small allotment of territory.

When an anomalous person enters a room, the "average" human occupants pretend that such an encounter is a daily occurrence. No one asks—"Hey, so what does it feel like to be a crippled dwarf in a room full of the rest of us 'normal giants'?" Children often speak up: What is wrong with that boy? Why does that man look like that? The children are told to be silent, and their parents apologize. Where does the sense of suffocation come from? Alone, in the company of a dwarf, a giant, or conjoined twins, a single person of average stature and traditional configuration must relinquish the cherished position of being normal. Even a single Quasimodo may force the abdication of all biologically average persons from center stage. The rest of humanity, in his presence, exists on the edge of things—out on the rim of his very old world.

Think of Ovid; for him forms of life were always in flux. And Kircher with his mirrors: there are, he asserts, "a thousand ways to deform a man," and, if you use the methods he recommends, "no monster is so ugly whose shape you will not find in yourself."

Endnotes

INTRODUCTION

1. Quote by Thomas Huxley from frontispiece of T. H. White, trans., *The Book of Beasts* (New York: G. P. Putnam's Sons, 1954).
2. All quotations are from Athanasius Kircher, *Physiologia* (Amsterdam: Janssonio-Waesbergiana, 1680). All translations from the original by Vally Miatto Buonanno for the author.
3. Ulisse Aldrovandi, *Monstrorum Historia* (Bologna: Marci Antonius Berniae, 1658). Translated from the orginal by Vally Miatto Buonanno for the author.
4. Scheuchzer's findings of *Homo Diluviens* are described in *The Book of Life: An Illustrated History of the Evolution of Life on Earth,* ed. Stephen Jay Gould (New York: W. W. Norton, 1993), 14-15.
5. See Emily Vermeule, *Aspects of Death in Early Greek Art and Poetry* (Berkeley: University of California, 1981), 138.
6. William Shakespeare, *Othello* (New York: Washington Square Press, 1993), 1.3.166–68.
7. Pliny, the godfather of early Western sources, even in translation has the most poetic ways of describing the awesomeness of the natural world. More encyclopedic than accurate and more revered than doubted, he is responsible for passing along both real information and pure nonsense, all in a sober yet poetic fashion appropriate to his time.
8. Mary Campbell, *The Witness and the Other World: Exotic European Travel Writing, 400-1600* (Ithaca, NY: Cornell University Press, 1988), 83.
9. William Butler Yeats, "The Circus Animals' Desertion," verse III, in *The Collected Poems of W. B. Yeats,* 12th ed. (New York: Macmillan, 1966), 335-36.
10. Campbell, *The Witness,* 86.

COLLECTIONS

1. Susan Stewart, *On Longing: Narratives of the Miniature, the Gigantic, the Souvenir, the Collection* (Durham, NC: Duke University Press, 1993), 109.
2. This classification system was first established by Carolus Linnaeus (1701-78), a Swedish botanist, whose work was continued by Georges Cuvier (1769-1832), a French naturalist, as well as other pioneers of early modern natural history.
3. Oleg Neverov, "His Majesty's Cabinet and Peter I's Kunstkammer," in *The Origin of Museums,* ed. Oliver Impey and Arthur MacGregor (Oxford: Clarendon Press, 1985), 60.
4. Krzysztof Pomian, *Collectors and Curiosities: Paris and Venice, 1500-1800* (Cambridge: Polity Press, 1990), 25, 27.
5. Conversation with Paula Findlen. See Paula Findlen, *Possessing Nature: Museums, Collecting, and Scientific Culture in Early Modern Italy* (Berkeley: University of California Press, 1994).
6. Quotes from Robert Garland, *The Eye of the Beholder: Deformity and Disability in the Graeco-Roman World* (Ithaca, NY: Cornell University Press, 1995), 54-55.
7. William Schupbach, "Cabinets of Curiosities in Academic Institutions," in *The Origin of Museums,* ed. Oliver Impey and Arthur MacGregor (Oxford: Clarendon Press, 1985), 172-73.
8. Ibid., 170.
9. See Rosamond Purcell and Stephen Jay Gould, *Finders Keepers: Treasures and Oddities of Natural History, Collectors from Peter the Great to Louis Agassiz* (New York: W. W. Norton, 1992), for an overview of international collecting, particularly pp. 139-50.
10. Wilma George, "Alive or Dead: Zoological Collections in the Seventeenth Century," in *The Origin of Museums,* ed. Oliver Impey and Arthur MacGregor (Oxford: Clarendon Press, 1985), 186.
11. The fixed dimensions of a "cubit," the unit of measurement used by Kircher in his plans for Noah's actual ark, was subject to warm debate among scholars. The measurement

of the cubit, some argued, would have to be revised to a larger cubit to accommodate all the creatures to be saved from the flood. Precise measurements, size, and comparative sizes become a frustrating issue when the subject is not on hand to be measured. Given all the birds and animals to be rescued, how could any single ark suffice?

12. Many of van Heurn's collected specimens are discussed and photographed in "A Taxonomist's Taxonomist," in Purcell and Gould, *Finders Keepers,* 44-55.

13. This item is currently on display at Yale University in the Historical Library, Cushing Tumor Collection (R49). It's inscribed with the date, place, and circumstance of the incident.

14. See Dudley Wilson, *Signs and Portents: Monstrous Births from the Middle Ages to the Enlightenment* (London: Routledge, 1993), 70, for a complete list of items. See also Ambroise Paré, *On Monsters and Marvels,* trans. Janis L. Pallister (Chicago: Chicago University Press, 1982).

15. The current incarnation of Peter the Great's *Kunstkammer* is notable for the presence of a very few remaining specimens from the famous anatomist Frederik Ruysch. Because several recent writers have quite thoroughly reviewed, written, and rewritten the story of Peter and Ruysch, I will confine my remarks to this and to brief texts in "Generation." See Dr. Antonie Luyendijk-Elshout, "Death Enlightened," *Journal of the American Medical Association* (April 6, 1970); Purcell and Gould, *Finders Keepers;* F. Gonzalez Crussi, *Suspended Animation* (San Diego: Harvest Book, 1995), afterword and photographs by R. Purcell; Lawrence Weschler, *Mr. Wilson's Cabinet of Wonder* (New York: Pantheon Books, 1995); and Julie Hansen, "Resurrecting the Dead: Anatomical Art and Representation in the Cabinet of Dr. Frederik Ruysch," in *The Art Bulletin* 58 (December 1996): 673–79.

16. For a description of the Cospi Collection, see *Museo Cospiano, Annesso a Quello del Famoso Ulisse Aldrovandi* (Bologna: Giacomo Monti, 1677). Translated by Vally Miatto Buonanno for the author.

17. See Findlen, *Possessing Nature,* 27, 119.

18. Leslie Fiedler, *Freaks: Myths and Images of the Secret Self* (New York: Anchor Books, 1978), 111–13.

19. Harriet Ritvo, "Professional Scientists and Amateur Mermaids: Beating the Bounds in Nineteenth-Century Britain," *Journal of Victorian Literature and Culture* 19 (1995): 277-91.

20. See Stephen Jay Gould, *The Flamingo's Smile: Reflections in Natural History* (New York, W.W. Norton, 1985), 292-305.

21. Jared Diamond, *The Third Chimpanzee: The Evolution and the Future of the Human Animal* (New York: Harper Perennial, 1993), 281.

22. Both the monster market and Domitian's slave are described in Garland, *Eye of the Beholder,* 46-47, 49.

23. See Patrick J. Geary, *Furta Sacra: Thefts of Relics in the Central Middle Ages* (Princeton: Princeton University Press, 1978).

24. George Eliot, *Romola,* (Boston: Little, Brown and Co., 1900), 154-55.

25. Michel Lemire, *Artistes et Mortels* (Paris: Chabaud, 1990), 28.

26. The overwhelming number of virgins may have come from misinterpretation of a word from the original story, in which the number eleven acquired a thousand and, for emotional reasons, the sense of a multitude passed into perpetuity. The symbolic iconographies of these reliquaries are outlined in Lisa A. Melandri's unpublished paper "Talking Heads and Silenced Bodies: Bust and Cranial Reliquaries as Emblems of Virginity" (Williams College Graduate Program in the History of Art, Spring 1996).

27. P. V. Glob, *The Bog People: Iron-Age Man Preserved* (London: Faber and Faber, 1969).

28. Don Brothwell, *The Bog Man and the Archaeology of People* (Cambridge: Harvard University Press, 1987), 42.

29. Pero Tafur, *Travels and Adventures, 1425-1439,* ed. and trans. Malcolm Letts (London: Routledge and Sons, 1926), 140.

30. Katharine Park, "The Criminal and the Saintly Body: Autopsy and Dissection in Renaissance Italy," *Renaissance Quarterly* 47 (1994): 1–33.

31. Tafur, *Travels,* 88.

32. Brehaut, "On Floods by St. Isidore of Seville, from *Etymologies,*" in *An Encyclopedia of the Dark Ages* (New York: Columbia University Press, 1912).

33. Scheuchzer is quoted by Carlos Sarti in *I Fossili e il Diluvio Universale: Le Collezioni Settecentesche del Museo di Geologia e Paleontologia dell'Università di Bologna* (Bologna: Pitagora Editrice, 1988). Translated by Lisa A. Melandri for the author.

TWISTED FRUIT

1. Sherwood Anderson, *Winesburg, Ohio* (New York: Penguin Twentieth Century Classics, 1992), 36.
2. Willy Ley, *Exotic Zoology* (New York: Bonanza Books, 1987), 50. Natural historians later identified the vegetable lamb from Tartary as a fringed horizontal "semi-root" that runs off a certain fern and has the look of four small dangling feet (no head) of a small animal. Linnaeus named the fern *polypodium baromitz* (in honor of the mythical lamb). In the nineteenth century, one British naturalist, Henry Lee, decided that the original word "lambs" actually referred to tufts of cotton, growing, as they should be, on cotton plants. He warned that figures of speech sometimes mistakenly lead to the conjuring up of imaginary creatures in the traveler's mind; "the fleece that grows on trees" has turned into the entire animal in the telling of it (see Ley, *Exotic Zoology*, 61).
3. Florike Egmond and Peter Mason, "Report on a Wild Goose Chase," *Journal of the History of Collections* 7 (1995): 25-44.
4. Ibid., 35.
5. Svetlana Alpers, *The Art of Describing: Dutch Art in the Seventeenth Century* (Chicago: University of Chicago Press, 1983), 81.
6. Battista Ferrari, *Hesperides sive Malorum Aureorum Cultura et Usu* (Rome: Sumptibus Hermanni Scheus, 1646). Translated by author.
7. Ovid, *The Metamorphosis*, bk. 1, lines 24, 44-50, ed. and trans. Allen Mandelbaum (San Diego: Harvest Books, 1993).
8. Ferrari, *Hesperides*, 3.
9. Jakob Rueff, *De Conceptu et Generatione Hominis* (Frankfort-am-Main: G. Corvinus, 1580), frontispiece.
10. Erasmus Darwin, *The Botanic Garden: A Poem in Two Parts* (London, 1799), 143-45. See E. M. Beekman, ed. and trans., *The Poison Tree: Selected Writings of Rumphius on the Natural History of the West Indies* (Amherst: University of Massachusetts Press, 1981), 138-39.
11. Georgius Rumphius as quoted in Beekman, *Poison Tree*, 129.
12. Ibid., 14.
13. John Donne, "Song," in *The Norton Anthology of Poetry*, 3rd ed., ed. Alexander Allison, Herbert Barrows, Caesar Blake, Arthur Carr, Arthur Eastman, and Hubert English (New York: W. W. Norton, 1970), 100.

GENERATION

1. William Faulkner, *As I Lay Dying* (New York: Vintage Books, 1957), 79.
2. Garland, *Eye of the Beholder*, 174-76.
3. All of the following stories by Giovanni Battista Della Porta are from *Natural Magick, in XX Books* (London: R. Gaywood, 1658), bk. 2.
4. In 1637, Jan Swammerdam in Amsterdam determined by dissection that the king bee—full of eggs—had been a queen all along.
5. Carlo Ginzburg, *The Cheese and the Worms: The Cosmos of a Sixteenth Century Miller,* trans. John and Anne Tedeschi (New York: Penguin Books, 1980), 119.
6. Quote by Aristotle in T. H. White, trans., *The Book of Beasts* (New York: Dover Publications, 1984), 184.
7. Ibid., 126.
8. Henri, Cordier, ed. and trans., *Ser Marco Polo* (London: John Murray, 1920), 120-21.
9. David Gordon White, *Myths of the Dog-Man* (Chicago: University of Chicago Press, 1991), 60.
10. "Homunculus" is actually a twentieth-century term for this "little man," even though the word was long attributed to seventeenth-century Preformationists.
11. Gould, *Flamingo's Smile*, 145, 151.
12. Ibid., 151.
13. Ambroise Paré, *On Monsters and Marvels,* trans. Janis L. Pallister (Chicago: Chicago University Press, 1982), 13.
14. Touffain Bridoul, *The School of the Eucharist* (London: Randall Taylor, 1687), 17.
15. James Dickey, "The Sheep Child" in *The Whole Motion, Collected Poems 1945-1992* (Hanover: Wesleyan University Press, 1992), 248-49, verse 5.
16. Vermeule, *Aspects of Death.*
17. Fortunio Liceti, *De Monstris* (Amsterdam: Andre Frisii, 1665).

18. George M. Gould and Walter L. Pyle, *Anomalies and Curiosities of Medicine* (New York: Bell Publishing, 1973), 827.
19. James Duplessis, *Prodigies and Monstrous Births* (c. 1680) f.4 verso- f.5 verso, quoted in Dudley Wilson, *Signs and Portents: Monstrous Births from the Middle Ages to the Enlightenment* (New York: Routledge, 1993), 94-95. Spelling and punctuation as transcribed from book.
20. Geoffrey G. Harpham, *On the Grotesque: Strategies of Contradiction in Art and Literature*, (Princeton: Princeton University Press, 1982).

TOO MUCH, NOT ENOUGH, AND IN THE WRONG PLACE

1. Eudora Welty, "The Petrified Man," in *A Curtain of Green and Other Stories* (San Diego, New York: Harcourt Brace, 1979), 39–40.
2. Comte de Buffon, *Histoire Naturelle, Supplément* (Paris: l'Imprimerie Royale, 1778), 410-14. Translation by author.
3. Katharine Park and Lorraine Daston, *Wonders and the Order of Nature, 1150-1750* (New York: Zone Books, forthcoming).
4. Ibid.
5. Robert Louis Stevenson, *Treasure Island* (London: Cassell and Company, 1884), 4.
6. Christian Morgenstern, "Das Knie," in *Alle Galgenleider* (Wiesbaden: Insel, 1956), 34.
7. Buffon, *Histoire Naturelle*, 413-14.
8. See Park and Daston, *Wonders*, forthcoming. Katharine Park kindly first did this original research for the exhibition *Special Cases: Natural Anomalies and Historical Monsters* at the Getty Research Institute, Santa Monica, CA, Fall 1994.
9. For a discussion of the Chulkhurst twins, see George Gould and Walter Pyle, *Anomalies and Curiosities of Medicine* (New York: Bell Publishing, 1956), 174-76. For a discussion of the Hensel twins, see Kenneth Miller, "One Body, Two Souls," *Life* (April 1996): 44-56.
10. Mark Twain, "Those Extraordinary Twins," in *Pudd'nhead Wilson and Other Tales*, ed. R. D. Gooder (Oxford: Oxford University Press, 1992), 156.
11. Ibid., 169.
12. Upon waking after the delivery of her twin daughters and hearing a nurse speak, Mrs. Hensel said, "Siamese? I thought I'd had cats" (Miller, "One Body," 52).
13. Fiedler, *Freaks*, 218.
14. Gould, *Flamingo's Smile*, 64-77.
15. Park and Daston, *Wonders*, forthcoming.
16. Garland, *Eye of the Beholder*, 70
17. Ibid., 71
18. Pliny the Elder, *Natural History* 7.34, in Garland, *Eye of the Beholder*, 70.
19. Michel Foucault, introduction to *Herculine Barbin: Being the Recently Discovered Memoirs of a Nineteenth Century Hermaphrodite*, trans. Richard McDougall (New York: Pantheon Books, 1980), 8-18.

HEADS AND TAILS

1. Ritvo, "Professional Scientists," 278.
2. John Friedman, *The Monstrous Races in Medieval Art and Thought* (Cambridge: Harvard University Press, 1981), 160. Friedman points out that "both the illustrator and compiler exhibit a deeply rooted ethnocentrism which makes the perceiving eye in the pictures that of a biased and civilised Western traveler."
3. Quotation taken from curatorial text, courtesy of the Morgan Library. Text written by Meta P. Harrsen, Curator of Medieval Manuscripts, 1941.
4. Conversation with Harriet Ritvo in December 1996. Ritvo stated that the creature was made in Japan and brought back to Europe in the fifteenth century as a treasure for a royal cabinet. There is no reason to believe that a Japanese taxidermist would have been inspired by a French painting to create a creature from scratch.
5. Beekman, *Poison Tree*, 242-43.
6. Ibid., 244-45.
7. In the *Island of Doctor Moreau* by H. G. Wells, the fictional vivisectionist sets up shop on a remote island to continue his experiments in cross-speciation, cutting and combining beasts in his desire to create new creatures. Among these new beings were bull creatures, a "creature made of hyena and swine, a silvery hairy man, a satyr-like creature of ape and goat, three swine-men and a woman, a bear-bull and . . . an old woman made of vixen and bear [and] a mare-rhinoceros creature."

Moreau wanted to bring their minds to a state of intellectual refinement—an impossible mission. He had instead created a miserable and hopelessly degenerate set of hybrids. Doctor Moreau was a cousin of Doctor Frankenstein. Today, we continue scientific experiments with DNA to create hybrid organic matter that "improves" on the original—"improve" being a euphemism for "usefulness." It remains to be seen how far this can go and how "successful" such combining will be.

8. Martin Luther quoted in Maarten 't Haart, *Ratten* (n.p., 1973), 72-74, 92-94. Translated into English for the author by Steven de Clercq.

9. Ibid., 74.

10. White, *Book of Beasts,* 34-35.

11. Herodotus, *The Persian Wars,* bk. 3, chap. 113, in Iobi Ludolphus, *Historia Aethiopica* (Frankfort: J. David Zunner, 1681), 113. Translated by Vally Miatto Buonanno for the author.

12. For more information on the Irish elk, see Stephen Jay Gould, *Ever Since Darwin* (London: Penguin, 1980), 197.

13. John Huygen van Linscoten, quoted in Park and Daston, *Wonders,* forthcoming.

14. Ruth Mellinkoff, *The Horns of Moses* (Los Angeles: University of California Press, 1984), 198.

15. The text of this story was supplied to the author by the National Museum of Natural History, Madrid. The translation from Spanish is by Katharine M. Wolff for the author.

16. Jorge Luis Borges and Norman Thomas di Giovanni, *The Book of Imaginary Beings* (New York: Discus Books/Avon, 1970), 101.

17. David Gordon White, *Myths of the Dog-Man* (Chicago: Chicago University Press, 1991), 61.

18. This text is also referred to as "The Contendings of the Apostles," a fourteenth-century text combining Eastern and Western Christian legends. The story of Abominable is fully told in White, *Myths of the Dog-Man,* 22.

19. The term "lobster man" refers to the congenital suppression of digits (fingers, toes) into single or double fleshy "claws." The boy Foma, kept by Peter the Great (see "Collections"), had two thick "digits" on each of his hands and feet.

20. Jesse L. Byock, "The Bones of Egil," *Scientific American* (January 1995): 82-87.

21. Stephen Jay Gould, *The Mismeasure of Man* (New York: W. W. Norton, 1981), 124-25.

22. Paolo Scarani, "Un Affascinante Legame Tra il Museo di Anatomia Patologica e l'Antico Ospedale dei Pazzi del S. Orsola," *Il Friuli Medico* 46 (1991): 197-212. Translated and paraphrased by the author.

23. Gretchen Worden, "The Hyrtl Skull Collection," *Transactions and Studies of the College of Physicians* ser. 5, vol. 17 (December 1995): 95.

24. Park and Daston, *Wonders,* forthcoming.

GIANTS AND DWARFS

1. Virgil, *The Aeneid,* bk. 3, lines 821-25, trans. Robert Fitzgerald (New York: Vintage Books, 1990).

2. Leonardo da Vinci, "Of the Order to be Observed in Study," in Edward MacCurdy, ed. and trans., *The Notebooks of Leonardo da Vinci* (New York: George Brazillier, 1958), 906.

3. Comte de Buffon, *Histoire Naturelle, Générale et Particulière, Servant de Suite à l'Histoire Naturelle de l'Homme,* bk. 4 (Paris: l'Imprimérie Royale, 1778), 395-97.

4. Homer quoted in Iobi Ludophus, *Historia Aethiopica* (Frankfort: J. David Zunner, 1681), 69. Translated by Vally Miatto Buonanno for the author.

5. Aristotle quoted in Ludophus, *Historia Aethiopica,* 69. Translated by Vally Miatto Buonanno for the author.

6. Véronique Dasen, "Dwarfism in Egypt and Classical Antiquity, Iconography and Medical History," *Medical History* 32 (1988): 257.

7. Ludolphus, *Historia,* 69-75

8. John Block Friedman, *The Monstrous Races in Medieval Art and Thought* (Cambridge: Harvard University Press, 1981), 192-96. Friedman synopsizes these arguments, which were perhaps influenced by the status of pygmies in the face of whites and the "built-in bias concerning the status of a captive race."

9. Mary Douglas, *Purity and Danger: An Analysis of the Concepts of Pollution and Taboo* (London: Routledge, 1995), 87.

10. Joan Mark, *The King of the World and the Land of the Pygmies* (Lincoln: University of Nebraska Press, 1995), 124.

11. Garland, *Eye of the Beholder*, 79.

12. Ibid., 46-47.

13. Fiedler, *Freaks*, 55-56.

14. Ibid., 85.

15. Dasen, "Dwarfism in Egypt," 256.

16. Ibid., 272-73.

17. Virgil, *The Aeneid*, bk. 1, verse 462, ed. Clyde Pharr (Lexington, MA: D. C. Heath and Co., 1964).

18. In the film *Tarzan and the Apemen*, Tarzan and his companions are captured by a village of malevolent, cannibalistic dwarfs, and they are treated to a night of threats and terror. Tarzan, because of his strength, agility, height, and whiteness (see "Conditions of the Skin"), assumes the metaphorical colonialist stature of an enlightened giant, here an innocent hero trapped by a throng of achondroplastic dwarfs in black paint. This is Hollywood, and Tarzan is a giant only relative to the size of his captors. While we sense "good" in Tarzan and "evil" in the dwarfs, it is the old good guys versus bad guys scenario, with danger and suspense without pathos. These Hollywood dwarfs, painted black, are cleverly staged to move and chant as an orgiastic throng. Hollywood must have decided, in one of the many distorted inaccuracies connected to this vision of Africa, that really, it amounts to the same old story: pygmy, dwarf, black, cannibalistic, ignorant, un-Christian, evil natives.

19. Susan Stewart, *On Longing: Narra-*

tives of the Miniature, the Gigantic, the Souvenir, the Collection (Durham, NC: Duke University Press, 1993), 111–14.

20. For a moving fictional account of an afflicted young giant, see Elizabeth McCracken, *The Giant's House* (New York: Dial Press, 1996).

21. Edward J. Wood, *Giants and Dwarfs* (London: Richard Bentley, 1868), 109.

22. Giants may be collected. Peter the Great and Frederick traded giants back and forth; Frederick had a standing army of very tall men, and Peter acquired other giants besides Bourgeois (see "Collections"). At one point he had to send a Belgian giant home because the man was so homesick.

23. Henrion quoted in Wood, *Giants and Dwarfs*, 10-11.

24. Homer, *The Odyssey*, bk. 9, lines 211-14, trans. Robert Fagles (New York: Viking, 1996).

25. Boccaccio's beliefs and findings are outlined in Ley, *Exotic Zoology*, 33-35.

26. The second edition of the Encyclopedia Britannica (1778–83) did not discount the possibility that twenty-five- to thirty-foot-tall giants once lived, since enormous bones were found in various places and examined by both experts and amateurs, who were not yet aware of the existence of dinosaurs and who therefore declared them to be human. See *The Treasury of the Encyclopedia Britannica*, ed. Clifton Fadiman (New York: Viking Penguin, 1992), 64–65.

27. Cordier, *Ser Marco Polo*, chap. 33.

28. Ibid.

29. Dante, *The Divine Comedy, Inferno*, canto XXXI, lines 42–46, 384–85, ed. and trans. John D. Sinclair (New York: Oxford University Press, 1976). The pinecone of Saint Peter's measures seven and a half feet high.

30. Ibid., canto XXXI, lines 41-42, 384-85. Montereggione is a fortress near Siena, studded with towers.

31. Athanasius Kircher, *Van China Monumentis qua Sacris qua Profanis* (Amsterdam: Janssonius and Elizeus Weyerstraet, 1667). All translations of the text by Vally Miatto Buonanno for the author.

32. Stewart, *On Longing*, 86.

33. Original pamphlet, collection of the author.

CONDITIONS OF THE SKIN

1. Toni Morrison, *The Song of Solomon* (New York: The Penguin Group, Penguin Books USA Inc., 1957), 36–37.

2. Tacitus quoted in Aldrovandi, *Monstrorum Historia*, 18-23.

3. A. Leib, "The Mystical Significance of Colours among the Natives of Madagascar," in *African Studies*, vol. 6, ed. C. M. Doke and Julius Lewin (Johannesburg: Witwatersrand University Press, 1947), 77-79.

4. Schiödte is quoted in Charles Darwin, *The Origin of the Species* (Cambridge: Harvard University Press, 1964), 138-39.

5. Translation of painting text by author.

6. Text quoted from Valentijn, *Oud en*

Nieuw Oost-Indien, in Beekman, *Poison Tree*, 167n.

7. Gould, *Flamingo's Smile*, 139-51.
8. Ibid. Gould has said this is various ways at various times.
9. Wells quotes here and below in Gould, *Flamingo's Smile*, 339.
10. Wells' theory that the skin of people living in the tropics darkened slowly over time makes biological sense. The sun is less brilliant north and far south of the equator; white-skinned people need their lighter pigment to absorb the ultraviolet rays.
11. Gould, *Mismeasure of Man*, 44-45. For more information on Agassiz, see Edward Lurie, *Louis Agassiz: A Life in Science* (Baltimore: Johns Hopkins University Press, 1988), 261.
12. Diamond, *Third Chimpanzee*, 282.
13. Umberto Eco, *The Name of the Rose*, trans. William Weaver (San Diego: Harcourt Brace Jovanovich, 1980), 201.
14. Michel Lemire, *Artistes et Mortels* (Paris: Raymond Chabaud, 1990), 40-41.
15. Park and Daston, *Wonders*, forthcoming.
16. Peter Josyph, "From Yale to Canton: The Transcultural Challenge of Lam Qua and Peter Parker," exhibition catalogue at the Mills Pond House Gallery of the Smithtown Township Arts Council, Long Island, and for the Conference at the Health Sciences Center of the SUNY Stony Brook School of Medicine (1992), 5. My thanks to Peter Josyph for all the text in this catalogue.

NEXT OF KIN

1. Plutarch, *Morals* (Boston: Harvard University Press, 1957).
2. David Attenborough, *Bridge to the Past: Animals and People of Madagascar* (New York: Harpers and Brothers, 1961), 113-25.
3. William L. Jungers, Laurie R. Godfrey, Elwyn L. Simons, and Prithjit S. Chatrath, "Subfossil Indri: Indri from the Ankarana Massif of Northern Madagascar," *American Journal of Physical Anthropology* 97 (1996): 357-66.
4. Carolus Linnaeus, *Systema Naturae*, 10th ed. (1758), 20-24. Translated from the Latin by Vally Miatto Buonanno for the author.
5. Gould, *Flamingo's Smile*, 263-80.
6. Ibid., 267.
7. Erling B. Holtsmark, *Tarzan and Tradition: Classical Myth in Popular Literature* (Westport, CT: Greenwood Press, 1981), 71-72.
8. Diamond, *Third Chimpanzee*.
9. Henry Louis Gates, Jr., *Figures in Black: Words, Signs, and the Racial Self* (New York: Oxford University Press, 1987), 236-38.
10. Aldrovandi, *Monstrorum Historia*.
11. Marjorie Lee Hendrix, "Of Hirsutes and Insects: Joris Hoefnagel and the Art of the Wondrous," *Word and Image* 11 (October–December 1995): 373–90.
12. Aldrovandi, *Monstrorum Historia*.
13. Natalie Angier, "Shades of Werewolves: Hair Gene," *New York Herald Tribune*, 1 June 1995, p. 7.
14. "Person Who Stars in Circus Amok!" *New York Times*, 9 June 1995, sec. C, p. 23.

BOUNDARIES

1. Robert Penn Warren, *All the King's Men* (Orlando, Florida: Harcourt, Brace, Jovanovich, 1974), 151.
2. Francois Rabelais, *Gargantua and Pantagruel*, trans. Sir Thomas Urquhart and Peter Le Motteux (New York: Dodd, Mead and Co., n.d.), 31.
3. Ranulf of Higden, *Polychronicon*, in John Block Friedman, *The Monstrous Races in Medieval Art and Thought* (Cambridge: Harvard University Press, 1981), 43.
4. Mary B. Campbell, *The Witness and the Other World: Exotic European Travel Writing, 400-1600* (Ithaca, NY: Cornell University Press, 1988), 122.
5. According to Ley, *Exotic Zoology*, 48-50, Mandeville claimed he was an English knight, and although a knight was found in England with a similar name, he had never traveled beyond England nor was he a writer.
6. Beekman, *Poison Tree*, 14.
7. Jorge Luis Borges, *Other Inquisitions 1937-1952*, trans. Ruth L. C. Simms (New York: Washington Square Press, 1966), 89.
8. Michael Camille, *Image on the Edge: The Margins of Medieval Art* (Cambridge: Harvard University Press, 1992), 15-16.
9. Michel Foucault, *Madness and Civilization: A History of Insanity in the Age of Reason*, trans. Richard Howard (New York: Vintage Books, 1988), 7-11.
10. Ibid., 75.

11. This quote comes from the film *Tarzan the Ape Man* (1932).

12. *Quadro de Historia natural, Civil y Geografico del Reyno del Peru, ano de 1799* by Oleo de Thibeault in the Museo Ciencias Naturales, Madrid. See "Conditions of the Skin."

13. Calvo and Dancette, *The Beast Is Dead: World War II Among the Animals*, trans. Charles Kingston (cartoon history, 1944-45).

14. James Arnold, ed., *Monsters, Tricksters and Sacred Cows: Animal Tales and American Identities* (Charlottesville: University Press of Virginia, 1996), 272.

15. Diamond, *Third Chimpanzee*, 230.

16. Arnold, *Monsters*. Afterword by Derrick Walcott, 272.

17. Richard Stoneman, ed. and trans., *Legends of Alexander the Great* (London: Everyman, 1994), 18.

18. Mark Twain, *Following the Equator* (n.p., 1897).

19. Quote from *The Travels of John Mandeville*, trans. C. W. R. D. Moseley (New York: Penguin Classics, 1983), 183.

20. Stoneman, *Legends*, 7.

21. French proverb.

22. Marlise Simons, "Himalayas Offer Clue to Legend of Gold-Digging Ants," *New York Times*, 25 November 1996.

23. Aelinus, *De Natura Animalium*, bk. 16, as quoted in Willy Ley, *Man the Collector* (Englewood Cliffs, NJ: Prentice-Hall, 1968), 58.

24. Mary Jo Arnoldi and Christine Mullen Kreamer, *Crowning Achievements: African Arts of Dressing the Head*, catalogue for Fowler Museum of Cultural History (Los Angeles: University of California Press, 1995), 116.

25. Evan M. Zuesse, *Ritual Cosmos: The Sanctification of Life in African Religions* (Athens: Ohio University Press, 1979), 69.

26. Mary Douglas, *The Lele of the Kasai* (London: Oxford University Press, 1963).

27. Beekman, *Poison Tree*, 181.

28. White, *Book of Beasts* (Dover), 50.

29. Paula Findlen, *Possessing Nature: Museums, Collecting, and Scientific Culture in Early Modern Italy* (Davis: Regents of University of California, 1994).

30. Marianne Moore, "Oh, to be a dragon," in *The Complete Poems* (New York: Macmillan, 1981), 177.

31. Jurgis Baltrusaitis, *Le Moyen Age Fantastique* (Paris: Flammarion, 1981), 227.

32. Ovid, *The Metamorphoses*, bk. 15, ed. and trans. Allen Mandelbaum (San Diego: Harvest Books, 1993), 523.

33. Maurice Krafft quoted from *Volcano!*, produced and written by Michael Rosenfeld, National Geographic Video, 1989, videocassette.

34. Katya Krafft quoted from *Volcano!*

35. Camille, *Image on the Edge*, 16.

AFTERWORD

1. William Butler Yeats, "The Stolen Child," in *The Collected Poems of Yeats* (New York: Macmillan, 1966).

2. Elizabeth McCracken's *The Giant's House* (New York: Dial Press, 1996) is an excellent fictional account of a contemporary giant.

Index

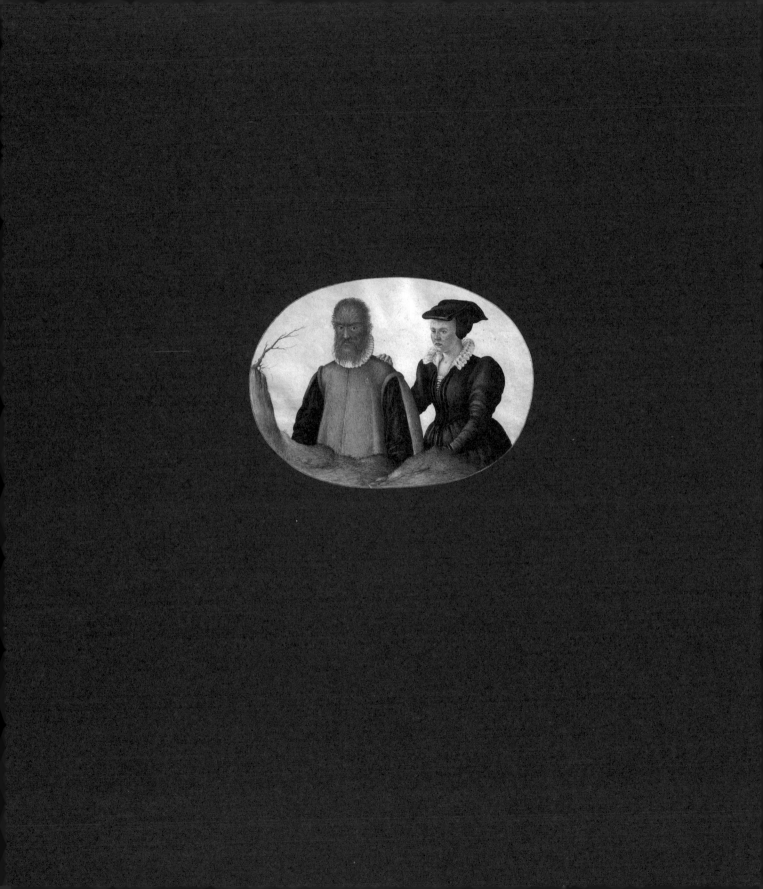